£12.99

.73 s/c

This edition published by Century in 2006

11 13 15 17 19 20 18 16 14 12

Copyright is for losers©™

Previously published in part as three small little books.

First published in the United Kingdom in 2005 by Century, The Random House Group Limited,
20 Vauxhall Bridge Road, London SW1V 2SA
www.randomhouse.co.uk
Addresses for companies within The Random House Group Limited can be found at: www.randomhouse.co.uk/offices.htm

The Random House Group Limited Reg. No. 954009. A CIP catalogue record for this book is available from the British Library.
The Random House Group Limited makes every effort to ensure that the papers used in its books are made from trees that have been legally sourced from well-managed and credibly certified forests. Our paper procurement policy can be found at:
www.randomhouse.co.uk/paper.htm

ISBN 1844137872
ISBN-13 9781844137879

Printed and bound by Firmengruppe Appl, aprinta druck, Wemding, Germany

Note from the publisher: This book contains the creative/artistic element of graffiti art
and is not meant to encourage or induce graffiti where it is illegal or inappropriate.

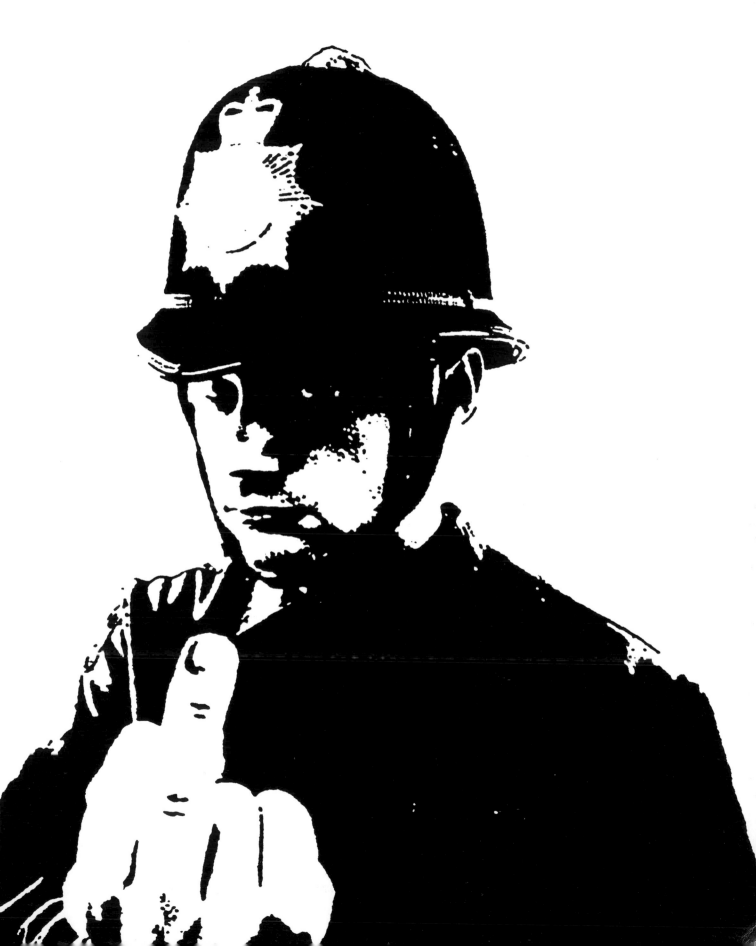

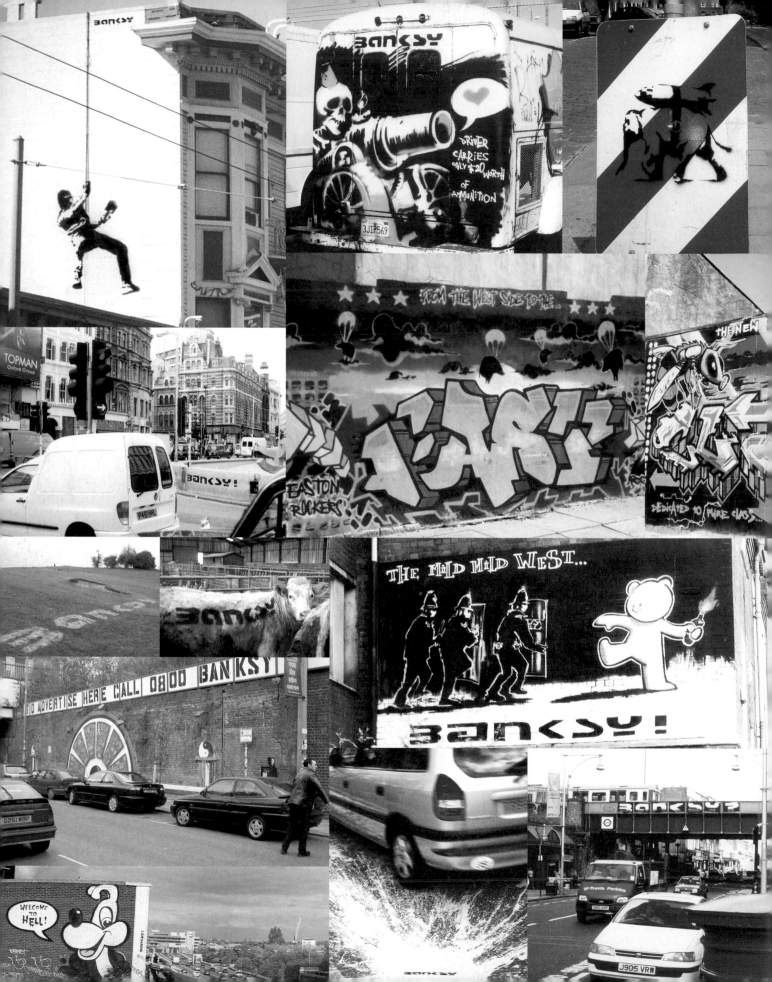

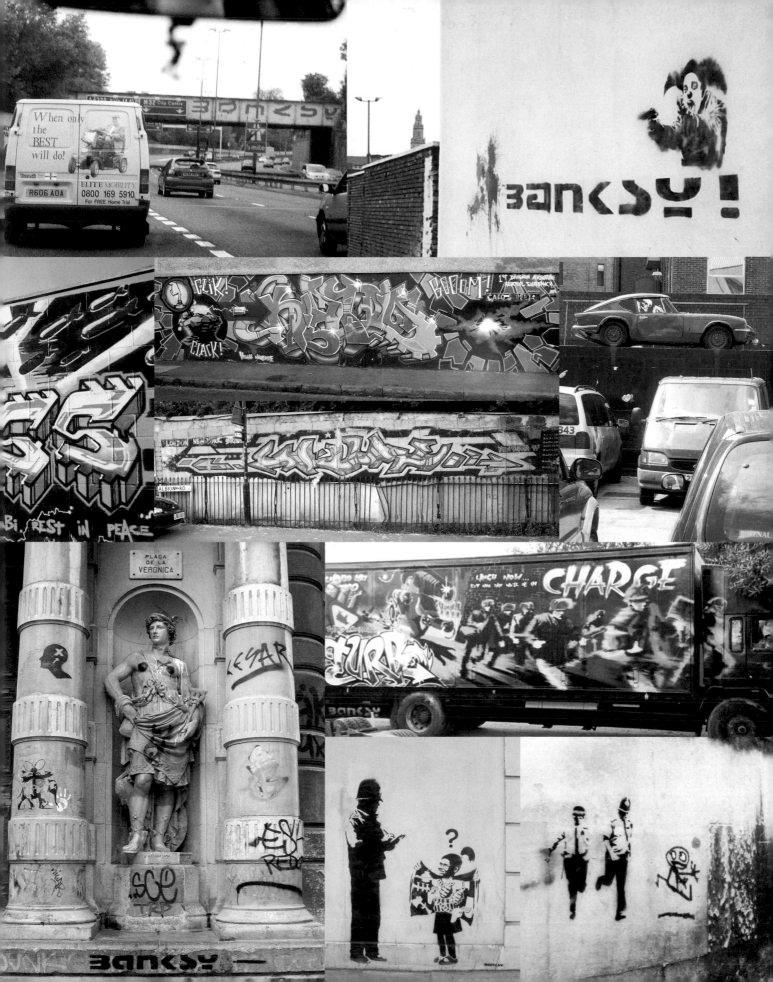

Wall and Piece

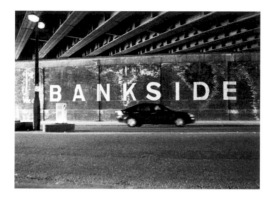

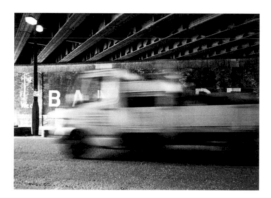

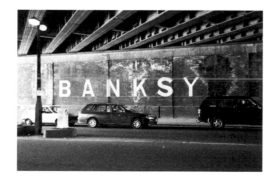

12 minutes, Bankside, London 2001

I'm going to speak my mind, so this won't take very long.

Despite what they say graffiti is not the lowest form of art. Although you might have to creep about at night and lie to your mum it's actually one of the more honest art forms available. There is no elitism or hype, it exhibits on the best walls a town has to offer and nobody is put off by the price of admission.

A wall has always been the best place to publish your work.

The people who run our cities don't understand graffiti because they think nothing has the right to exist unless it makes a profit, which makes their opinion worthless.

They say graffiti frightens people and is symbolic of the decline in society, but graffiti is only dangerous in the mind of three types of people; politicians, advertising executives and graffiti writers.

The people who truly deface our neighbourhoods are the companies that scrawl giant slogans across buildings and buses trying to make us feel inadequate unless we buy their stuff. They expect to be able to shout their message in your face from every available surface but you're never allowed to answer back. Well, they started the fight and the wall is the weapon of choice to hit them back.

Some people become cops because they want to make the world a better place. Some people become vandals because they want to make the world a better *looking* place.

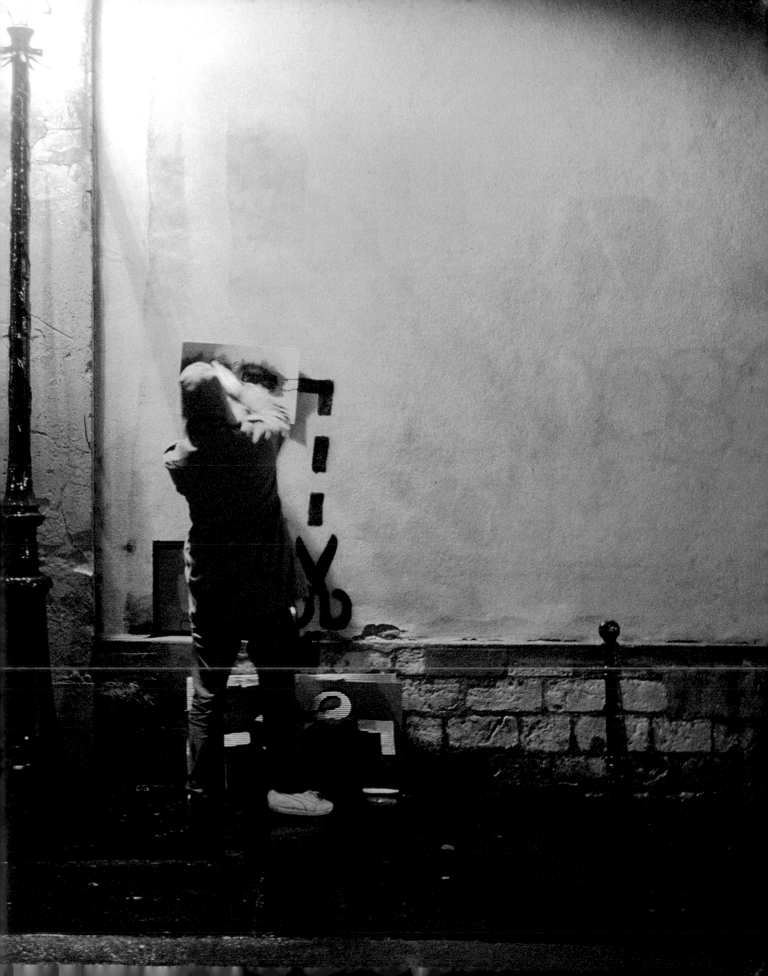

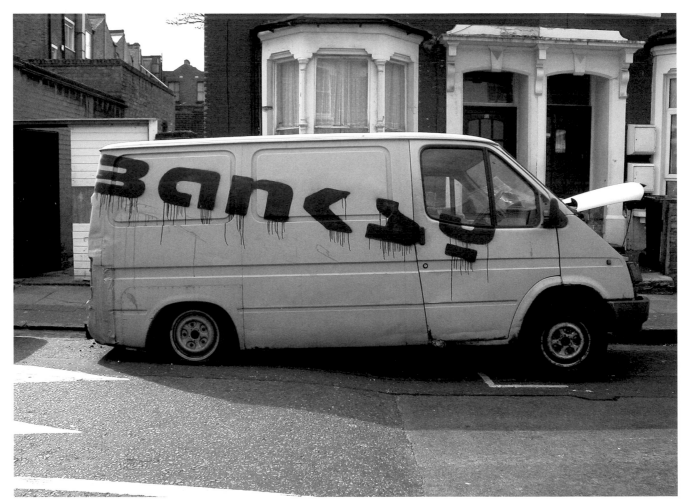

All artists are prepared to suffer for their work, but why are so few prepared to learn to draw?

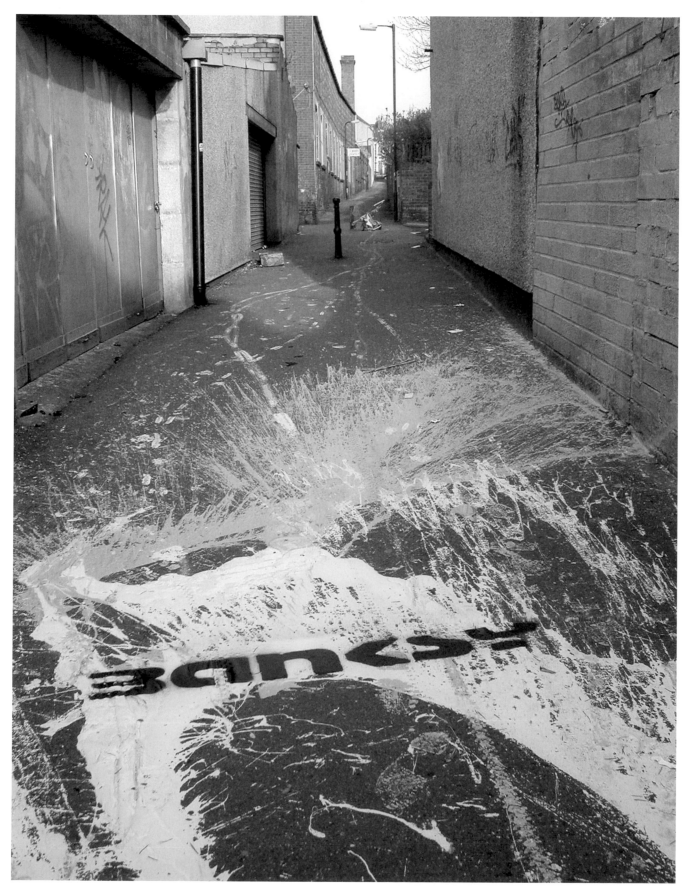

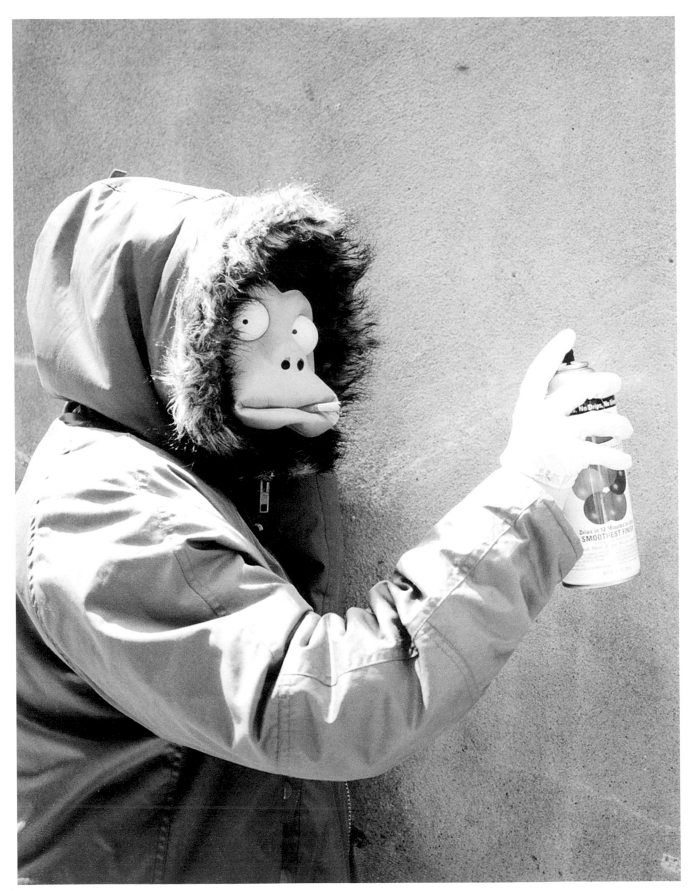

When I was eighteen I spent one
night trying to paint 'LATE AGAIN' in
big silver bubble letters on the side of
a passenger train. British transport
police showed up and I got ripped to
shreds running away through a thorny
bush. The rest of my mates made it
to the car and disappeared so I spent
over an hour hidden under a dumper
truck with engine oil leaking all over
me. As I lay there listening to the
cops on the tracks I realised I had to
cut my painting time in half or give up
altogether. I was staring straight up at
the stencilled plate on the bottom of
a fuel tank when I realised I could just
copy that style and make each letter
three feet high.

I got home at last and crawled into
bed next to my girlfriend. I told her I'd
had an epiphany that night and she
told me to stop taking that drug 'cos
it's bad for your heart.

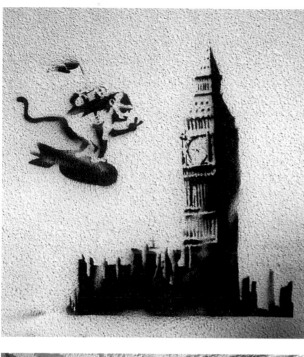

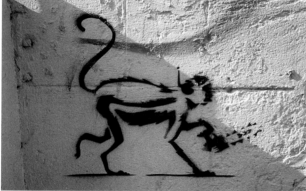

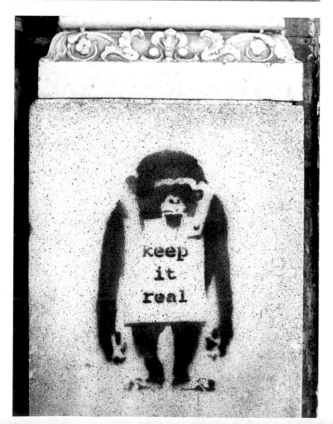

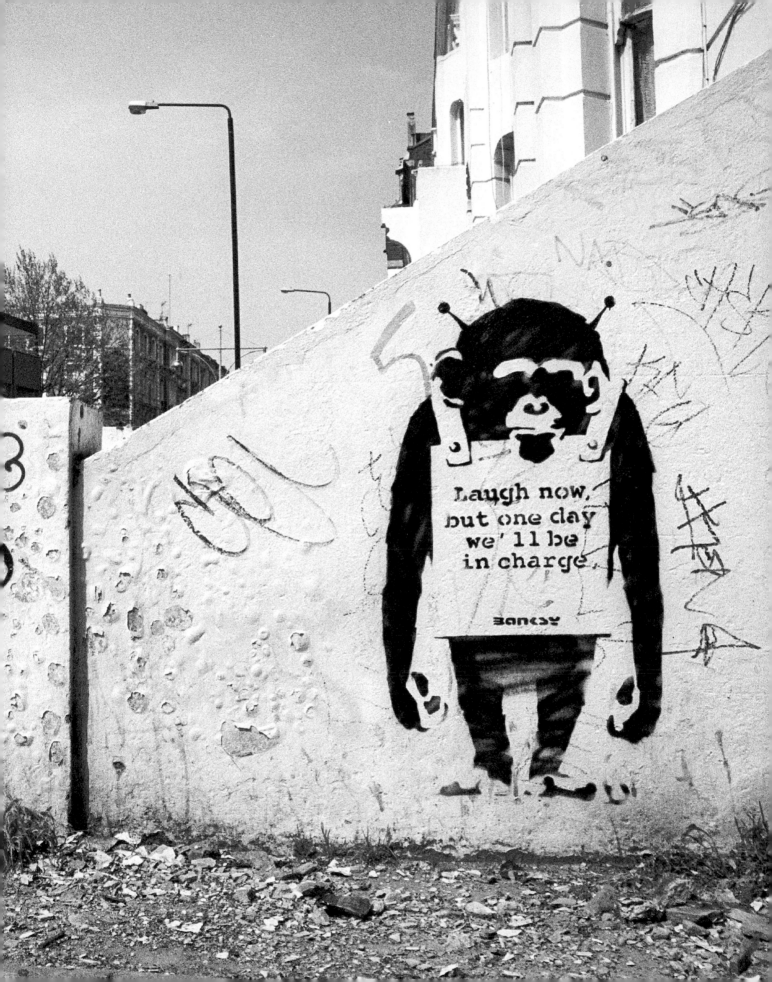

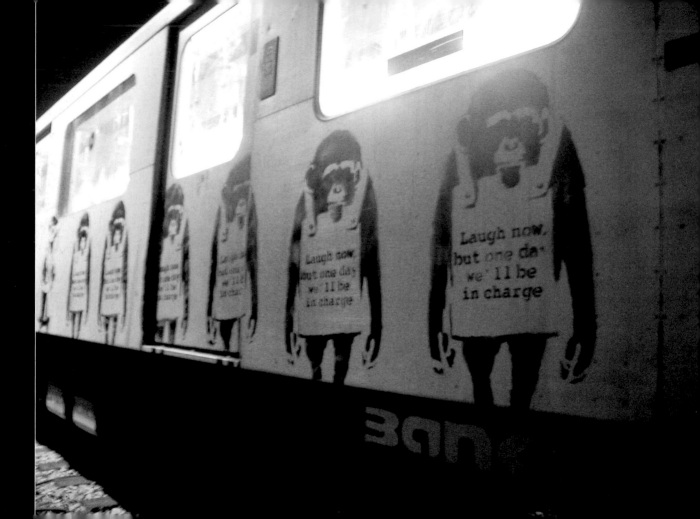

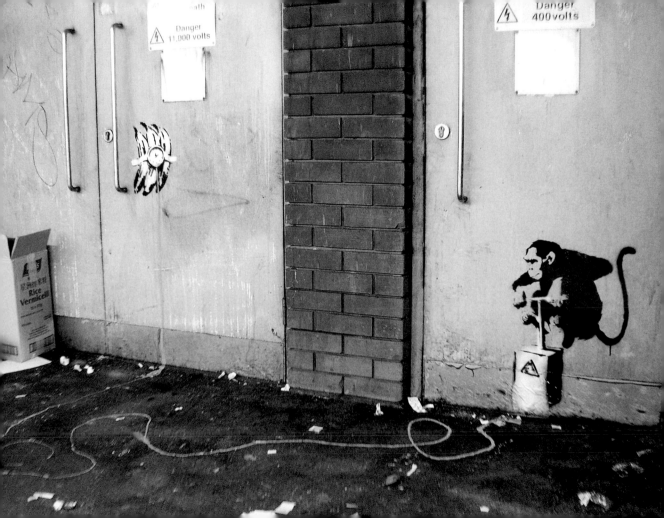

Simple intelligence testing

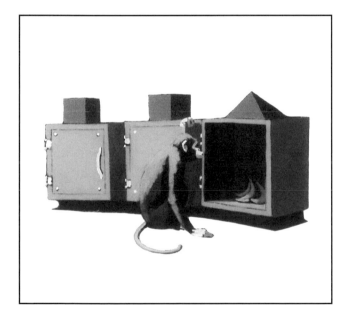 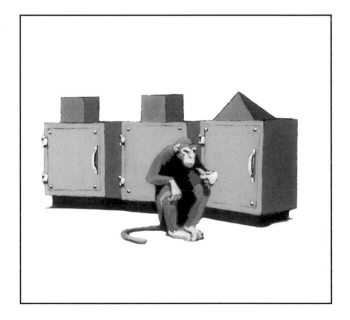

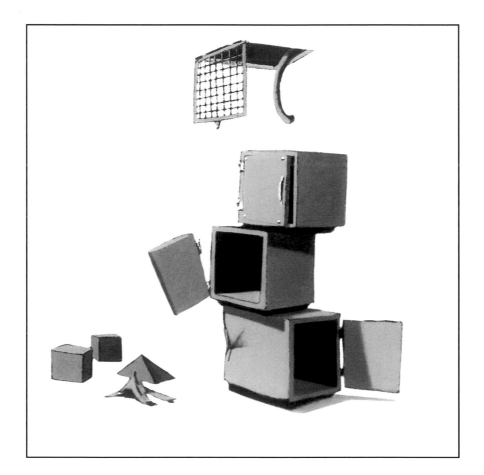

A lot of people never use their initiative because no-one told them to

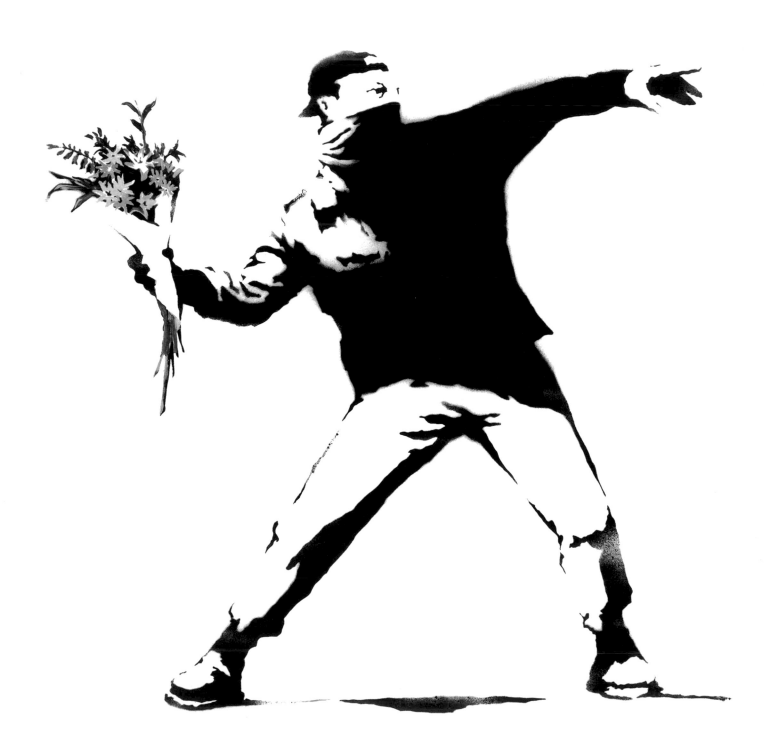

The corrupt and brutal regime of President Ceausescu of Romania was infamous across the world. His ferocious government had run the country emphatically for many years, crushing any signs of dissent ruthlessly. In November 1989 he was re-elected President for another five years as his supporters at Party Conference gave him forty standing ovations.

On December 21st the President, disturbed by a small uprising in the western city of Timisoara in support of a Protestant Clergyman, was persuaded to address a public rally in Bucharest.

One solitary man in the crowd, Nica Leon, sick to death with Ceausescu and the dreadful circumstances he created for everyone started shouting in favour of the revolutionaries in Timasoara. The crowd around him, obedient to the last, thought that when he shouted out 'long live Timisoara!' it was some new political slogan.

They started chanting it too. It was only when he called, 'Down with Ceausescu!' that they realised something wasn't right. Terrified, they tried to force themselves away from him, dropping the banners they had been carrying. In the crush the wooden batons on which the banners were held began to snap underfoot and women started screaming. The ensuing panic sounded like booing.

The unthinkable was happening. Ceausescu stood there on his balcony, ludicrously frozen in uncertainty, his mouth opening and shutting. Even the official camera shook with fright. Then the head of security walked swiftly acrosss the balcony towards him and whispered, 'They're getting in'. It was clearly audible on the open microphone and was broadcast over the whole country on live national radio.

This was the start of the revolution. Within a week Ceausescu was dead.

Source: John Simpson BBC News

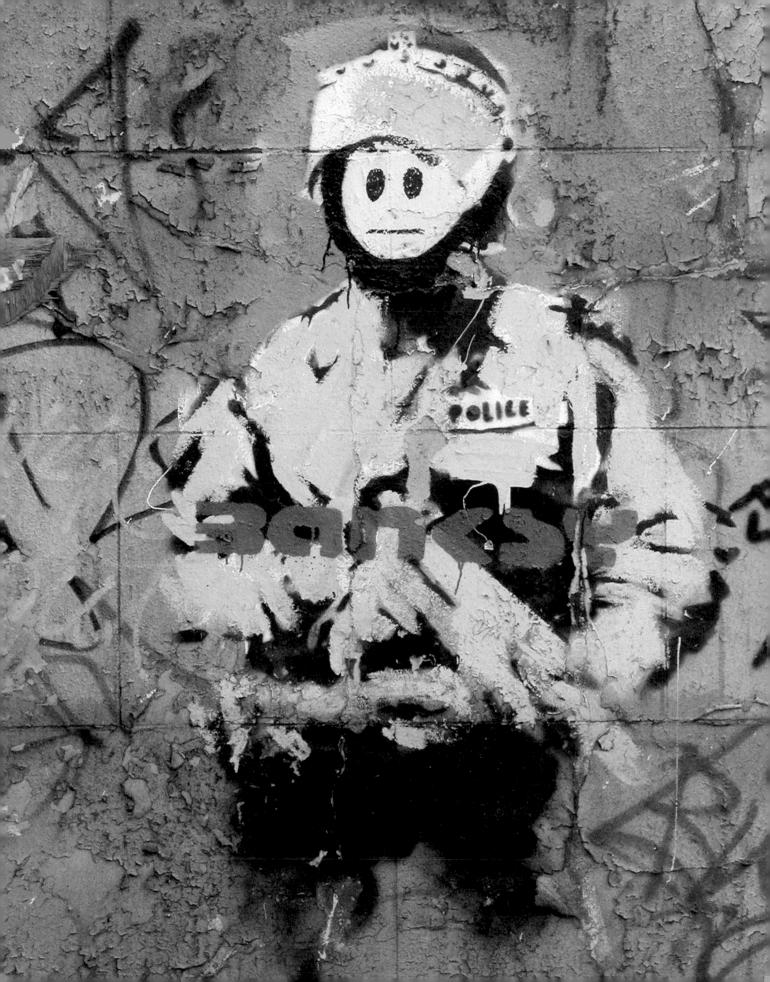

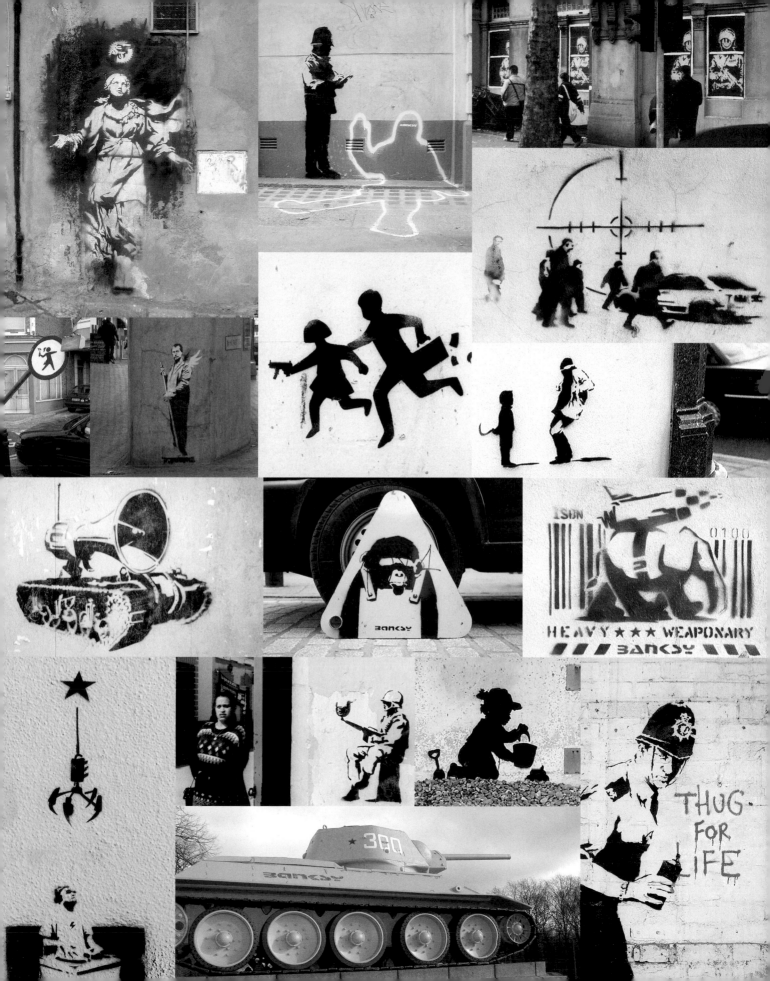

Mona Lisa with rocket launcher. 15 minutes, Soho 2001. Later converted to Osama Bin Laden by unknown persons, then removed after two days.

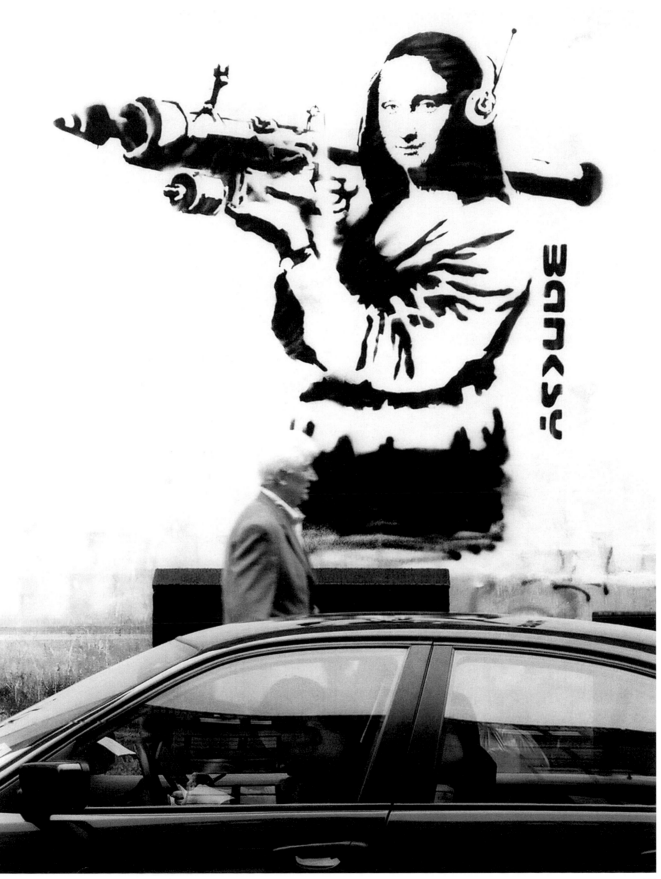

27

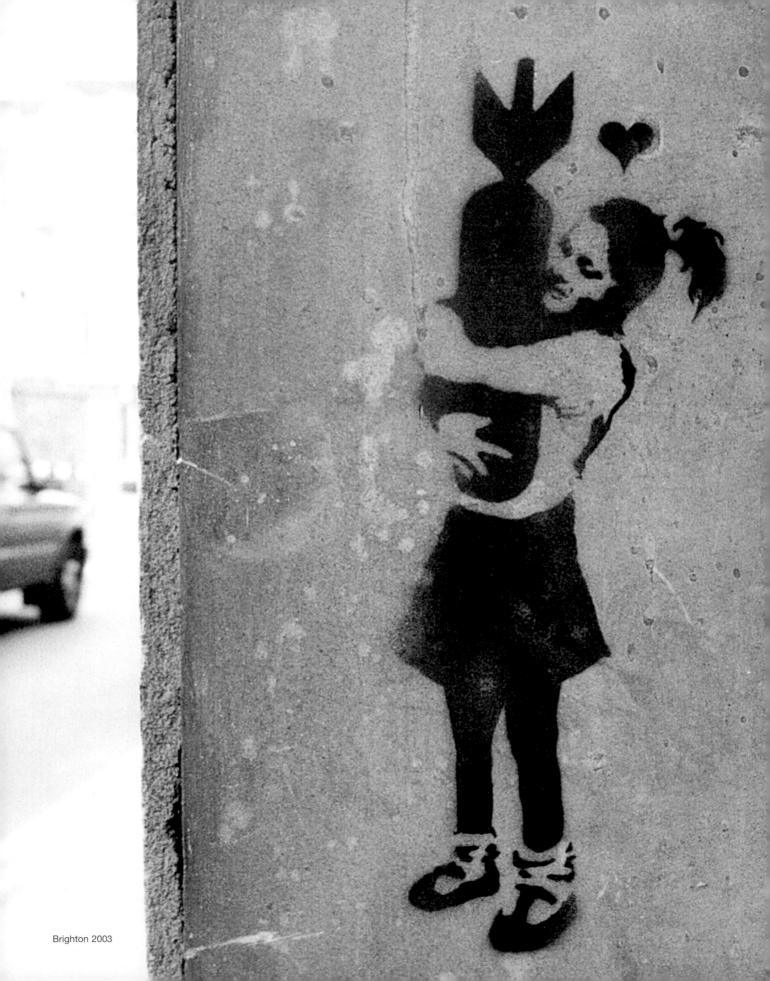

Brighton 2003

It takes a lot of guts to stand up anonymously in a western democracy and call for things no-one else believes in – like peace and justice and freedom.

Soho 2005

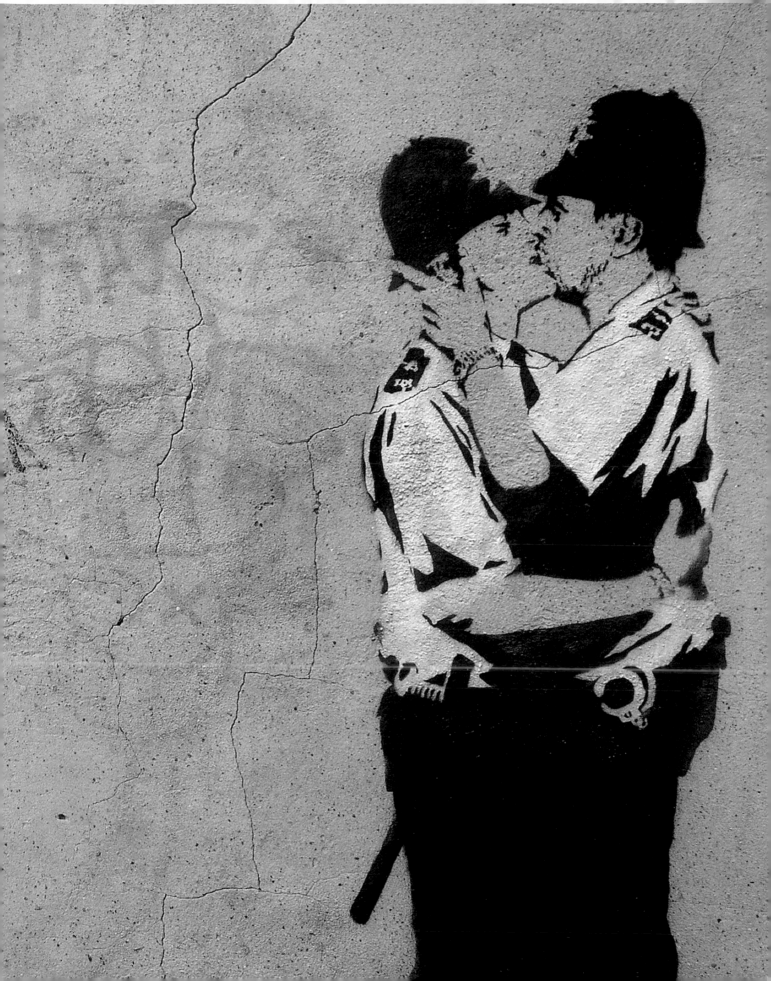

There are no exceptions to the rule that
everyone thinks they're an exception to the rules

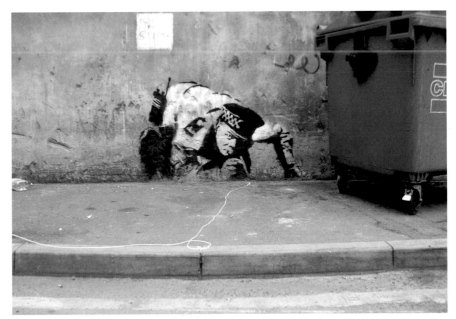

London 2005

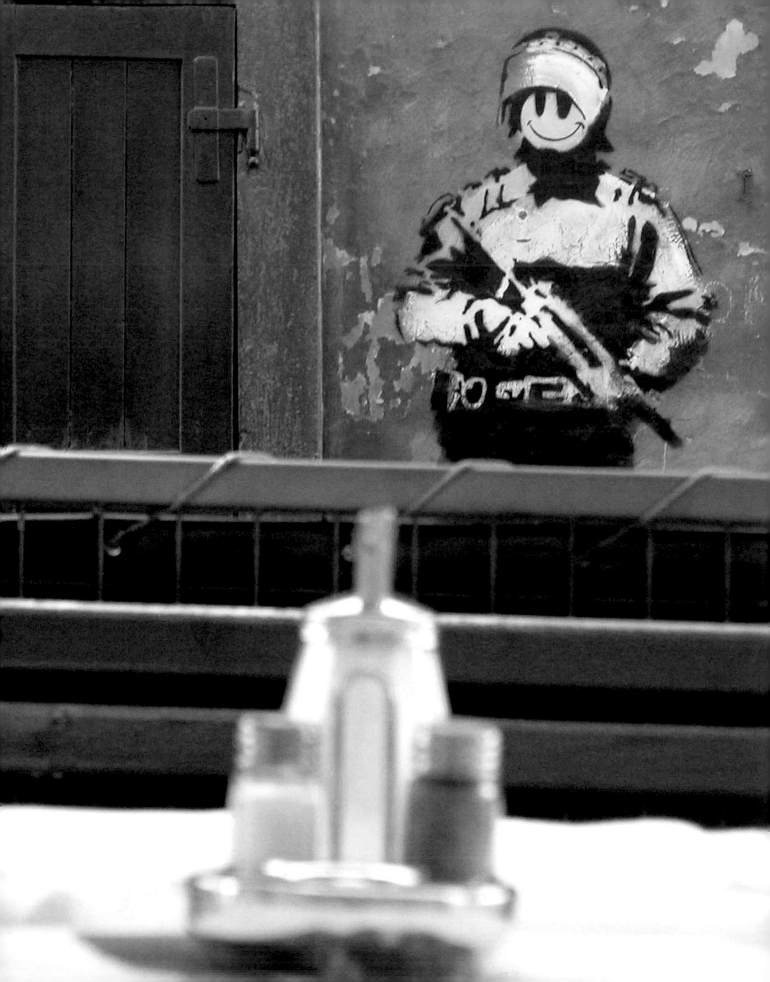

Vienna 2003

Borough, London 2002

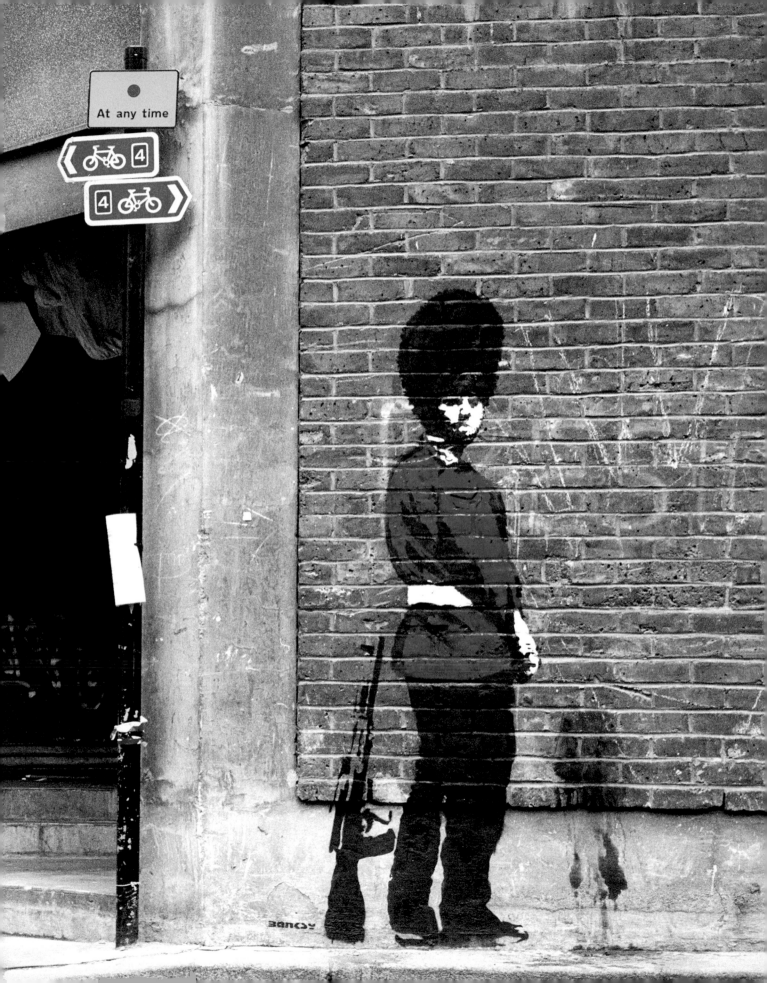

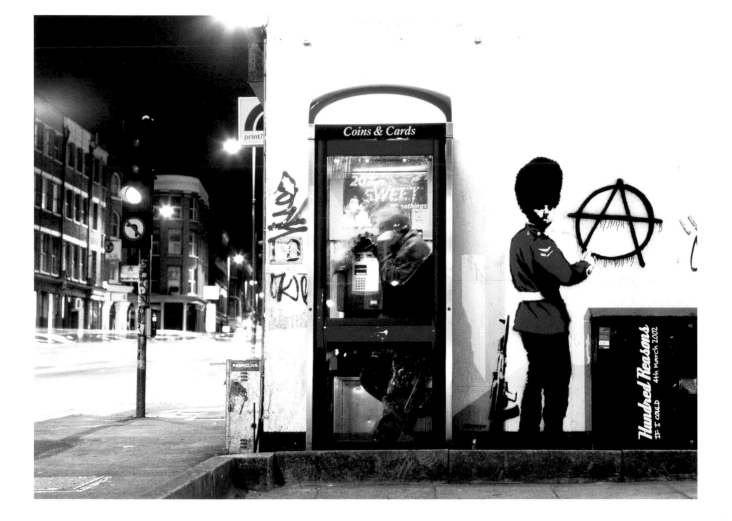

Shoreditch, London 2002

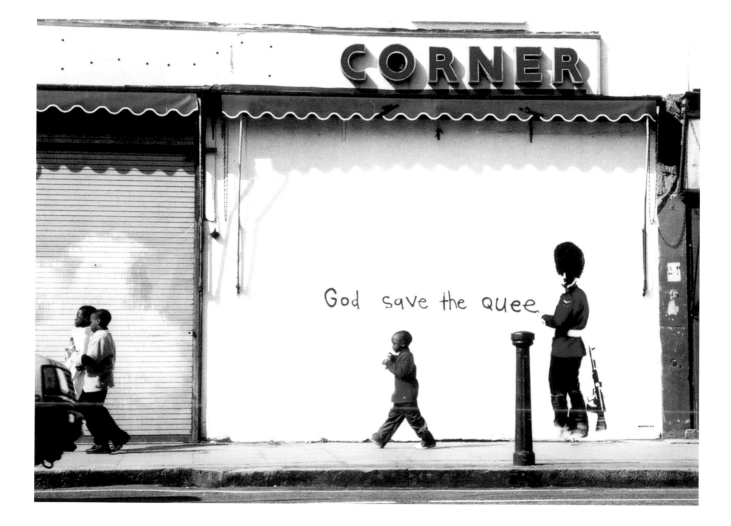

Notting Hill, London 2002

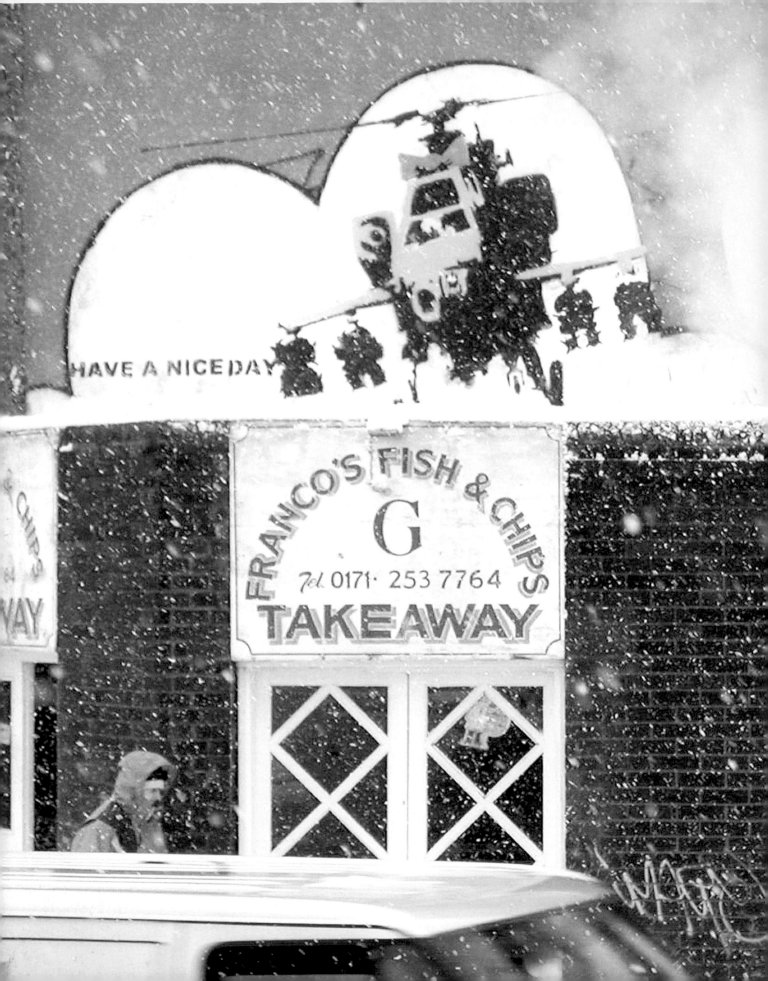

Happy Chopper, Shoreditch 2003. Smoke machine effect supplied by deep fat fryer

Ring road (W)
(A1, A400, A41)
The City
West End
Holborn

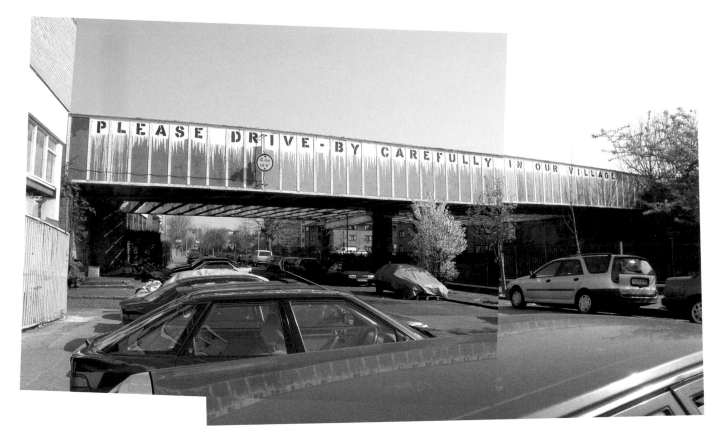

Policemen and security guards wear hats with a peak that comes down low over their eyes for psychological reasons. Apparently eyebrows are very expressive and by covering them up you appear a lot more authoritative.

The upside is this means it's harder for cops to see anything more than six foot off the ground and makes painting rooftops and bridges a lot easier.

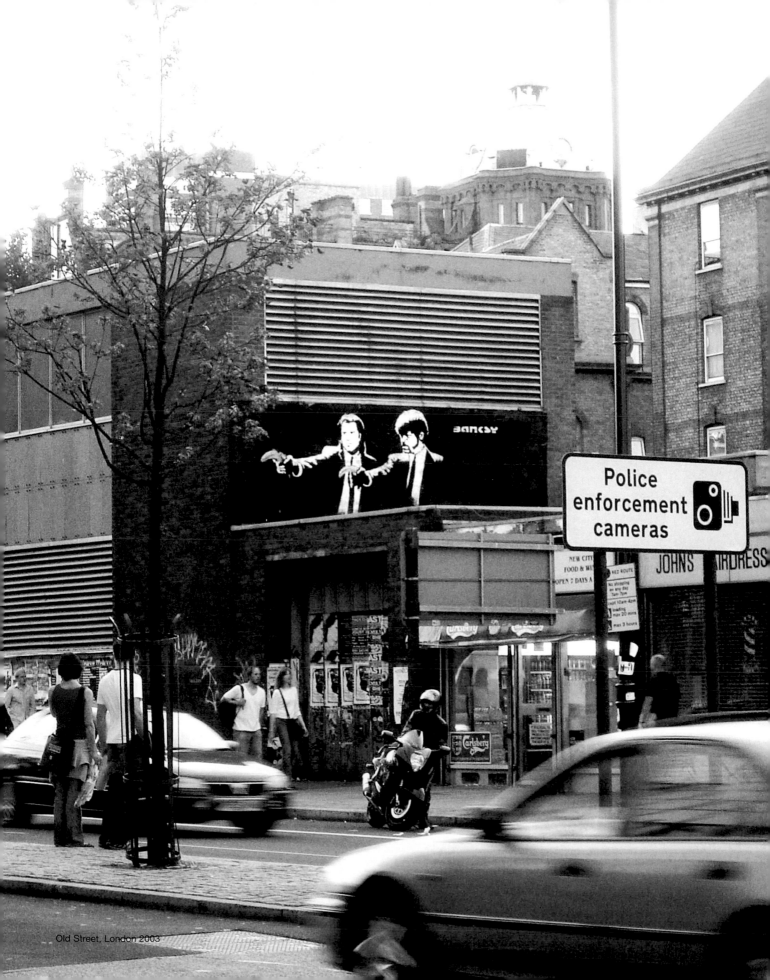

Old Street, London 2003

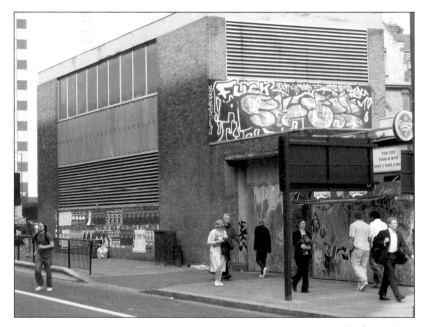

Old Street, 2005

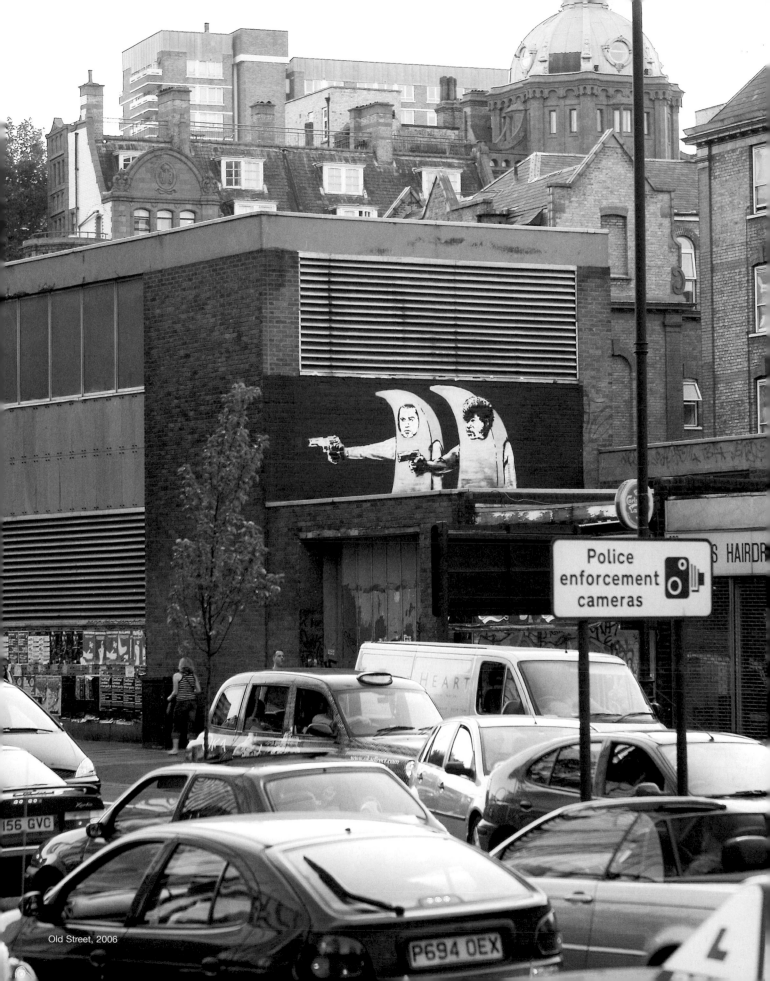

Old Street, 2006

Police
enforcement
cameras

S HAIRDR

This revolution is for display purposes only

On a Tuesday night in the summer I tried to paint a train bridge that spans Portobello Road in West London with posters showing the revolutionary icon Che Guevara gradually dribbling off the page. Every Saturday the market underneath the bridge sells Che Guevara t-shirts, handbags, baby bibs and button badges. I think I was trying to make a statement about the endless recycling of an icon by endlessly recycling an icon. People always seem to think if they dress like a revolutionary they don't actually have to behave like one.

I got up on the bridge about 4am. It was quiet and peaceful until two cars approached very slowly and parked on the street. I stopped pasting and watched from the side of the bridge through the bushes. After a few minutes there was no movement and I figured it was cool to carry on.

I reached the fifth poster when there was a huge bang and the sound of splitting wood. One of the cars had reversed back up the street and was on the pavement, wedged in the doorway of the mobile phone shop. Six small figures in hoods with scarves over their faces ran into the store throwing everything they could into black plastic bags. In less than a minute they were all back in their cars which screamed down Portobello Road beneath me. I stood there with my mouth hanging open, a bucket in one hand and a sawn-off sweeping brush in the other, the only young male in sportswear now within a mile of the store. I got the feeling things would look bad for me if I hung around so I dropped the bucket, climbed the fence and jumped to the street.

The area was full of cameras so I lowered my head, pulled my hood up and ran all the way to the canal. I imagined the kids were probably in Kilburn by then, lighting up a spliff and saying to each other 'Why would someone just paint pictures of a revolutionary when you can actually behave like one instead?'

Bristol Fashion

Wearing your jeans two sizes too big so they hang low off your ass was invented in Los Angeles. Apparently kids in the hood wear clothes handed down by their brothers so the bigger the trousers, the bigger your brothers.

This makes sense until you dress this way to go painting in a fountain. Then if your oversized jeans get damp and you haven't got a belt they tend to fall down halfway through the piece. It doesn't matter how big your brothers are when drunk geezers walk past you waiting for the last bus and it looks like you just pissed all over yourself.

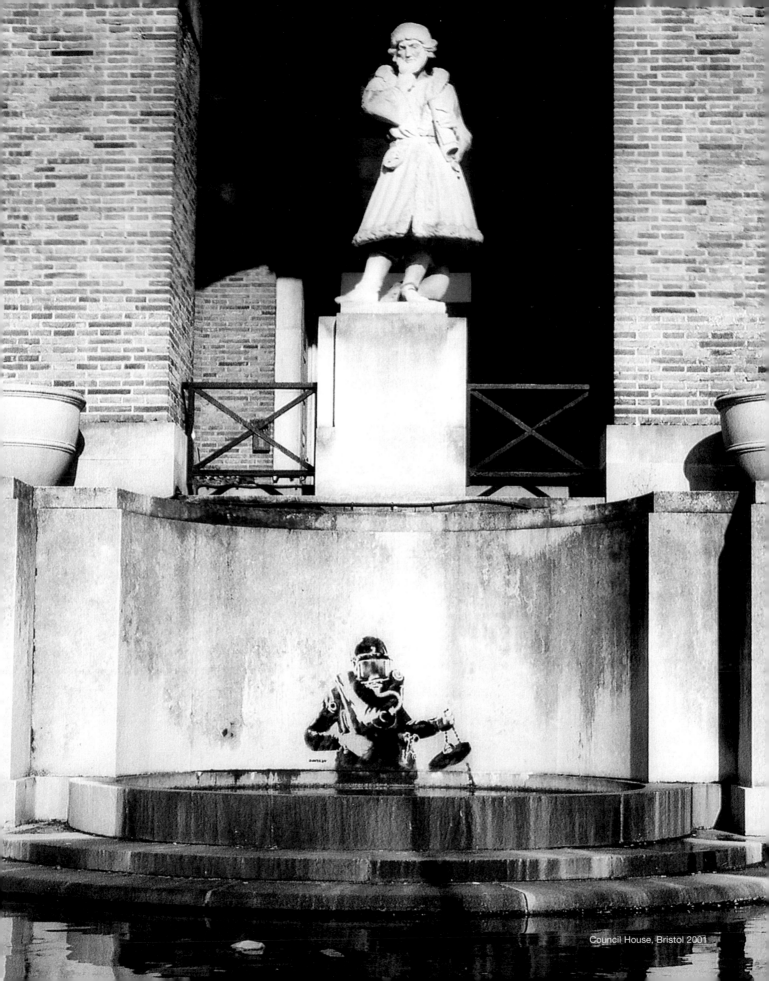

Council House, Bristol 2001

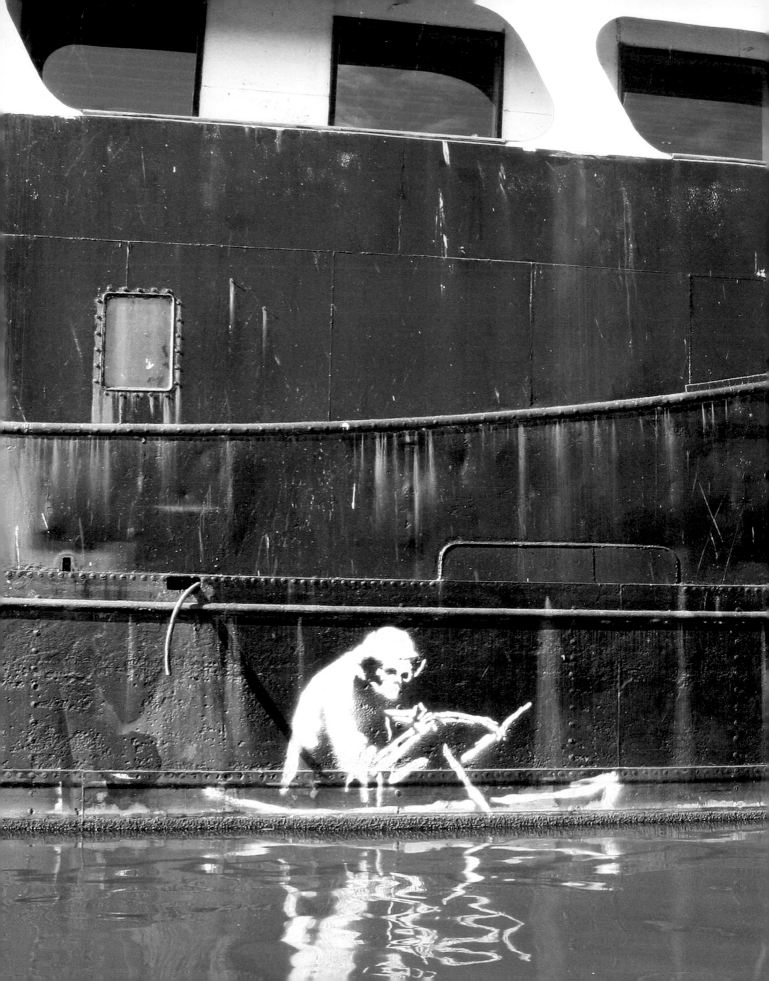

One night I painted my name on the side of a floating night club in Bristol. Apparently the owner quite liked it so when the harbour master [allegedly] painted over it the club threatened to sue.

They never pursued it any further so I went out and hit it again in the hope I could lure the harbour master out for a full custodial sentence this time.

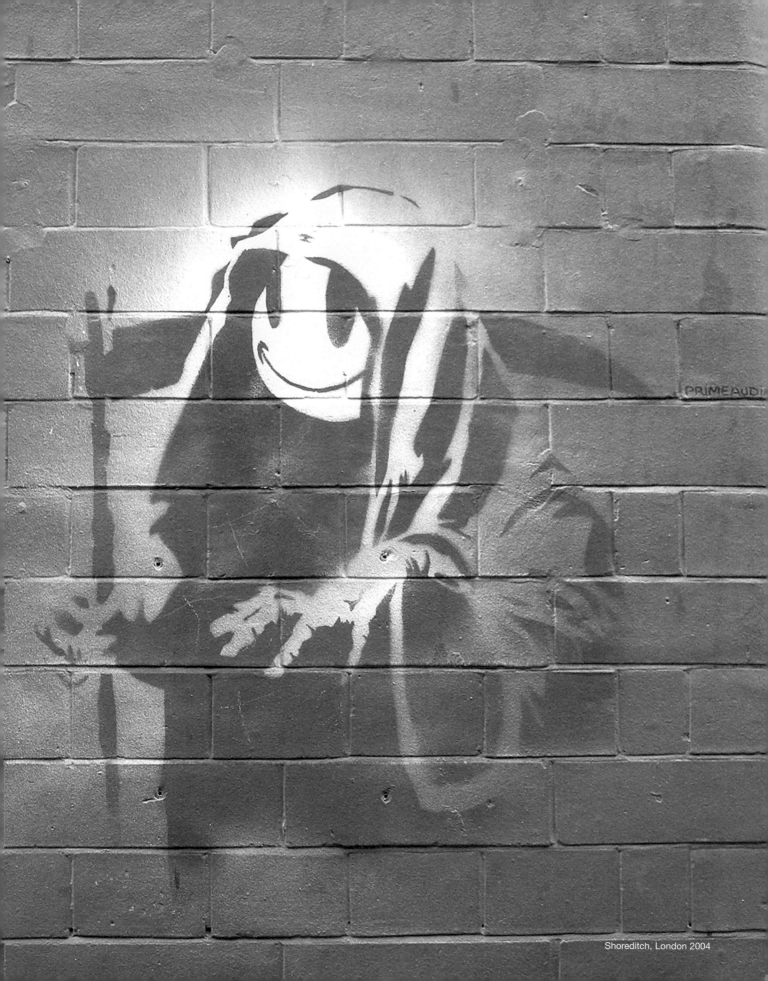

Shoreditch, London 2004

Once upon a time, there was a king who ruled a great and glorious nation. Favourite amongst his subjects was the court painter of whom he was very proud. Everybody agreed this wizzened old man painted the greatest pictures in the whole kingdom and the king would spend hours each day gazing at them in wonder.

However, one day a dirty and dishevelled stranger presented himself at the court claiming that in fact *he* was the greatest painter in the land. The indignant king decreed a competition would be held between the two artists, confident it would teach the vagabond an embarrassing lesson. Within a month they were both to produce a masterpiece that would out do the other.

After thirty days of working feverishly day and night, both artists were ready. They placed their paintings, each hidden by a cloth, on easels in the great hall of the castle. As a large crowd gathered, the king ordered the cloth to be pulled first from the court artist's easel. Everyone gasped as before them was revealed a wonderful oil painting of a table set with a feast. At its centre was an ornate silver bowl full of exotic fruits glistening moistly in the dawn light. As the crowd gazed admiringly, a sparrow perched high up on the rafters of the hall swooped down and hungrily tried to snatch one of the grapes from the painted bowl only to hit the canvas and fall down dead with shock at the feet of the king.

'Aha!' exclaimed the king. 'My artist has produced a painting so wonderful it has fooled Nature herself, surely you must agree that he is the greatest painter who ever lived!' But the vagabond said nothing and stared solemnly at his feet. 'Now, pull the blanket from your painting and let us see what you have for us,' cried the king. But the tramp remained motionless and said nothing. Growing impatient, the king stepped forward and reached out to grab the blanket only to freeze in horror at the last moment.

'You see,' said the tramp quietly, 'there is no blanket covering the painting. This is actually just a painting of a cloth covering a painting. And whereas your famous artist is content to fool Nature, I've made the king of the whole country look like a bit of a twat'.

Source: man in a pub

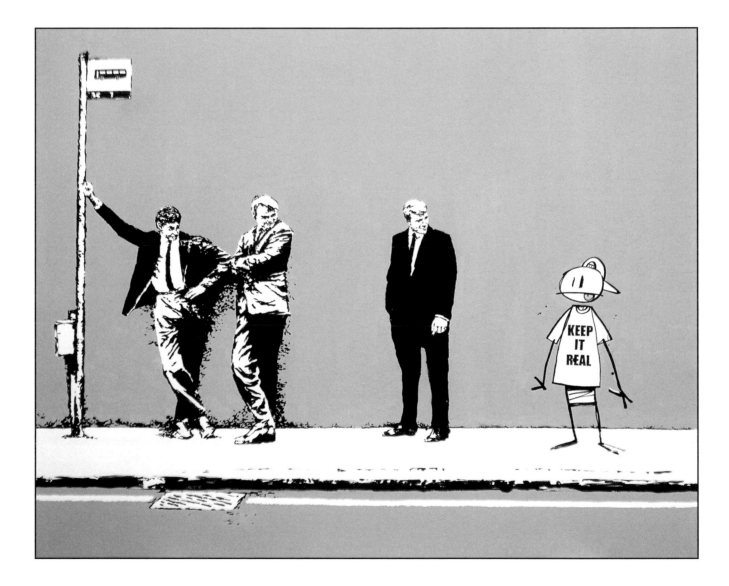

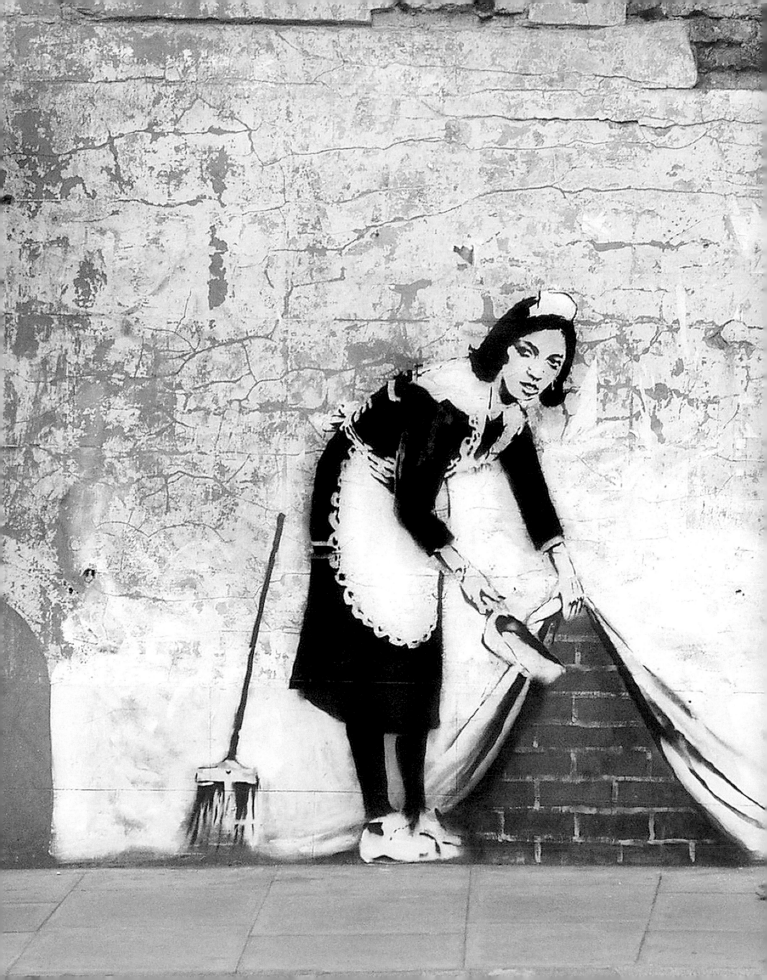

18 minutes, Chalk Farm, London 2006

BY ORDER
NATIONAL HIGHWAYS AGENCY

THIS WALL IS A DESIGNATED
GRAFFITI AREA

PLEASE TAKE YOUR LITTER HOME
EC REF. URBA 23/366

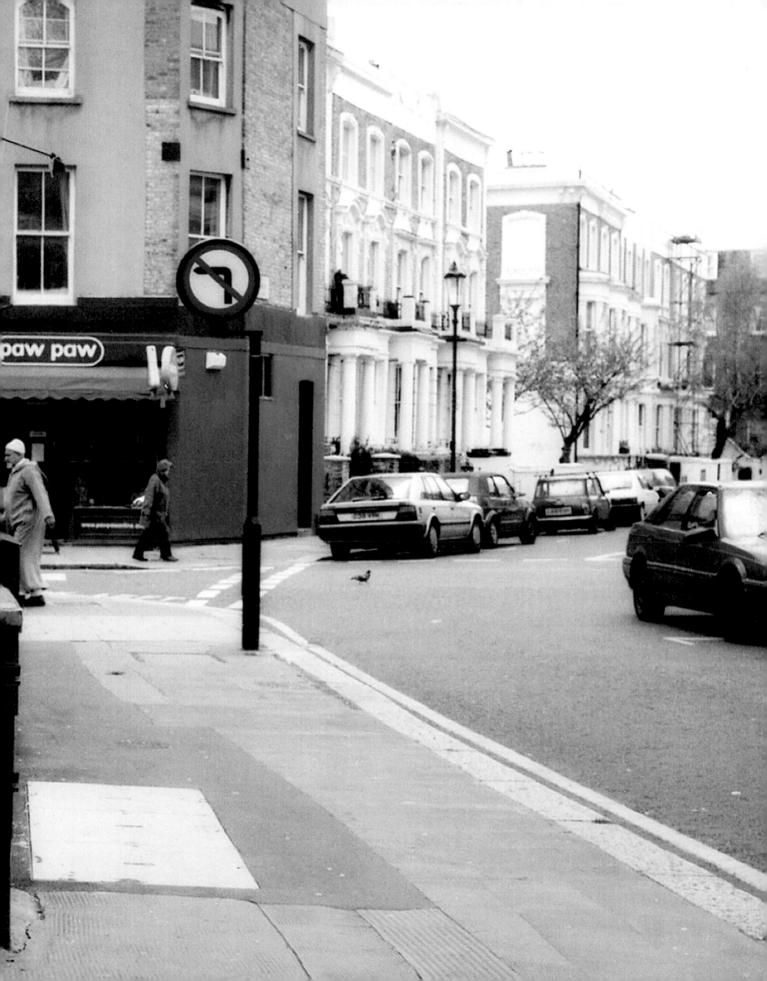

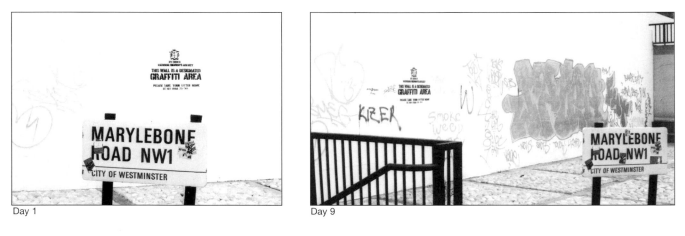

Day 1

Day 9

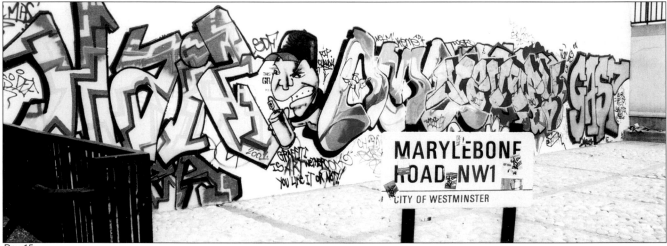

Day 15

email received to banksy website

I was one of the writers that fell for your 'legal' graffiti site thingy-ma-bob on marylebone street next to edgeware rd. i write AMBS SDF. i was there with gasp zeal and haze when we pieced it. you know we got nicked for it at the end of the day when we had finished by an undercover fed, but he let us go because before we had started we asked at the fed station across the road if it realy was legal and they said it was cool. anyway it was all good at the end and we got some nice pieces in a fuckin bait plot. mail me back if you want, anyway....... peace!

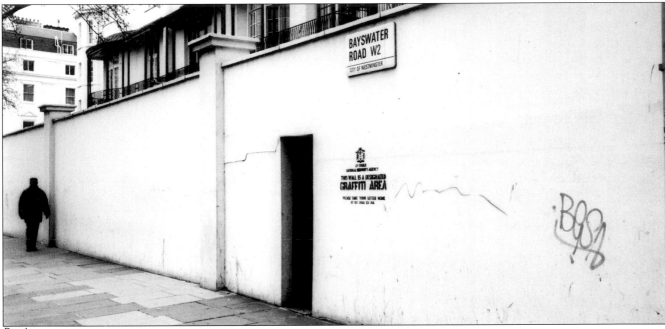

Day 1

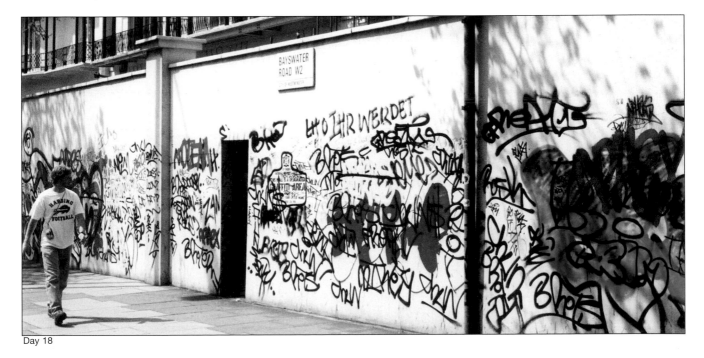

Day 18

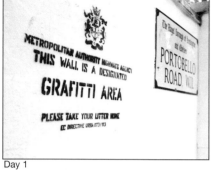
Day 1

First attempt (complete with incorrect spelling of graffiti and a crest taken off a fag packet).

Day 25

Day 34

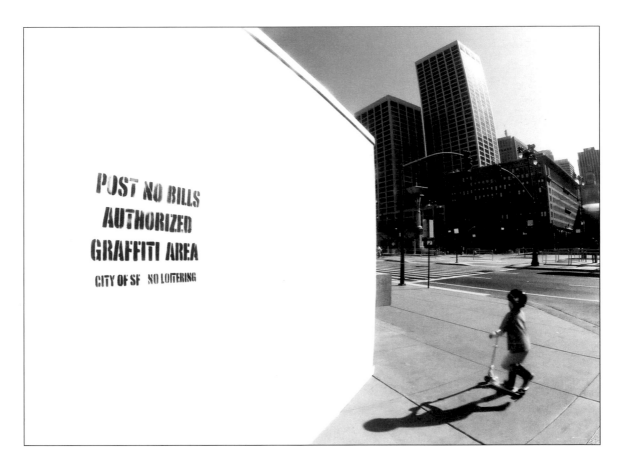

On Tuesday I went round San Francisco in the middle of the day dressed in overalls designating parts of it as legal graffiti areas.

By Friday a lot had been modified by city workers who simply removed the offending part with a lick of paint.

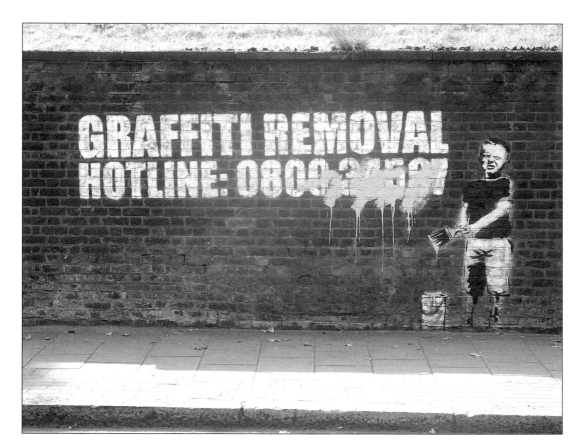

Celebrating the launch of the graffiti removal hotline, Pentonville Rd, London, May 2006

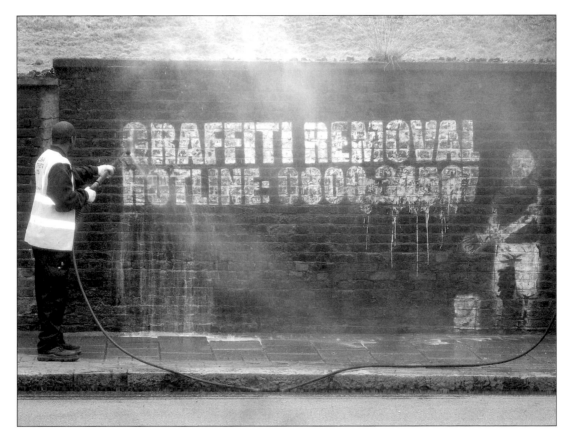

One month later

DESIGNATED
PICNIC AREA

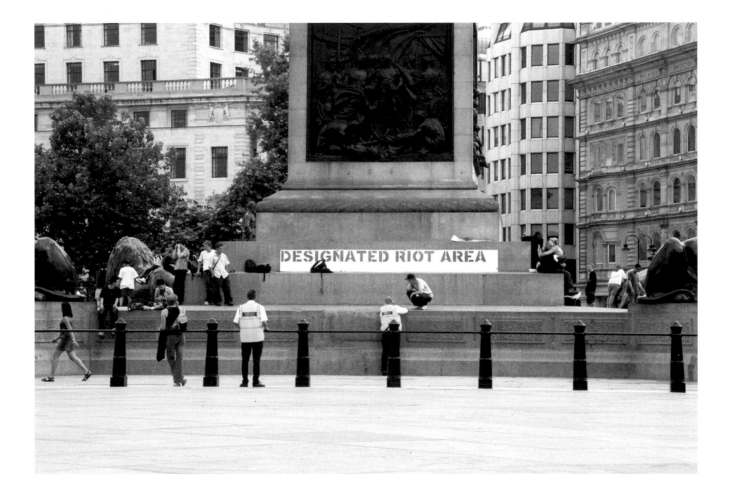

Four minutes, Trafalgar Square, London 2003

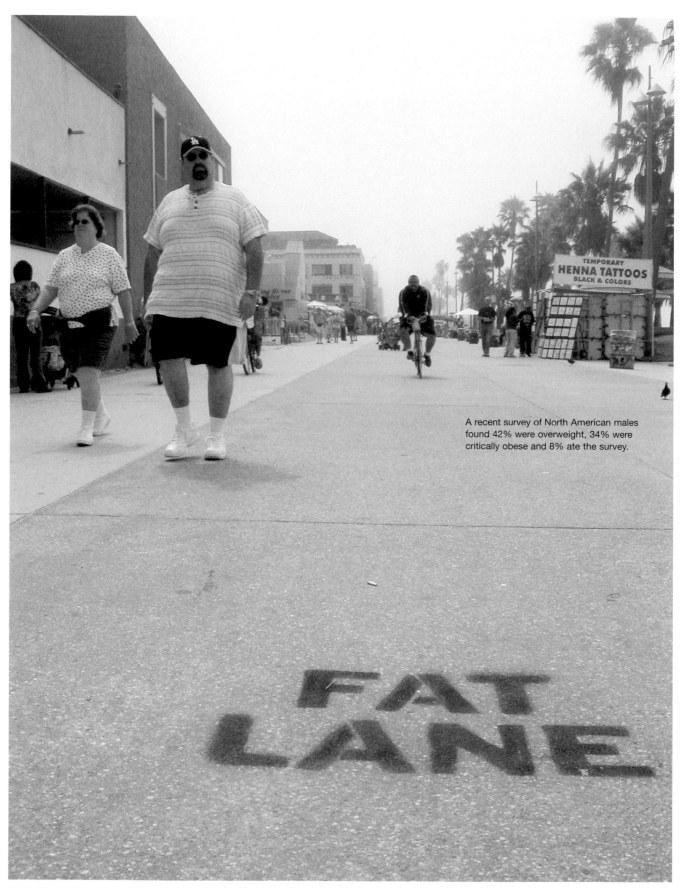

A recent survey of North American males found 42% were overweight, 34% were critically obese and 8% ate the survey.

TEMPORARY
HENNA TATTOOS
BLACK & COLORS

FAT LANE

Venice Beach, California 2003

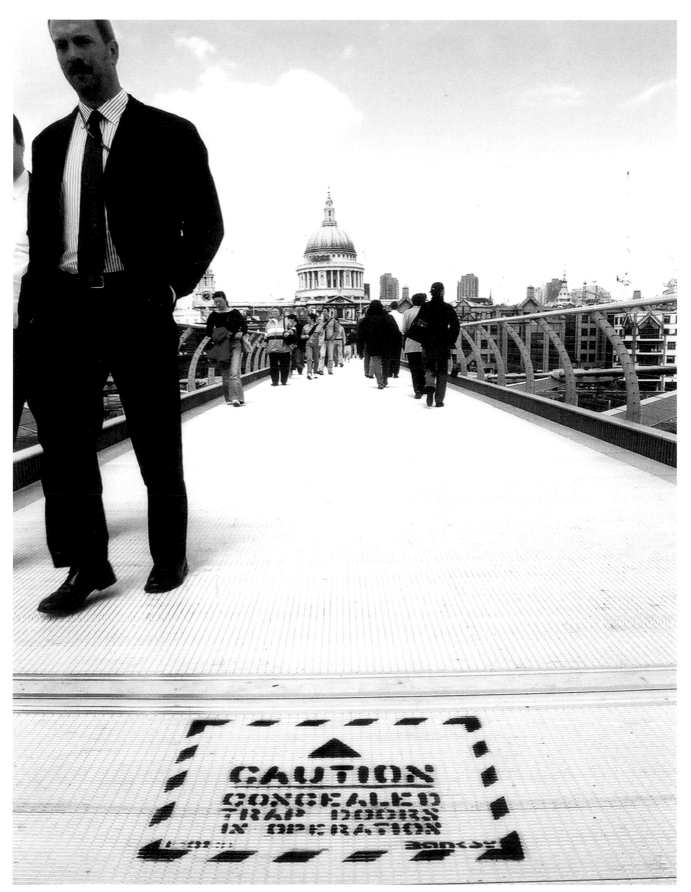

Millenium Bridge, London 2002

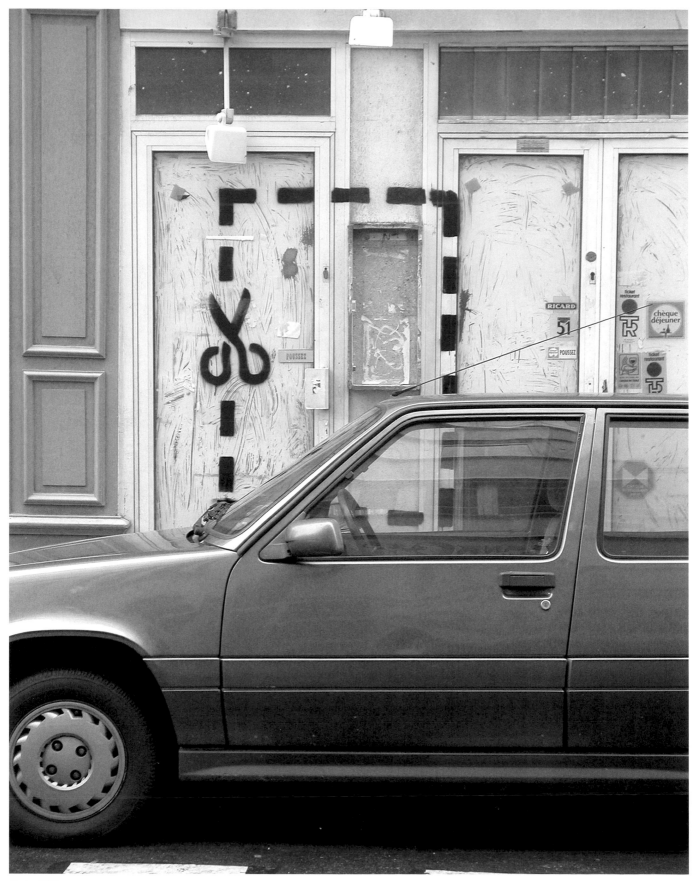

Paris, 2003

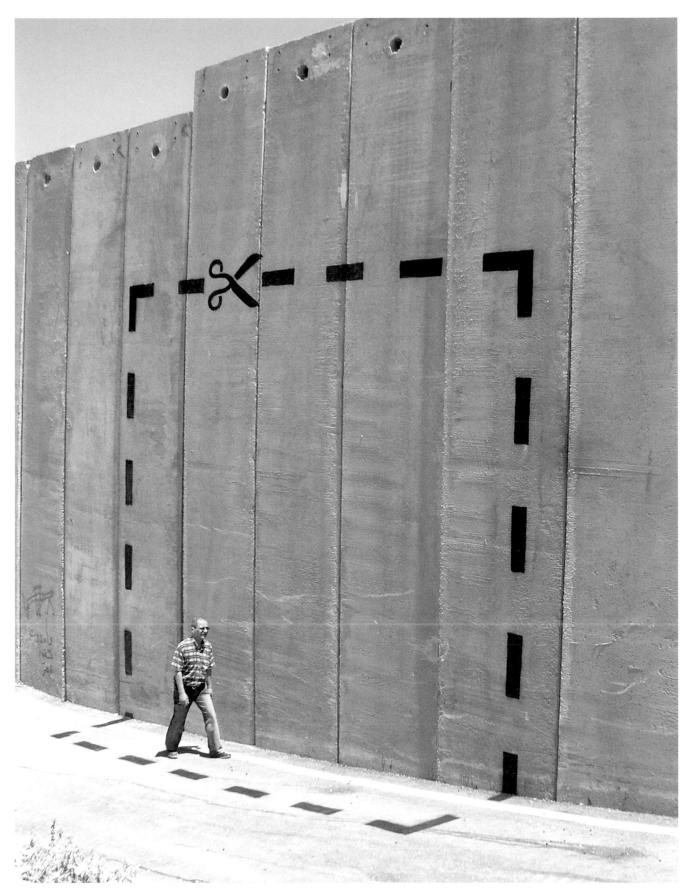

Palestine, 2005

Bethnal Green, London 2002

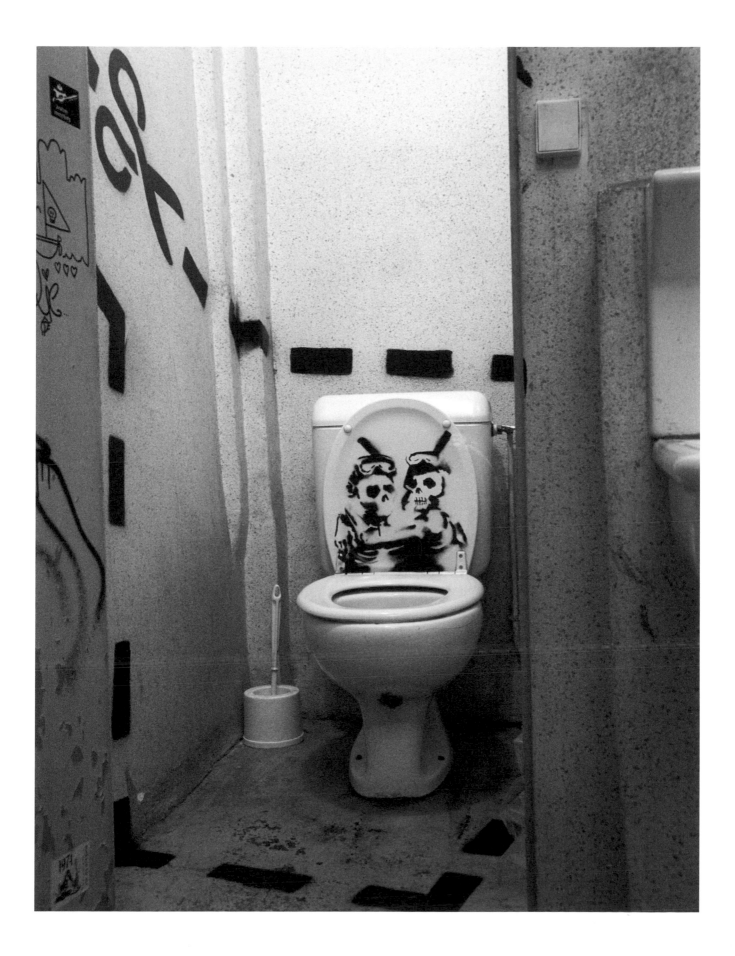

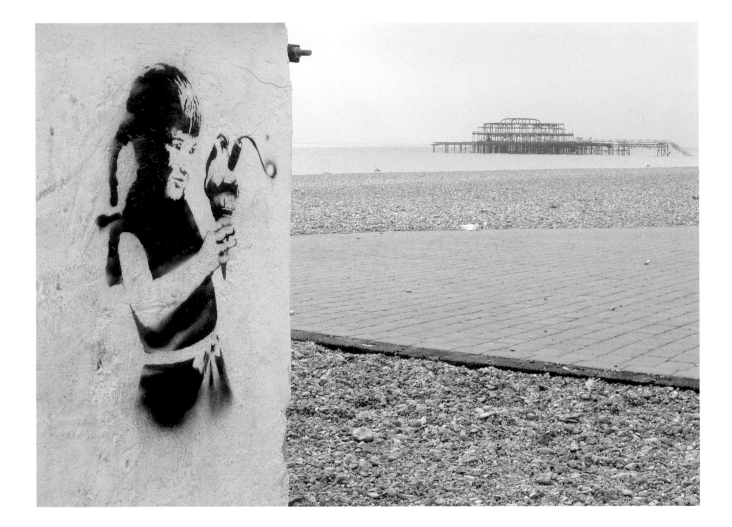

Brighton Beach 2004

Weston Super Mare 2003

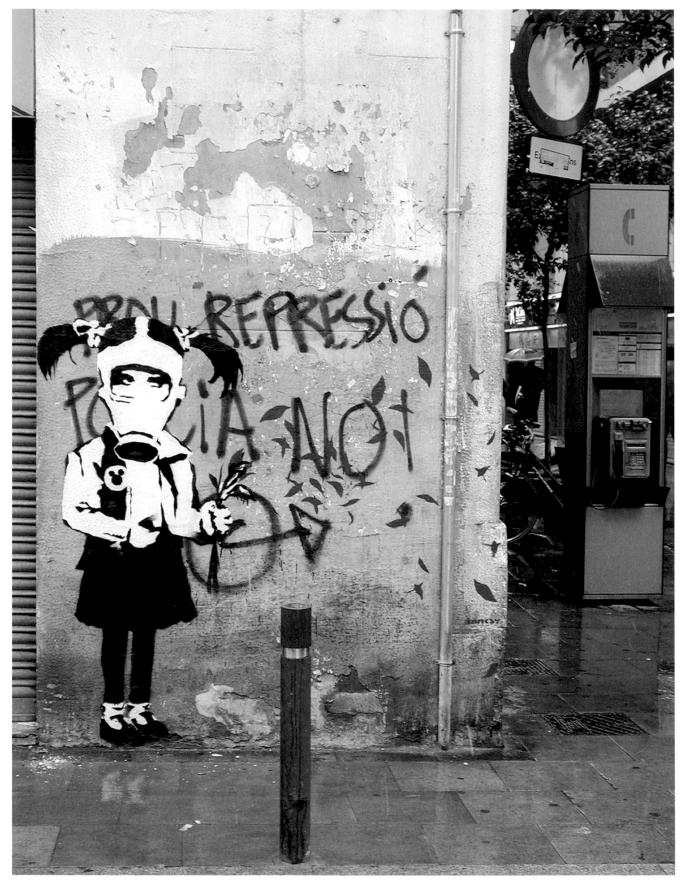

Barcelona 2003

Love Poem

Beyond watching eyes
With sweet and tender kisses
Our souls reached out to each other
In breathless wonder

And when I awoke
From a vast and smiling peace
I found you bathed in morning light
Quietly studying
All the messages on my phone

Soho, London 2004

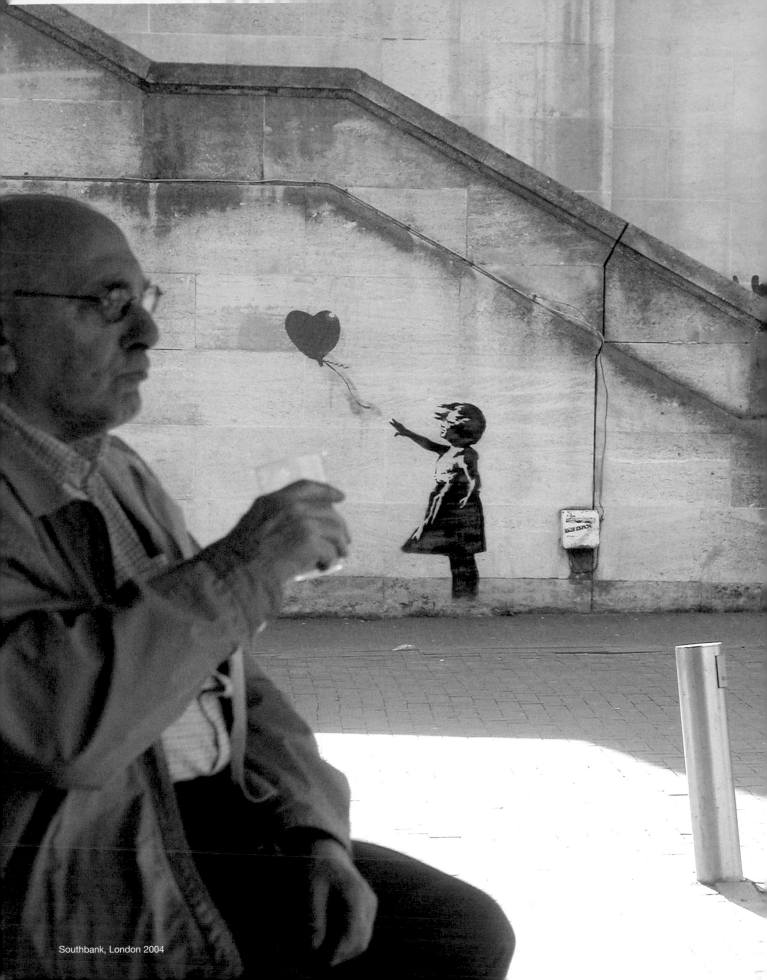

Southbank, London 2004

When the time comes to leave, just walk away quietly and don't make any fuss

Notting Hill, London 2005

Once upon a time there was a Bear and a Bee who lived in a wood and were the best of friends. All summer long the Bee collected nectar from morning to night while the Bear lay on his back basking in the long grass.

When Winter came the Bear realised he had nothing to eat and thought to himself 'I hope that busy little Bee will share some of his honey with me'. But the Bee was nowhere to be found – he had died of a stress induced coronary disease

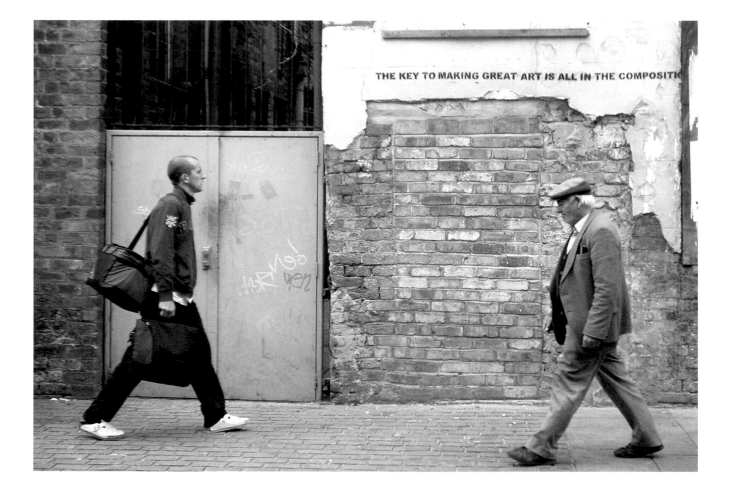

THE KEY TO MAKING GREAT ART IS ALL IN THE COMPOSITIO

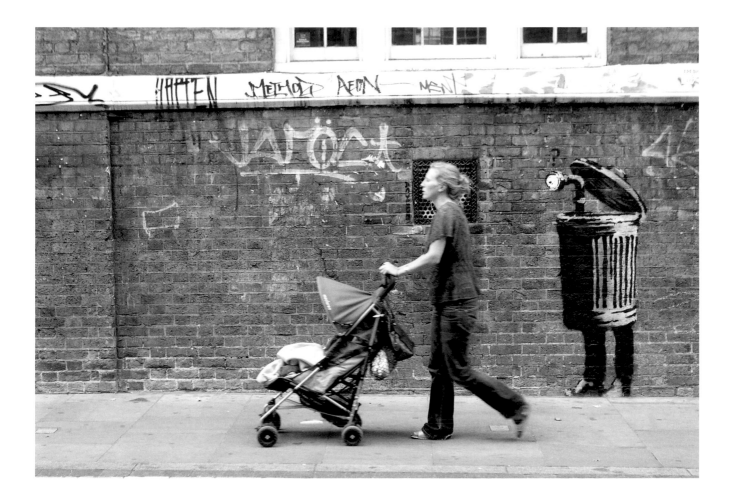

Brick Lane, London 2005

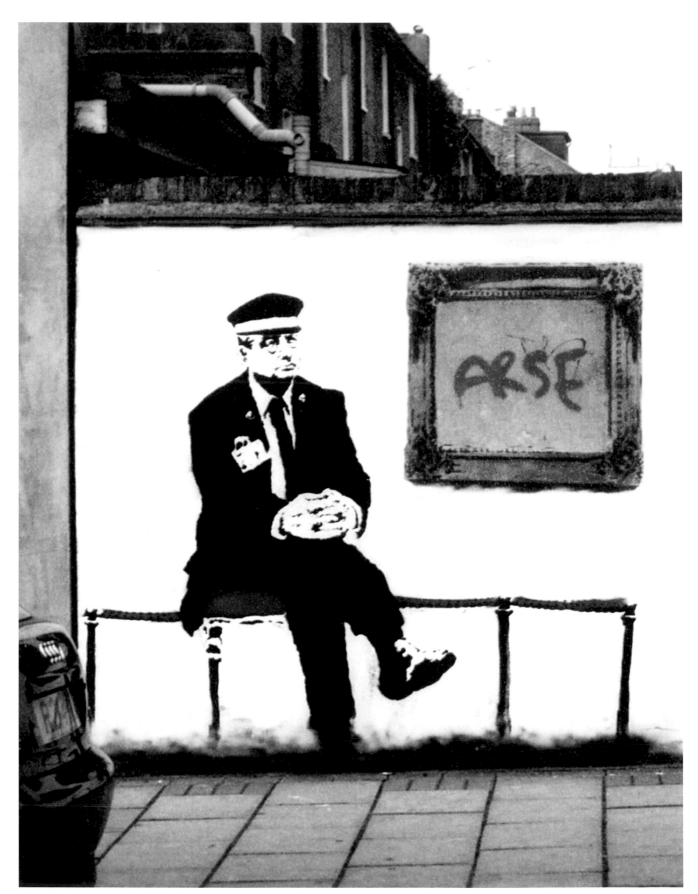

Garage wall in Highbury 2004

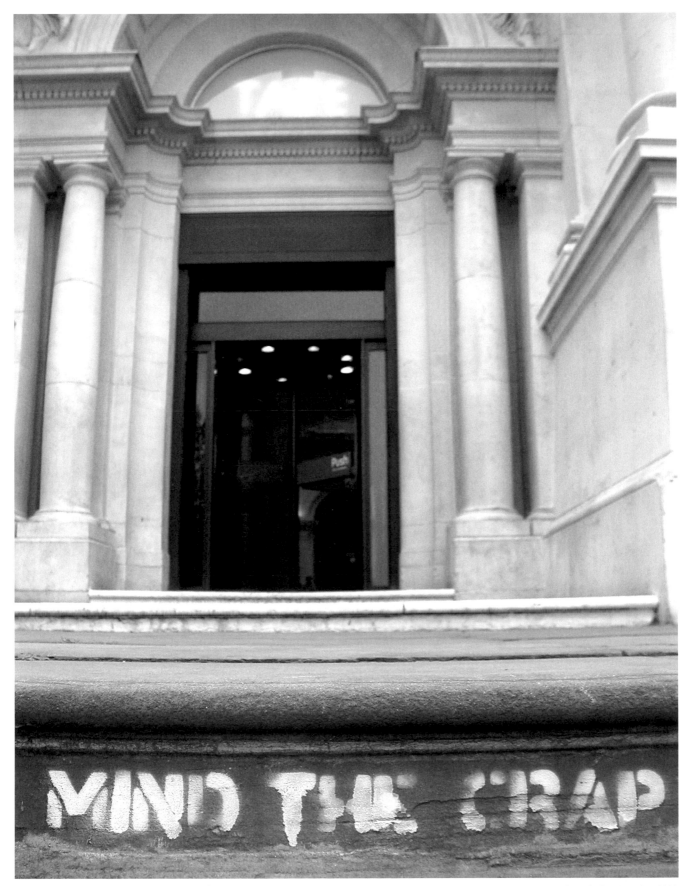

Tate Gallery, London 2002

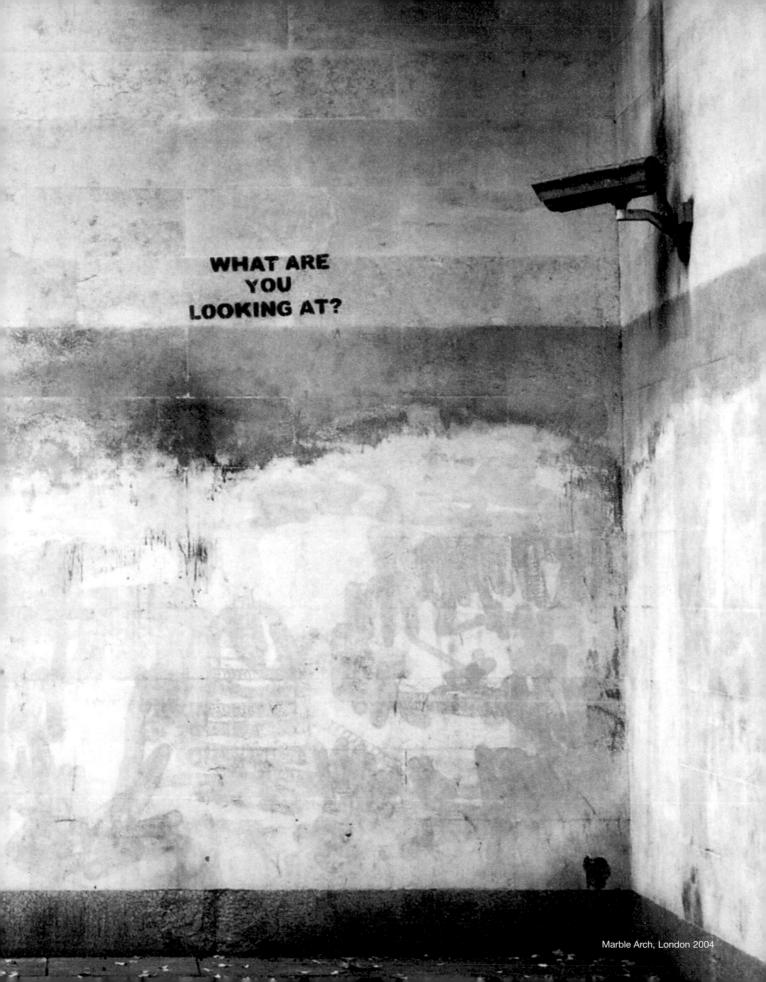

WHAT ARE
YOU
LOOKING AT?

Marble Arch, London 2004

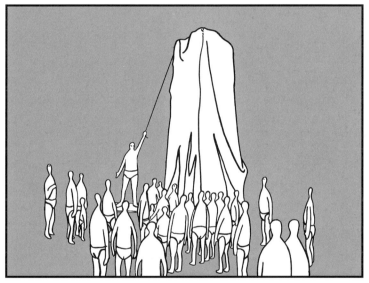

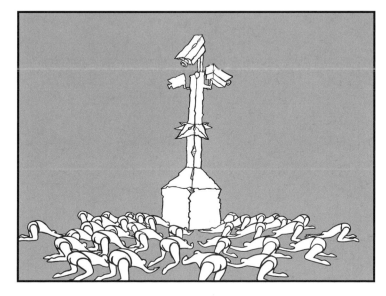

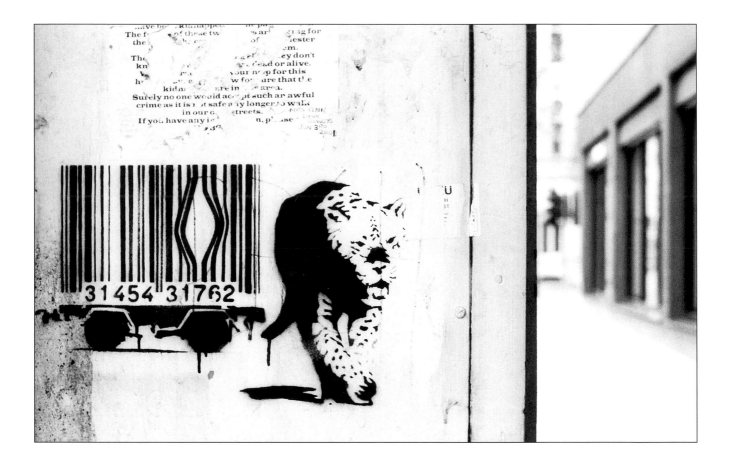

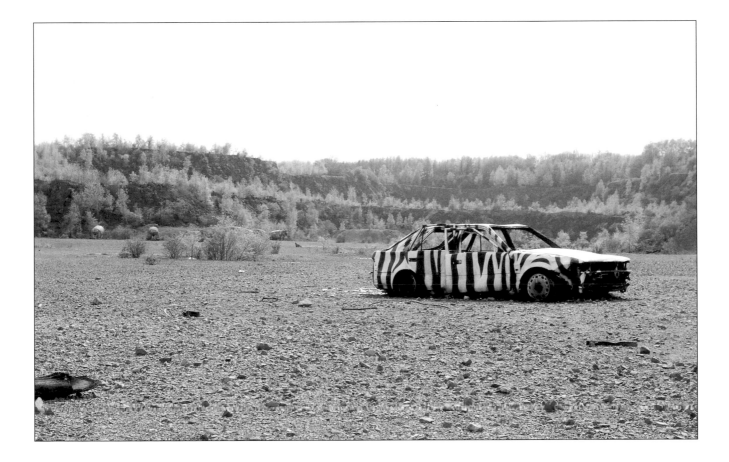

Somerset 2004

Hackney 2003

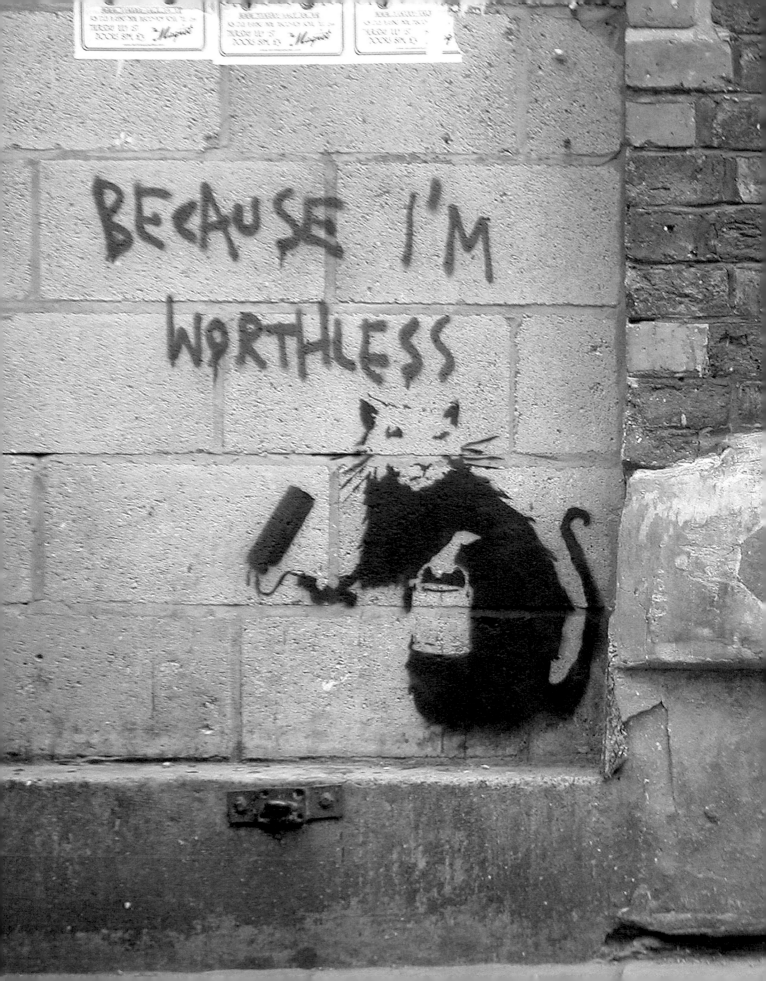

They exist without permission. They are hated, hunted and persecuted. They live in quiet desperation amongst the filth. And yet they are capable of bringing entire civilisations to their knees.

If you are dirty, insignificant and unloved then rats are the ultimate role model.

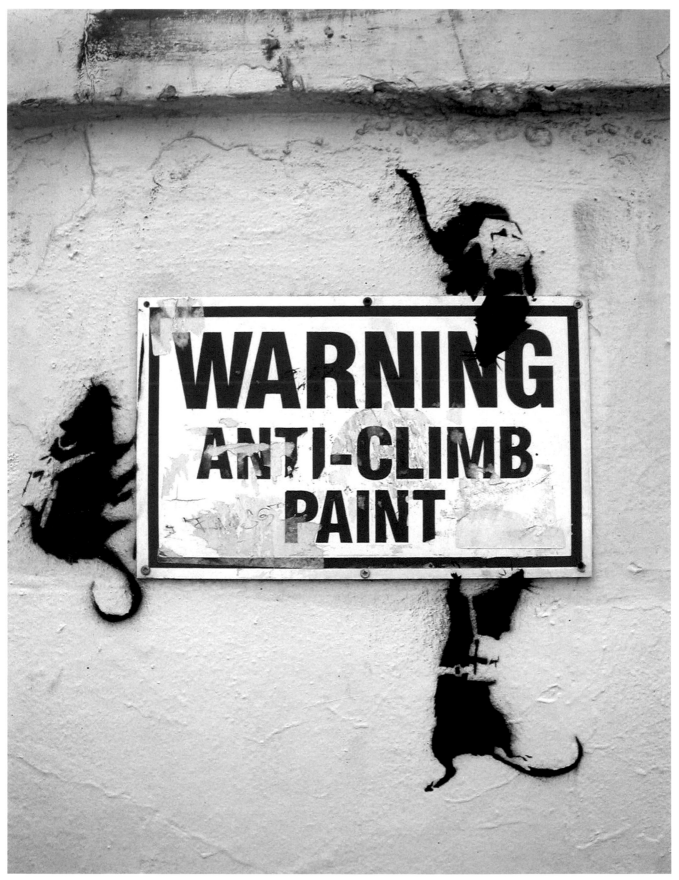

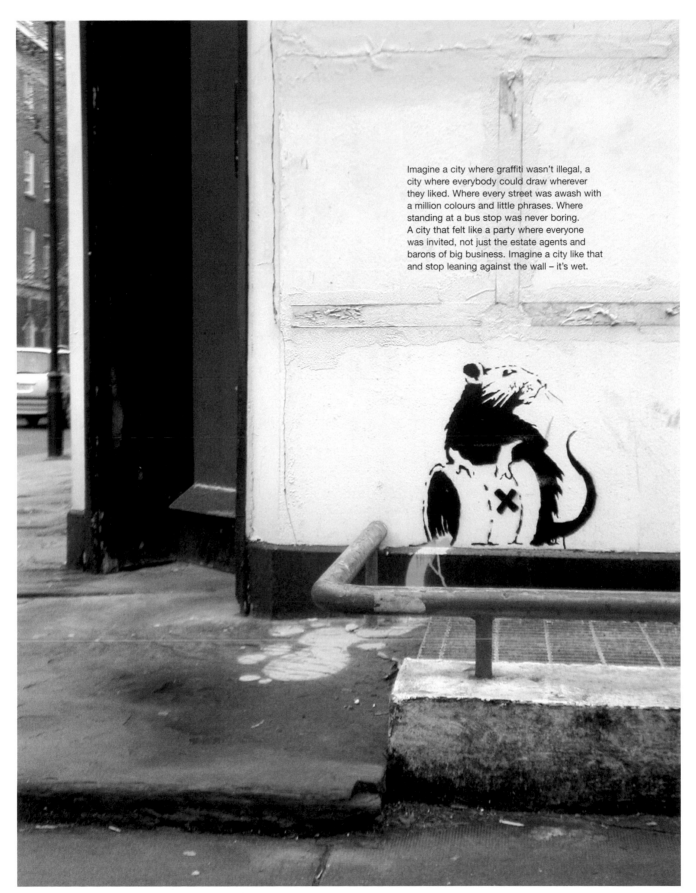

Imagine a city where graffiti wasn't illegal, a city where everybody could draw wherever they liked. Where every street was awash with a million colours and little phrases. Where standing at a bus stop was never boring. A city that felt like a party where everyone was invited, not just the estate agents and barons of big business. Imagine a city like that and stop leaning against the wall – it's wet.

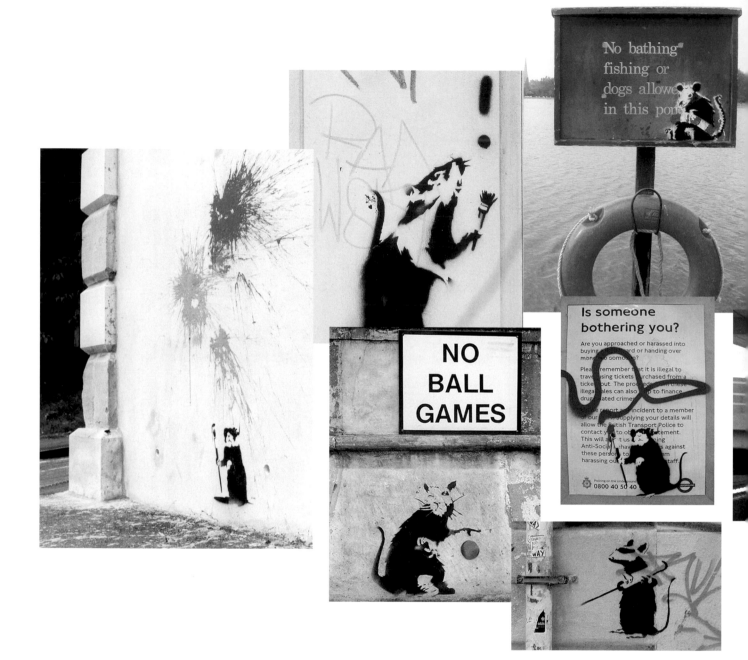

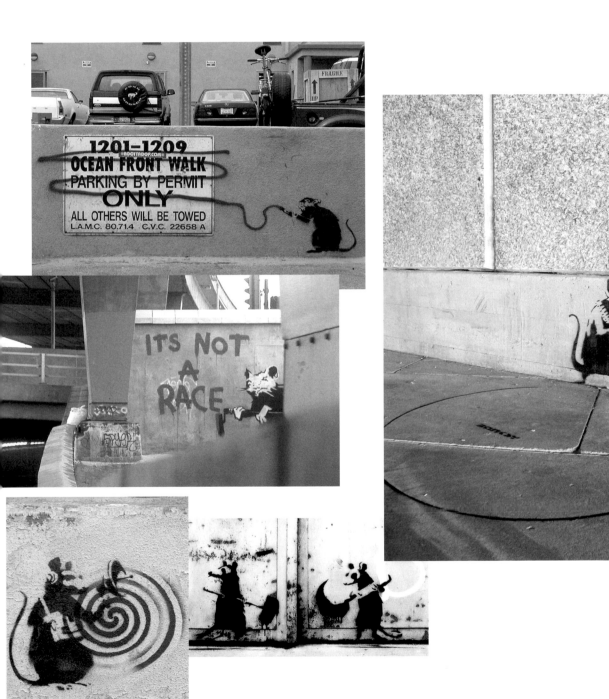

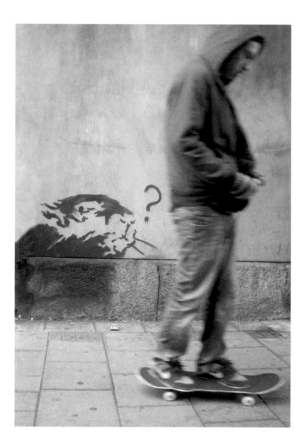

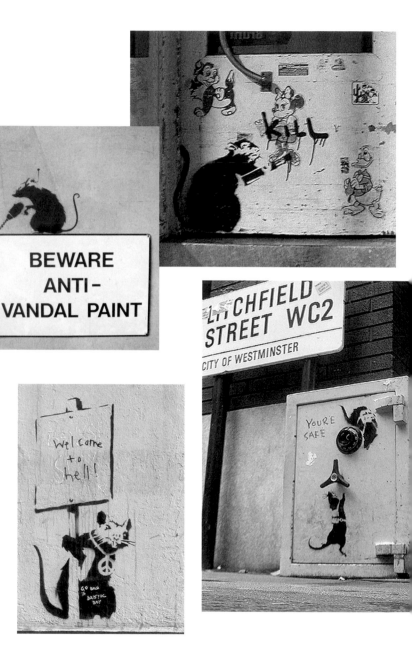

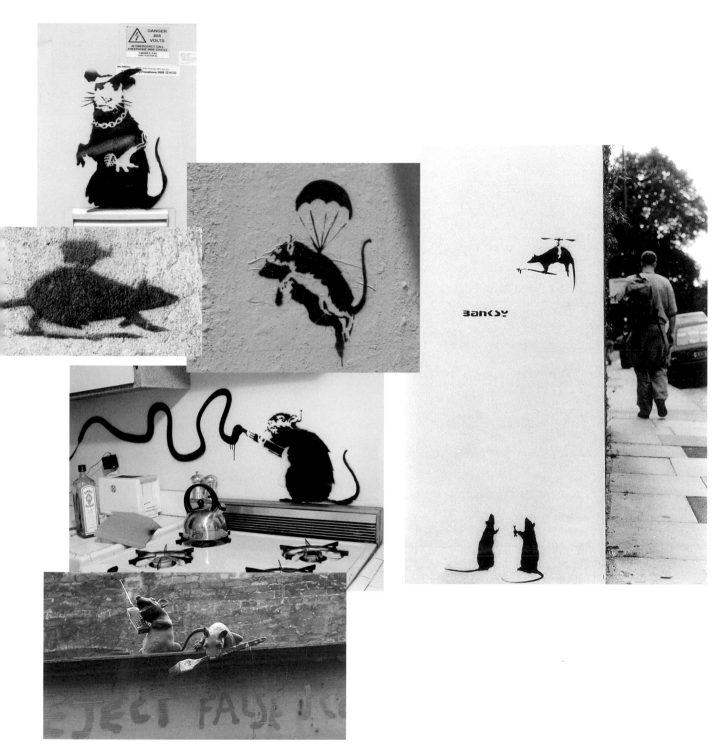

This box contains
documents of
no value

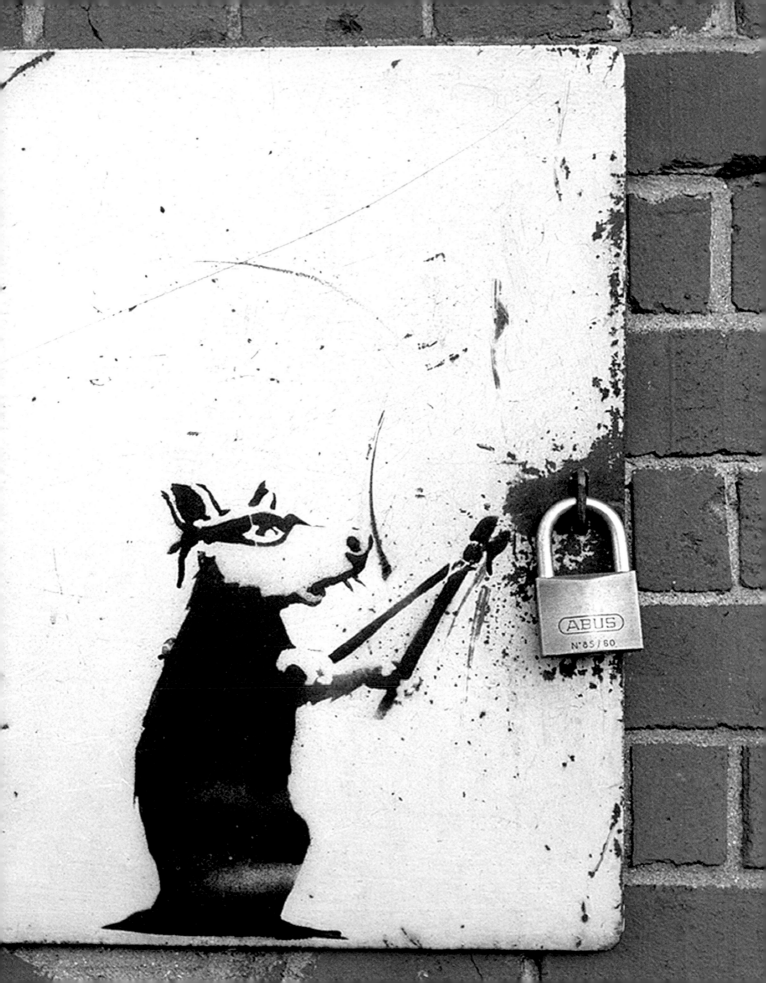

I'd been painting rats for three years before
someone said 'that's clever it's an anagram of
art' and I had to pretend I'd known that all along.

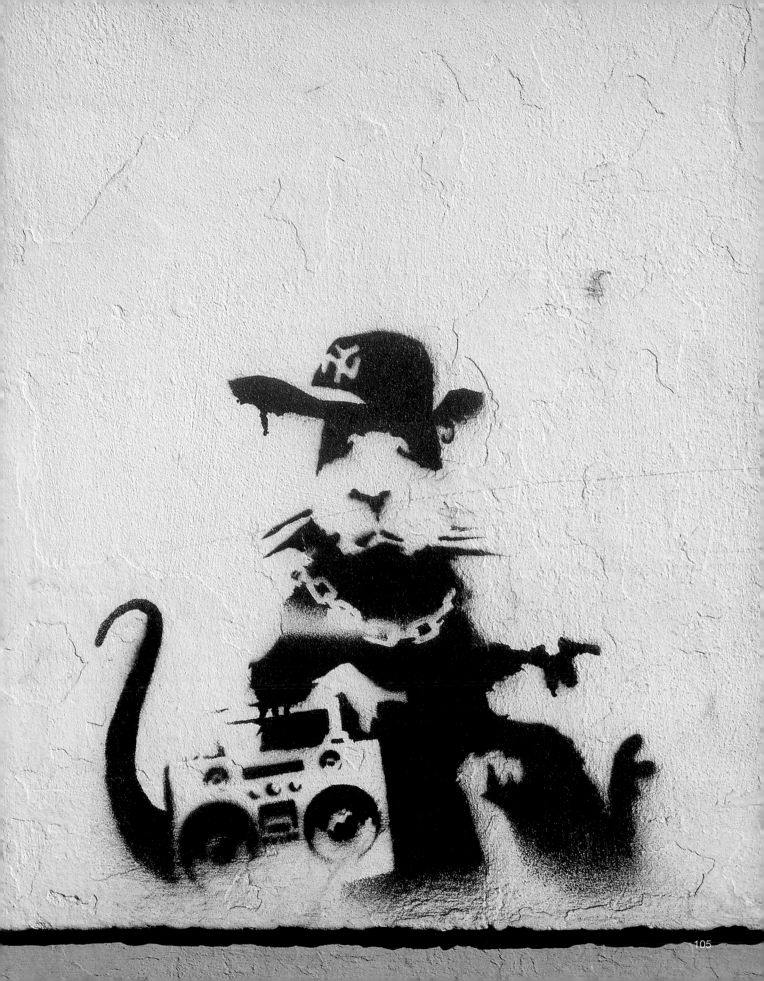

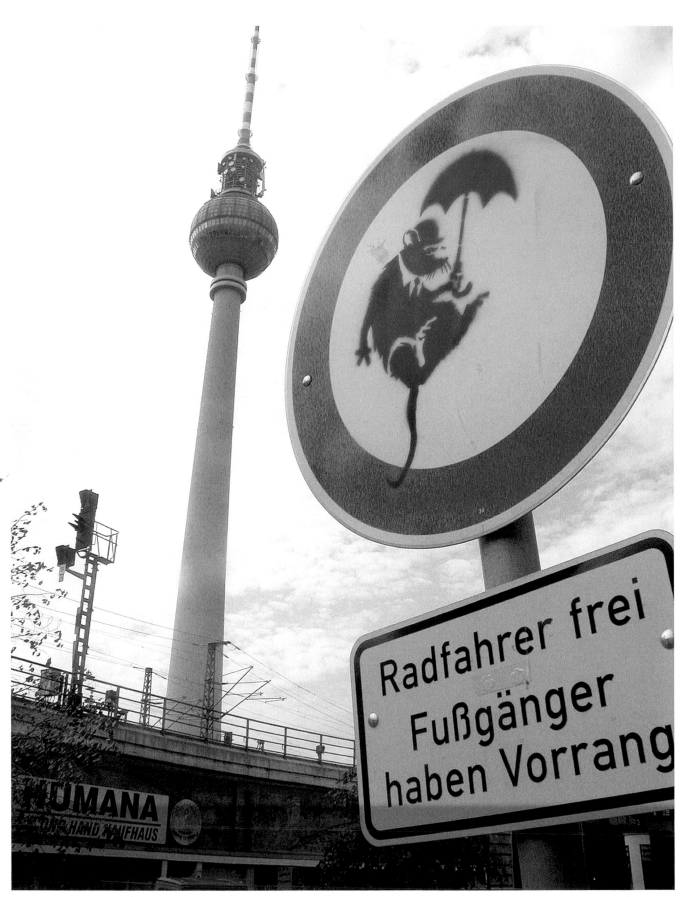

The human race is the most stupid and unfair kind of race. A lot of the runners don't even get decent sneakers or clean drinking water.

Some runners are born with a massive head start, every possible help along the way and still the referees seem to be on their side.

It's not surprising a lot of people have given up competing altogether and gone to sit in the grandstand, eat junk and shout abuse.

What the human race needs is a lot more streakers.

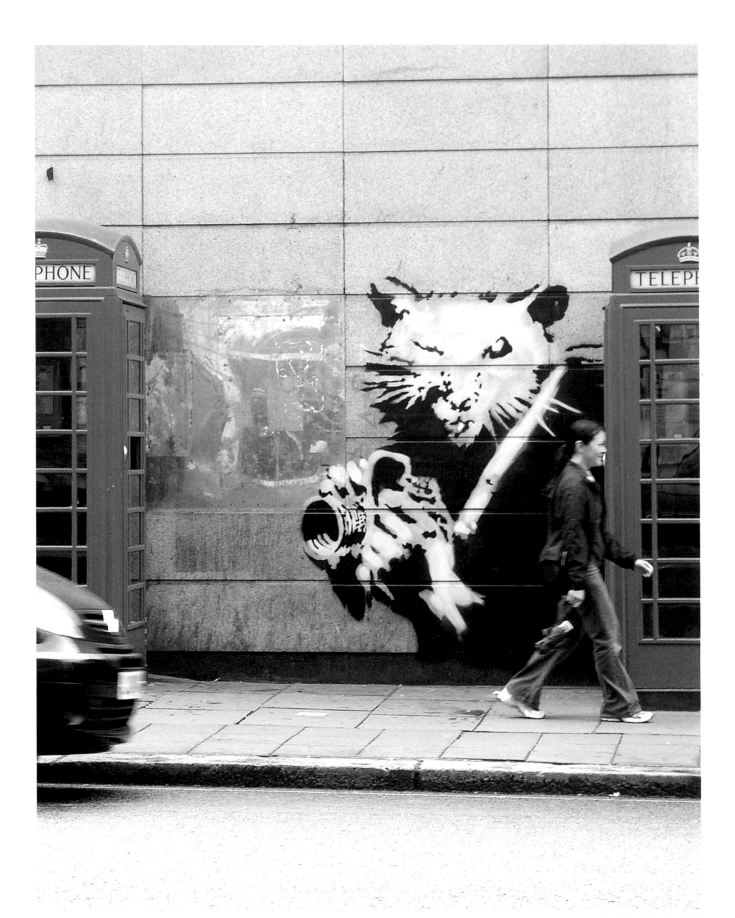

The Ritz, Picadilly 2005

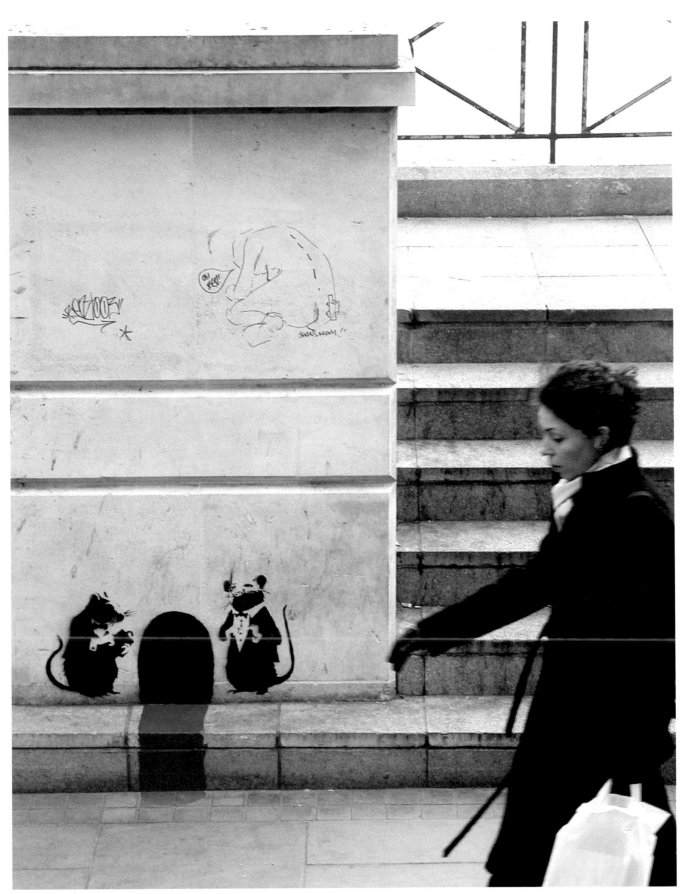

People who should be shot

- Facist thugs
- Religous fundamentalists
- People who write lists telling you who should be shot

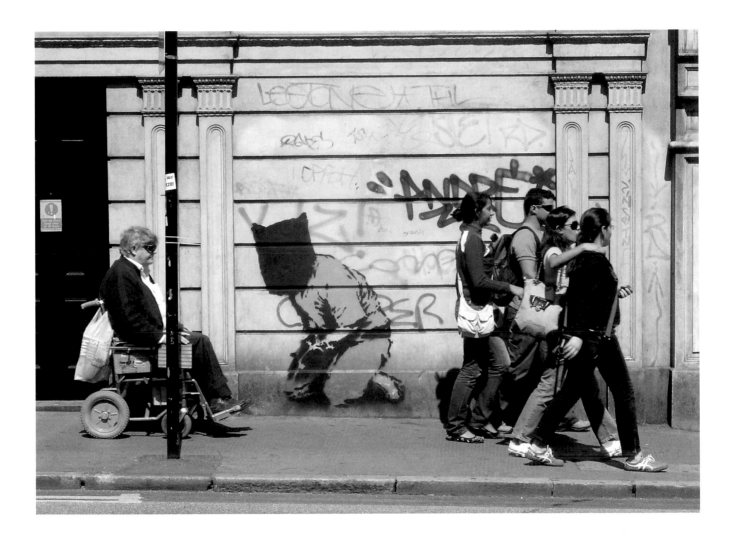

Angel, London 2005

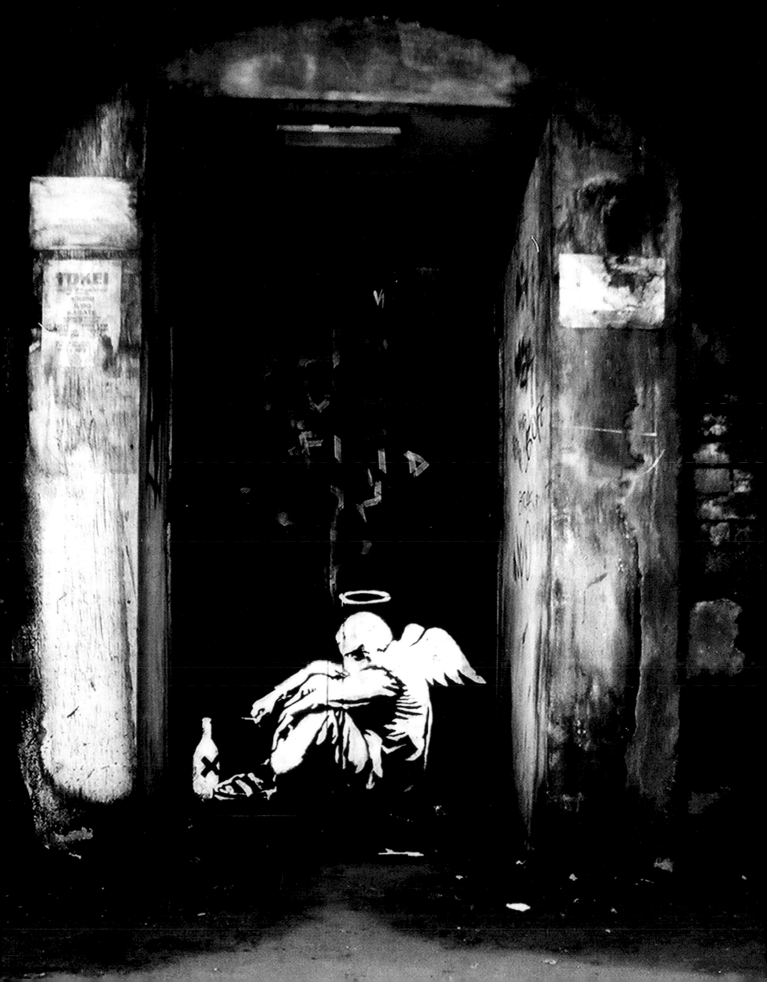

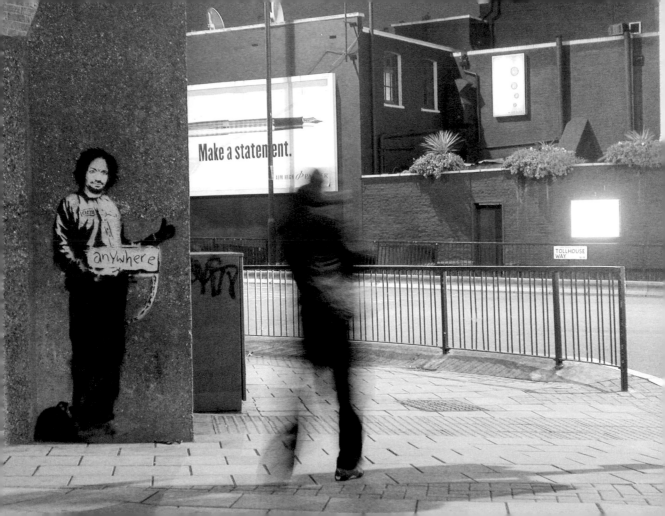

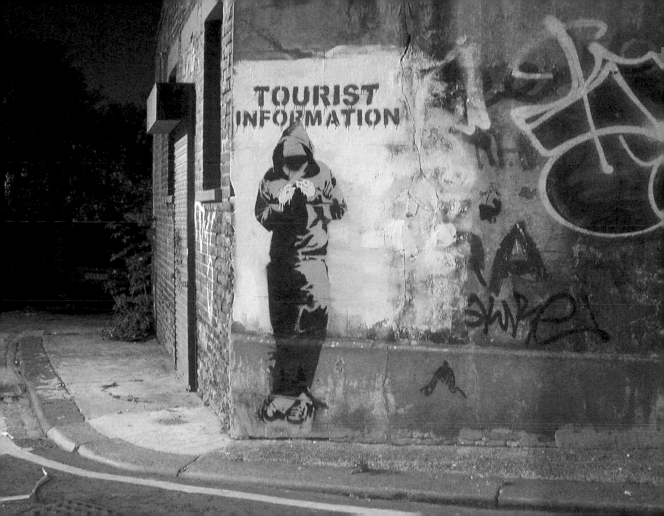

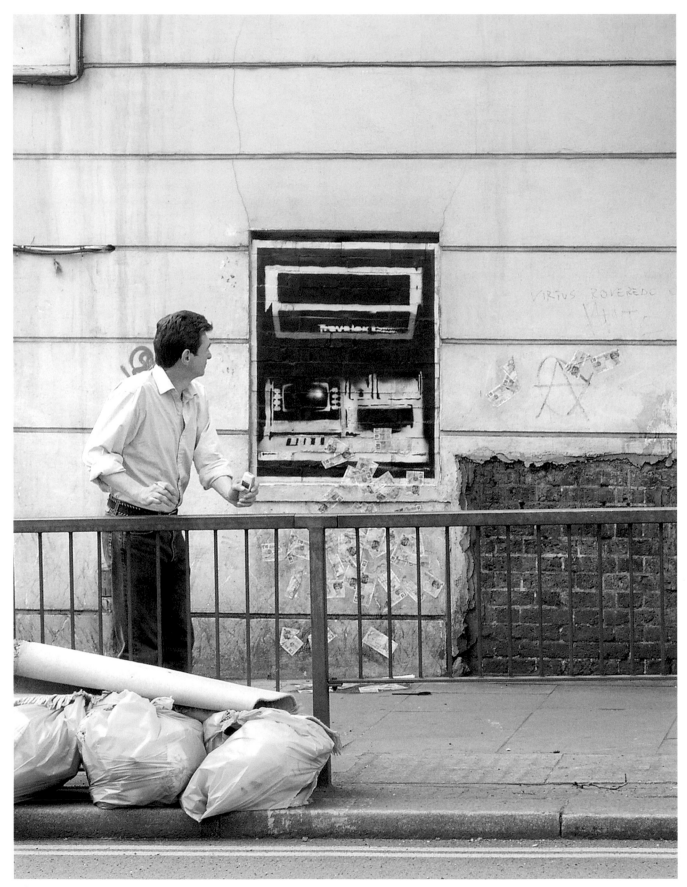

Cashpoint with Di-Faced Tenners, Farringdon, London 2005

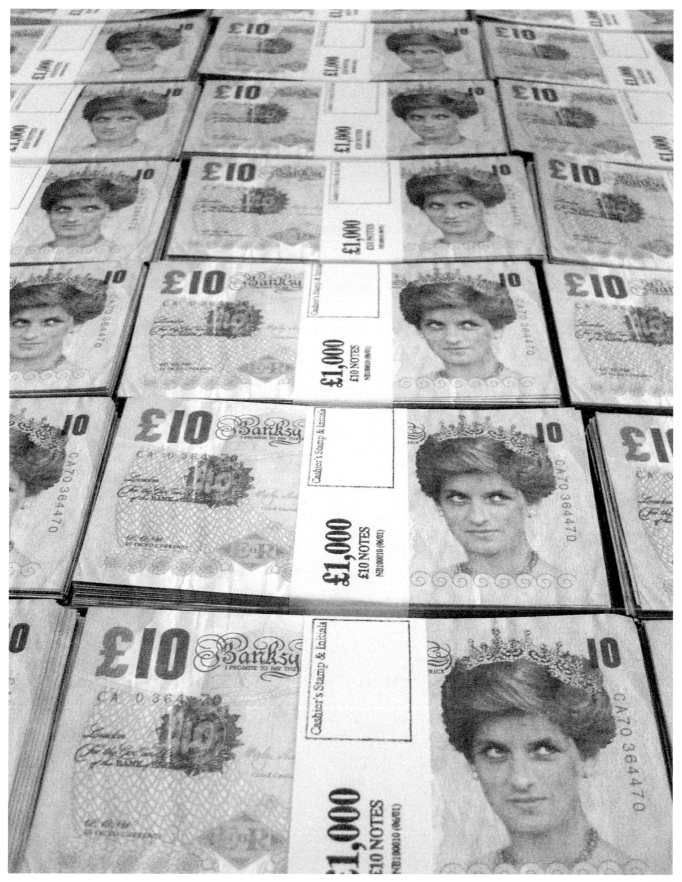

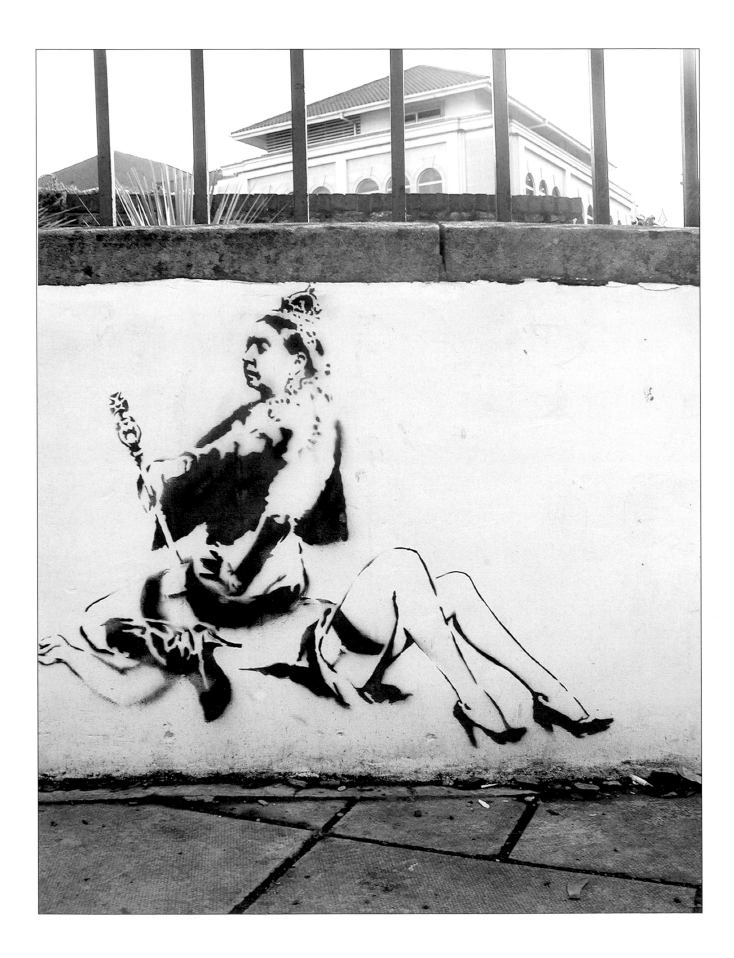

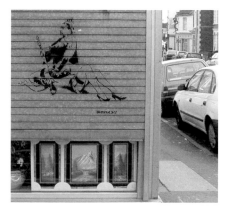

Most of these got cleaned off really quickly, all except one on the roller shutter of a gift shop. This meant you could only see it after nine o clock at night when they shut. A watershed which the boss enforced more strictly than any TV executive.

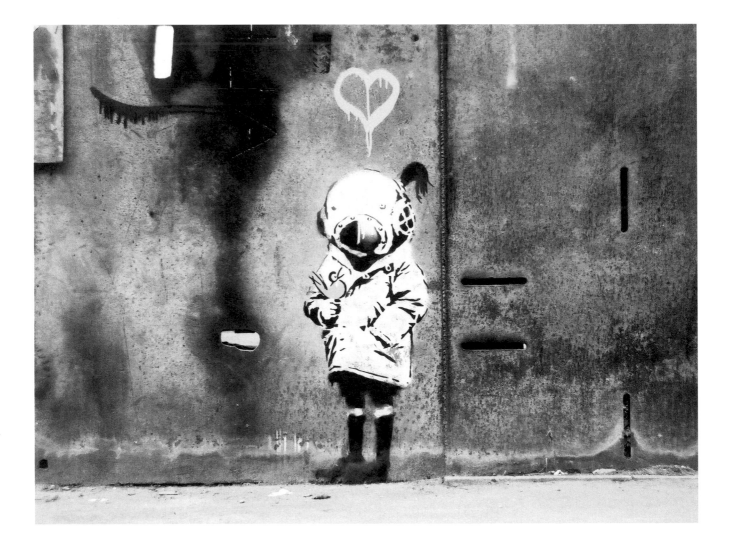

Conversations don't get any better as you get older

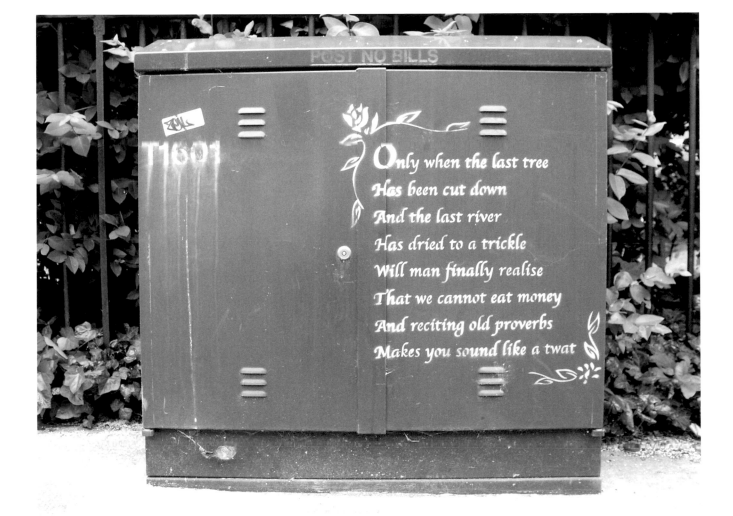

Only when the last tree
Has been cut down
And the last river
Has dried to a trickle
Will man finally realise
That we cannot eat money
And reciting old proverbs
Makes you sound like a twat

Columbia Road, London 2004

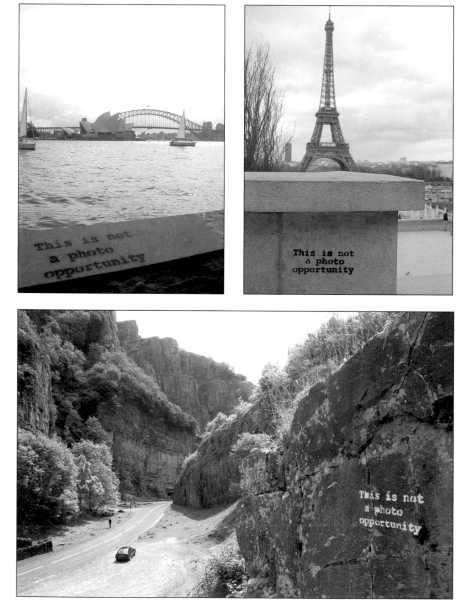

Tourism is not a spectator sport.

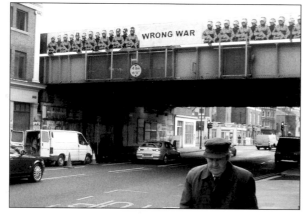

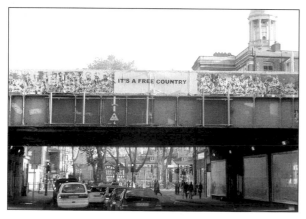

Shoreditch Bridge, London 2002-2005

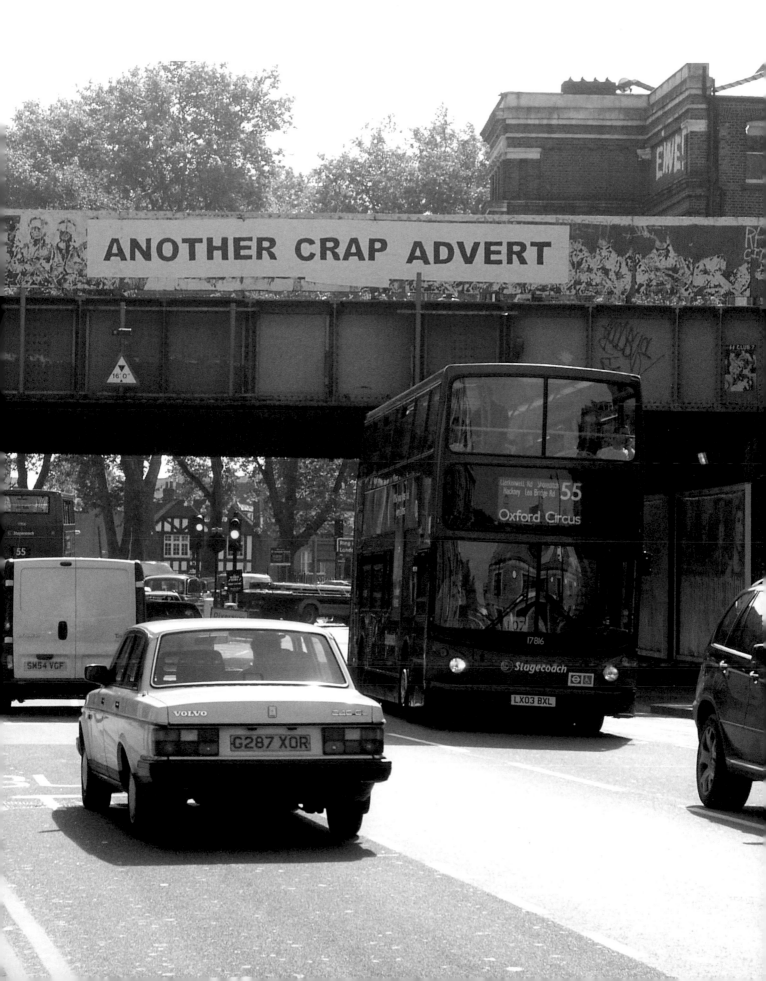

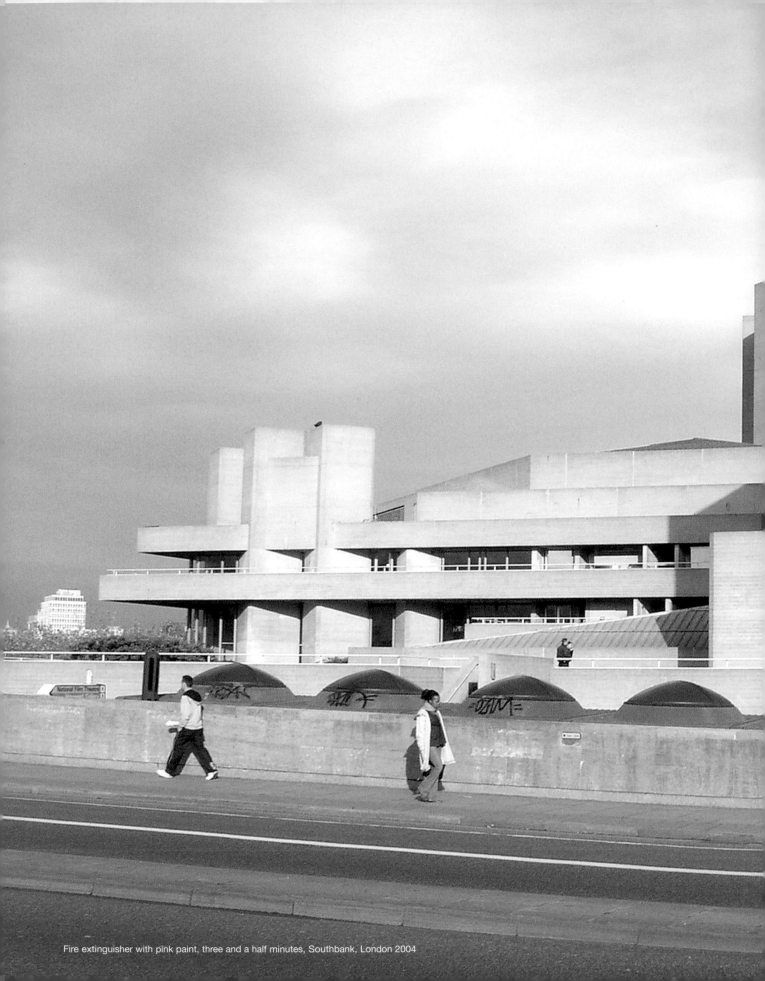

Fire extinguisher with pink paint, three and a half minutes, Southbank, London 2004

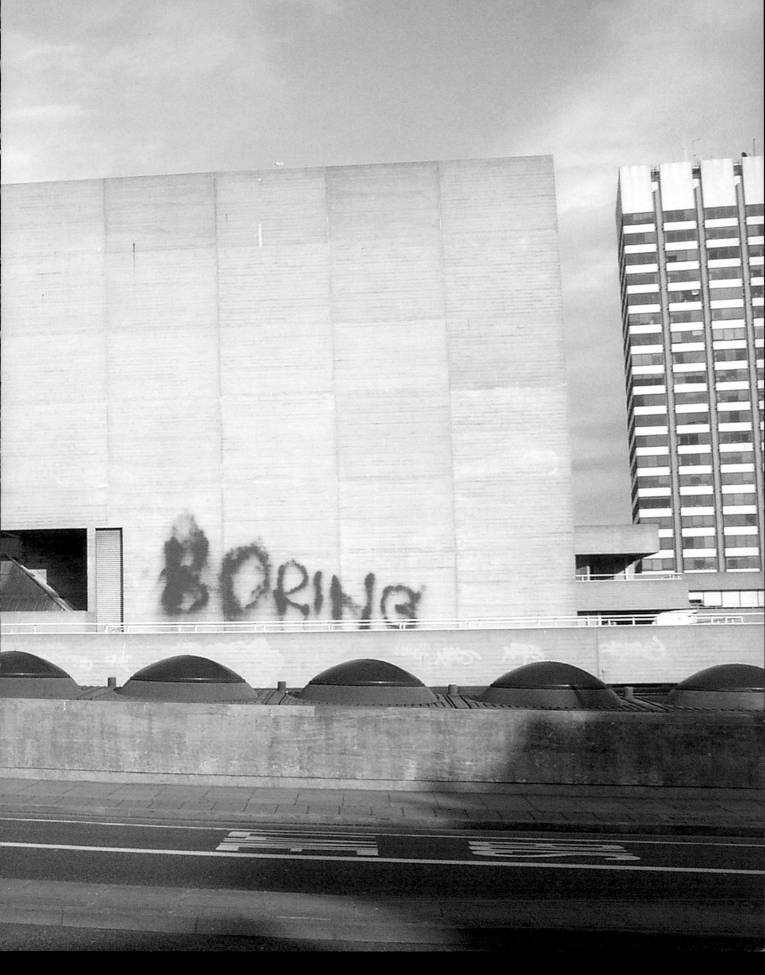

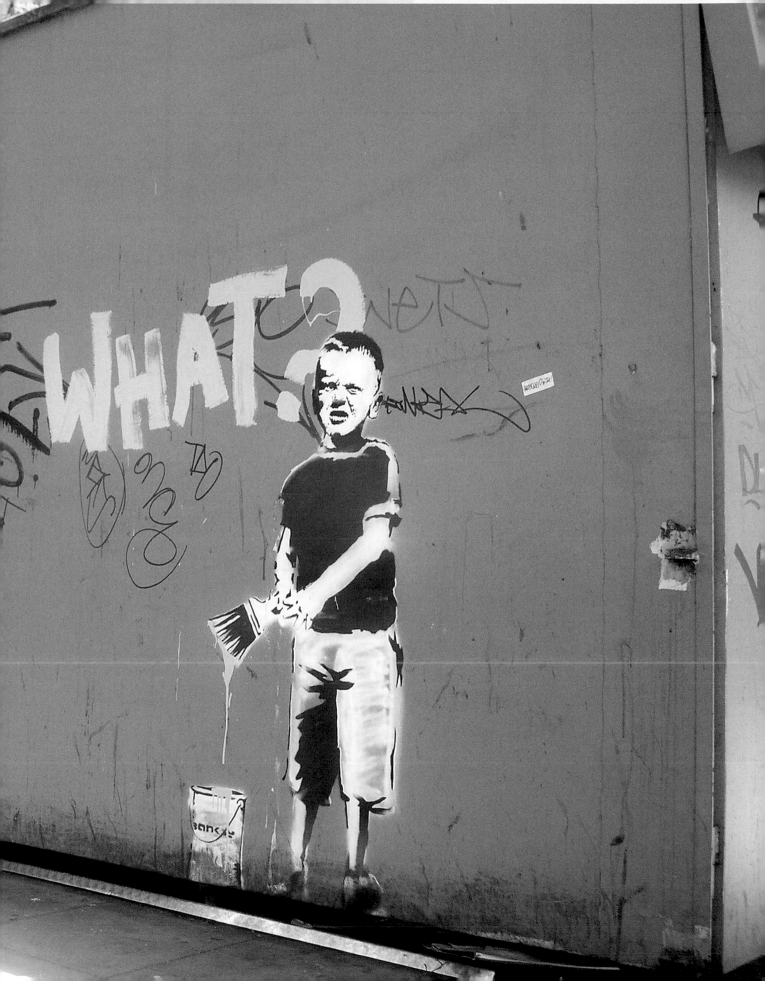

Broken Window Theory

Criminologists James Q Wilson and George Kelling developed a theory of criminal behaviour in the 1980's that became known as the 'Broken Window Theory'. They argued crime was the inevitable result of disorder and that if a window in a building is smashed but not repaired people walking by will think no-one cares. Then more windows will be broken, graffiti will appear and rubbish get dumped. The likelihood of serious crime being committed then increases dramatically as neglect becomes visible. The researchers believed there was a direct link between vandalism, street violence and the general decline of society. This theory was the basis of the infamous New York City crime purge of the early nineties and the zero-tolerance attitude to graffiti.

Letter received to Banksy website

I dont know who you are or how many of you there are but i am writing to ask you to stop painting your things where we live. In particular xxxxxx road in Hackney. My brother and me were born here and have lived here all our lives but these days so many yuppies and students are moving here neither of us can afford to buy a house where we grew up anymore. Your graffities are undoubtably part of what makes these wankers think our area is cool. You're obviously not from round here and after youve driven up the house prices youll probably just move on. Do us all a favour and go do your stuff somewhere else like Brixton.

daniel (name and address not witheld)

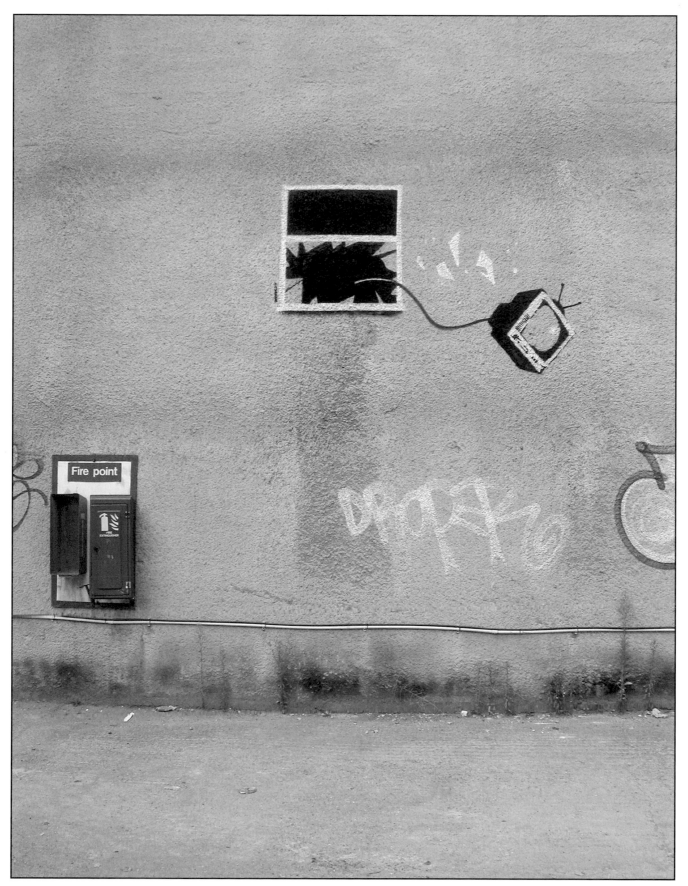

Old St, London 2004

Bristol 2006

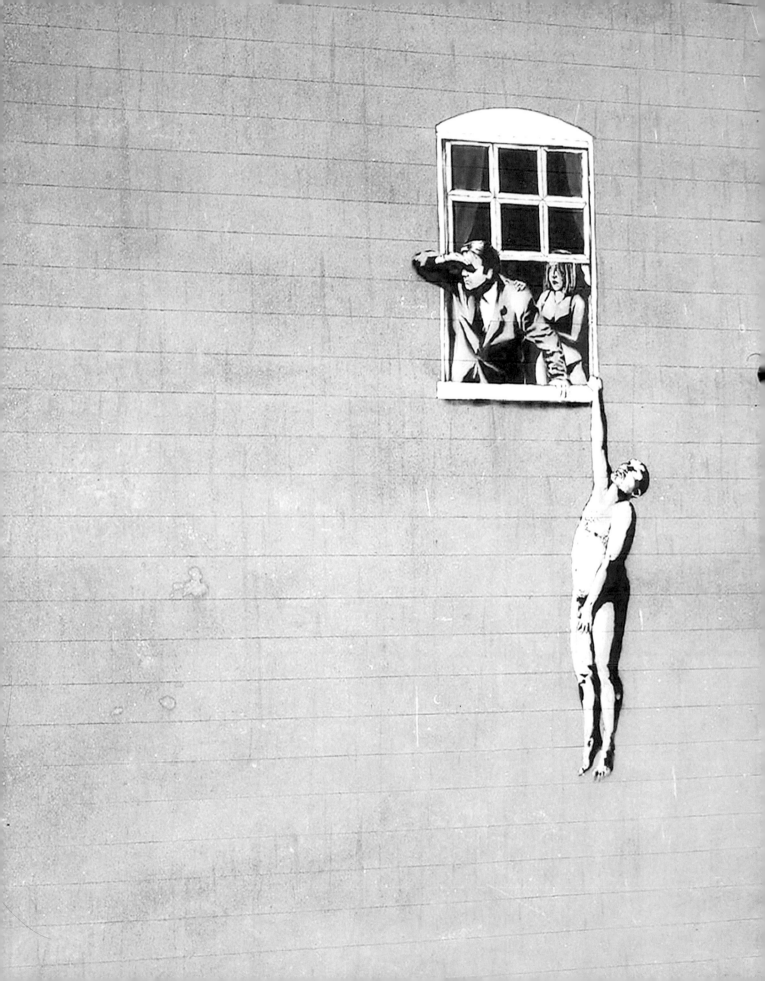

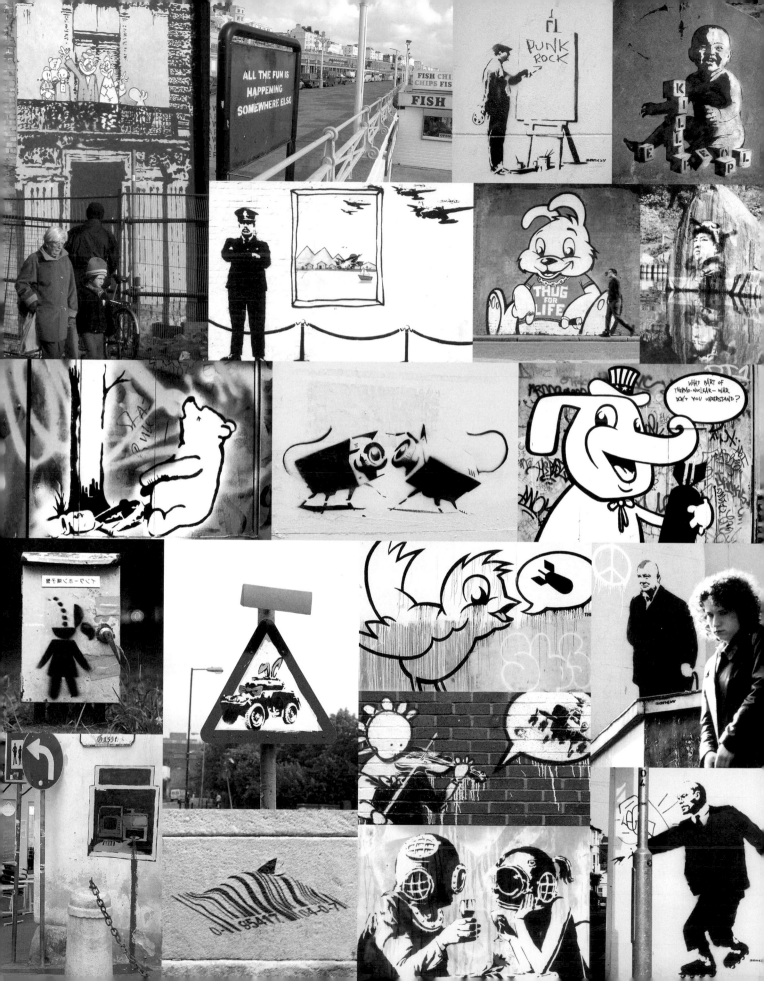

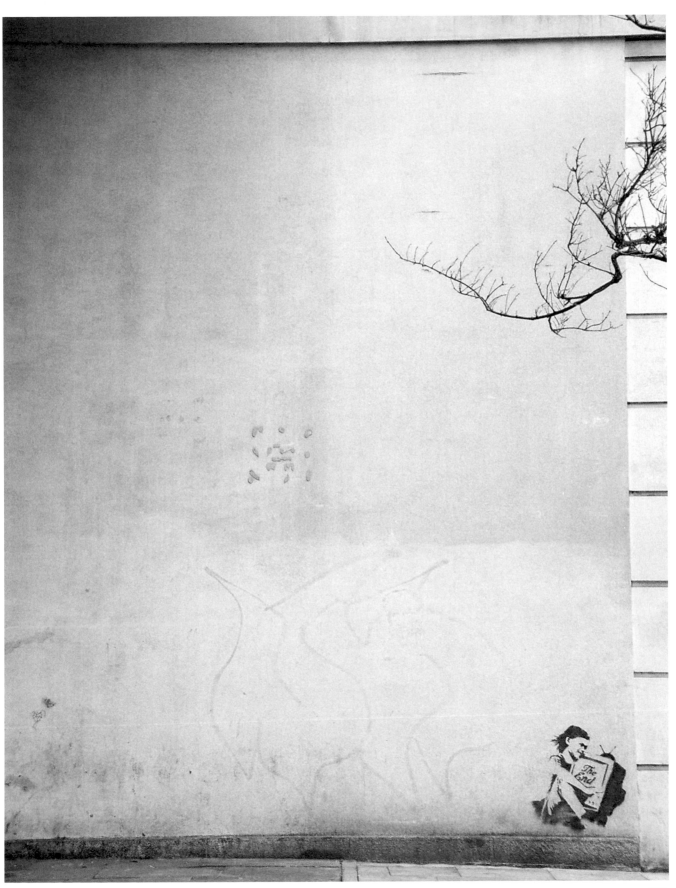

Holborn, London 2004

Segregation Wall, Palestine

Palestine has been occupied by the Israeli army since 1967. In 2002 the Israeli government began building a wall separating the occupied territories from Israel, much of it illegal under international law. It is controlled by a series of checkpoints and observation towers, stands three times the height of the Berlin wall and will eventually run for over 700km – the distance from London to Zurich. Palestine is now the world's largest open-air prison and the ultimate activity holiday destination for graffiti artists.

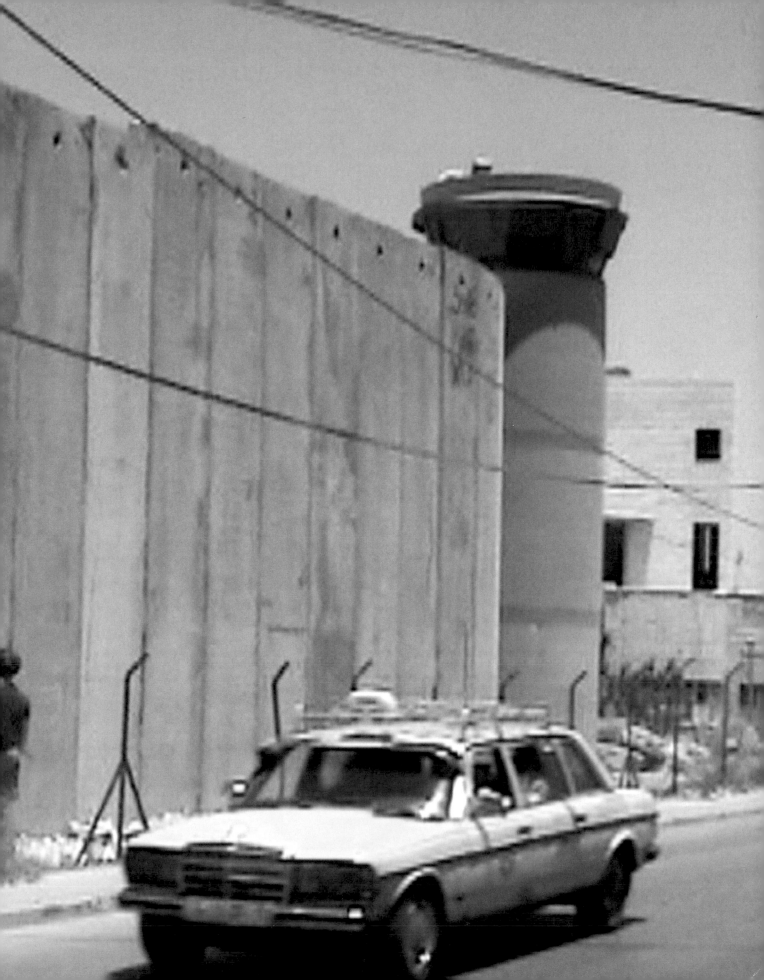

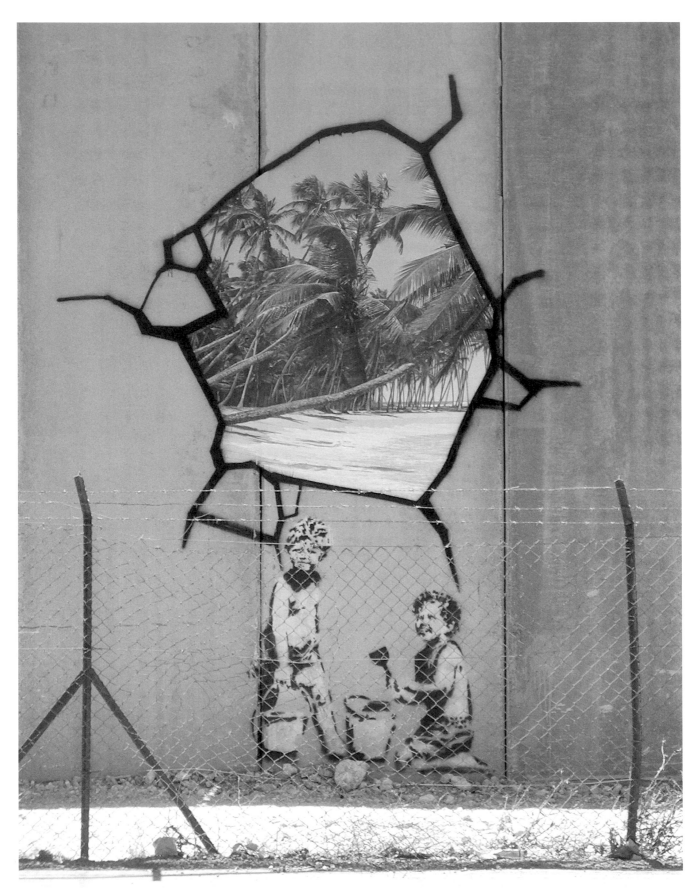

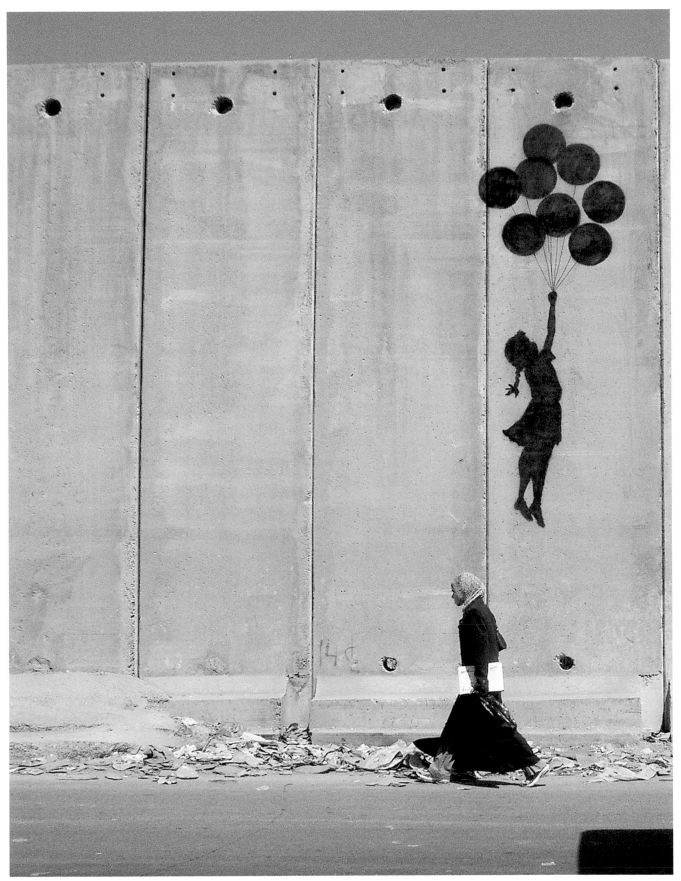

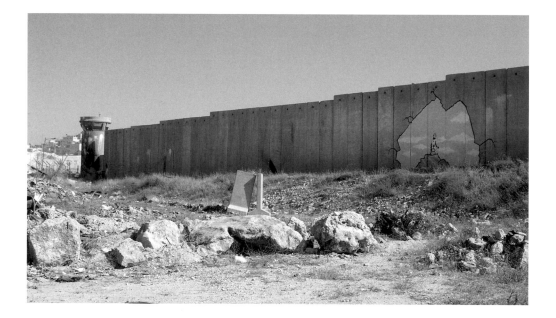

My guide	*You could paint here – there are no guards in the watch towers, they do not come until the winter.*
Me	*(Returning to the car after painting for 25 minutes) What's so funny?*
Guide	*(Lauging hysterically) Of course the guards are in the towers, they have the snipers with the walkie-talkies.*

Ramallah checkpoint 2005

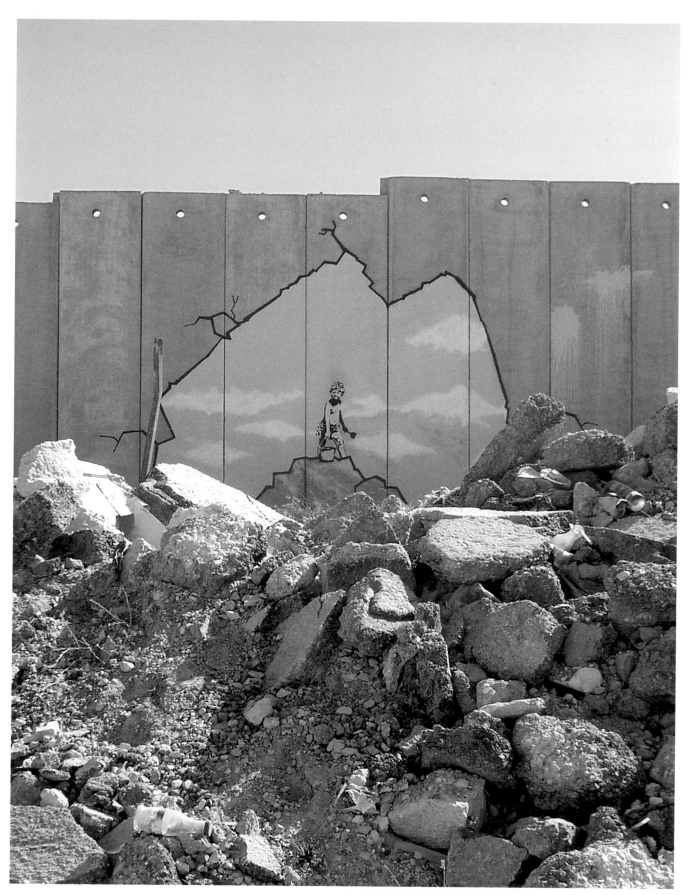

Old man *You paint the wall, you make it look beautiful*

Me *Thanks*

Old man *We don't want it to be beautiful, we hate this wall, go home*

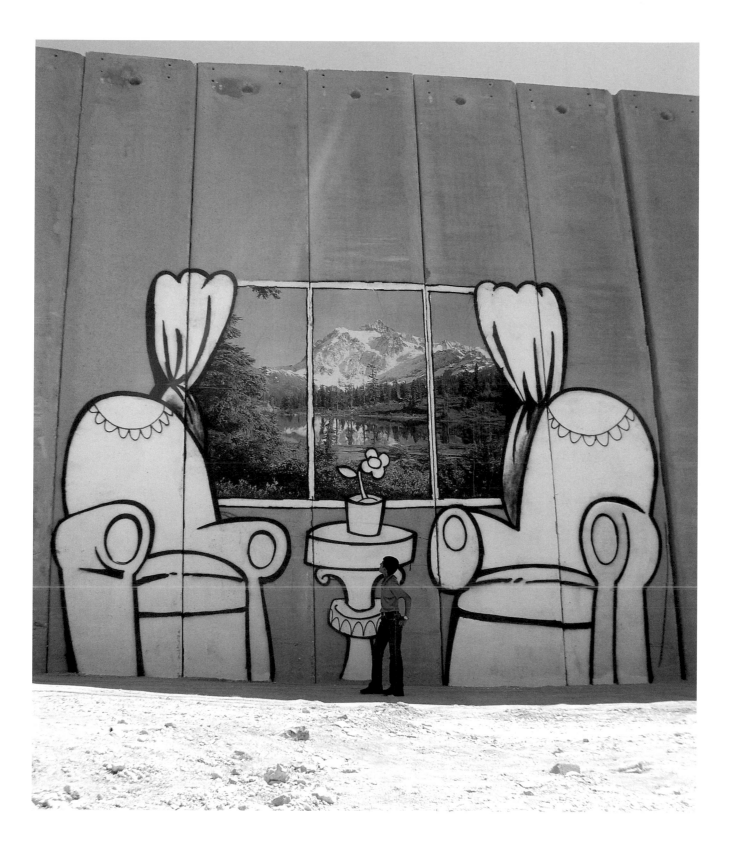

Bethlehem checkpoint

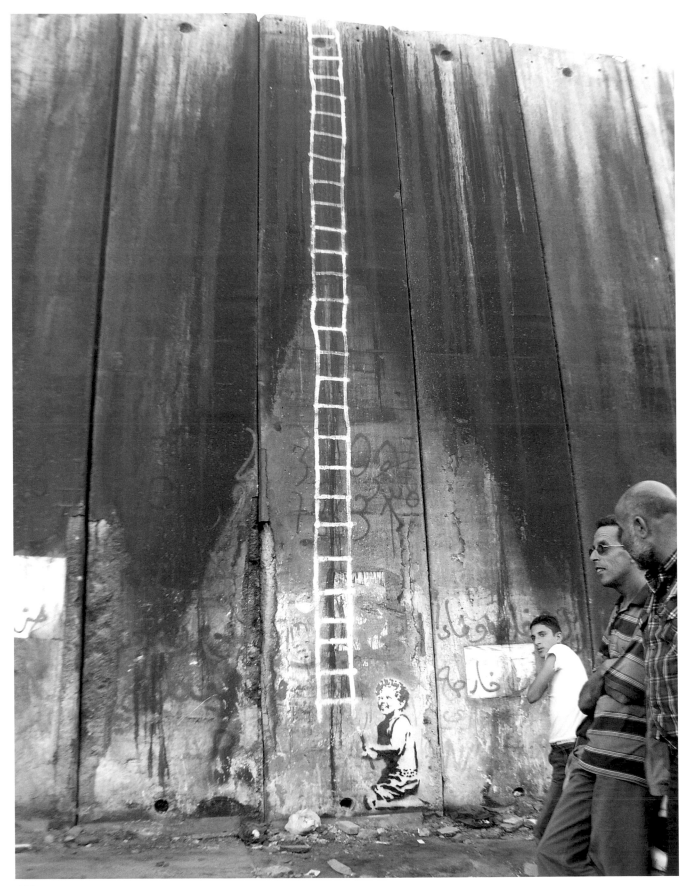

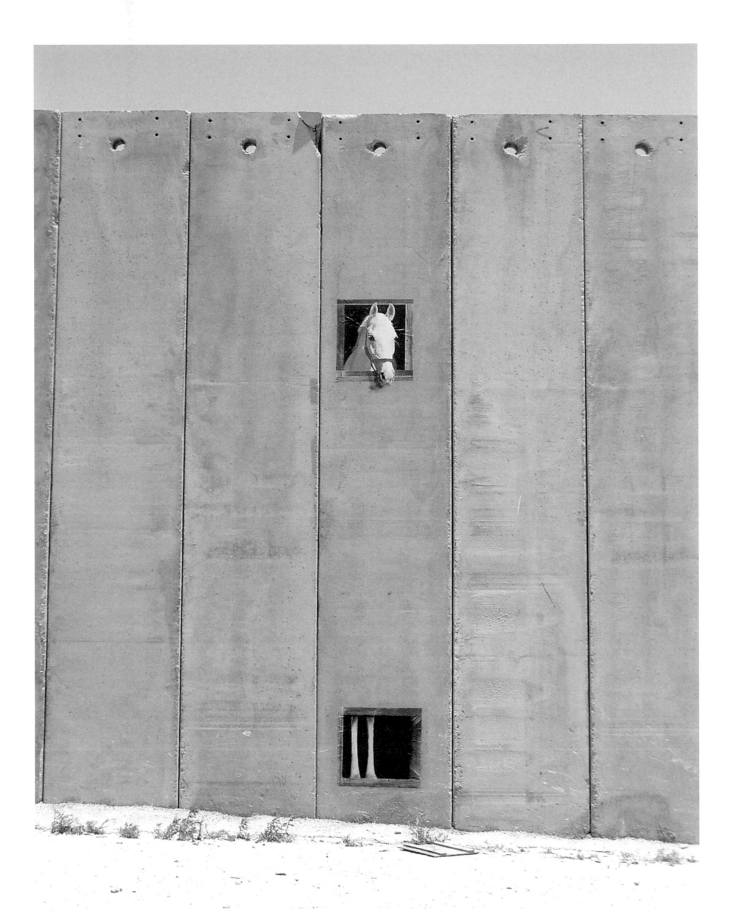

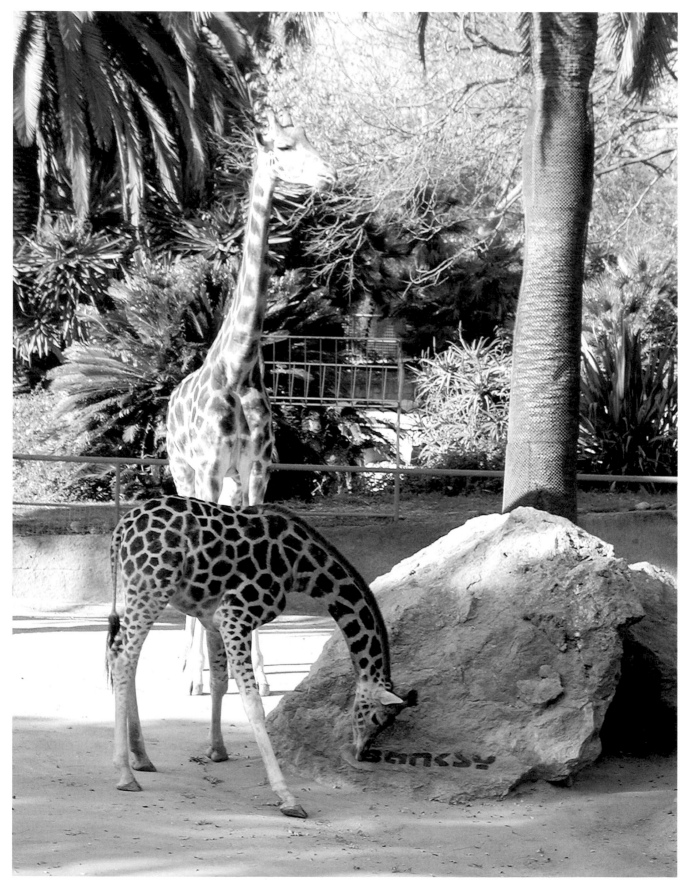

Zoo painting

I jumped the fence into central park in Barcelona at three o'clock in the morning without realising the park which houses the zoo is also home to the Catalan parliament. It's exceptionally well lit and patrolled by Guardia Civil in high-powered jeeps.

I was creeping across the edge of the park when a patrol took me by surprise and I dived into the shrubbery a bit too late.

The jeep pulled to a stop and didn't move for a long time. In my mind I formed the story I would tell about how I was a penniless traveller with no hotel room, sleeping rough in the park and that I always carried 12 cans of spraypaint, a climbing rope and stencils with me. Then I heard footsteps coming from the fence directly behind me and figured the cops were moving in.

I held my breath, parted the ivy leaves, and came eyeball to eyeball with an enormous kangaroo.

After a few minutes the Guardia jeep started up and drove away across the park. Within another minute I was inside the zoo.

British zoos have pictures of the animals on a board at the front of each enclosure. Barcelona Zoo doesn't do this so I was taking extra care before entering each pen. I was moving at speed putting up tags on the penguin, giraffe, bison and gazelle enclosures before reaching my ultimate destination – the elephant house.

A Spanish kid had translated 'Laugh now but one day we'll be in charge' for me on a small piece of paper. I got the paint out ready to write this in three foot high animal-like handwriting across the back wall, only to find I'd lost the piece of paper. Crouching next to a huge pile of dung my mind froze up. I speak no Spanish and writing something in English seemed a bit insensitive. I checked my watch for the fifteenth time and then figured this was my best option – ticking off the time in classic jailhouse style.

I weighed in five cans of fat black, scrawling ЖЖ ЖЖ ЖЖ ЖЖ over every available surface of the entire enclosure.

By the time I got up the following afternoon I didn't get any photos of the elephant enclosure. Emergency cleaners had been working hard on it and covered up the rest with plastic sheeting. It's frustrating when the only people with good photos of your work are the police department.

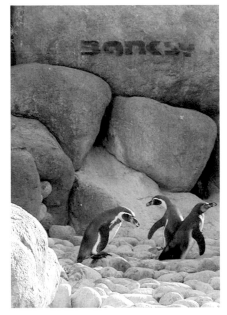

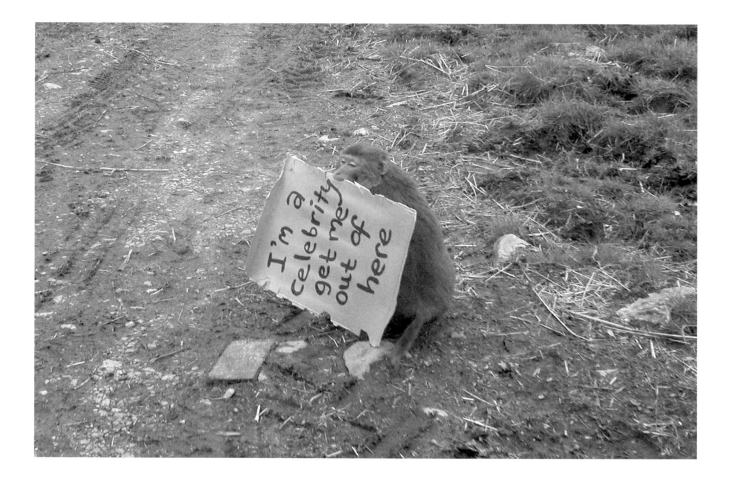

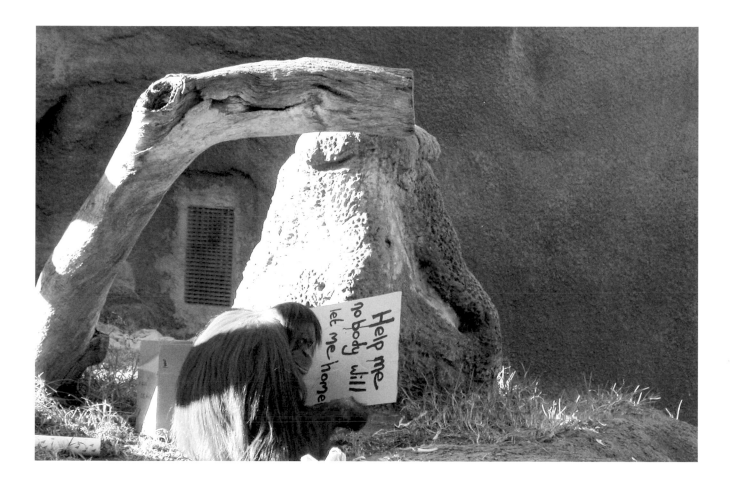

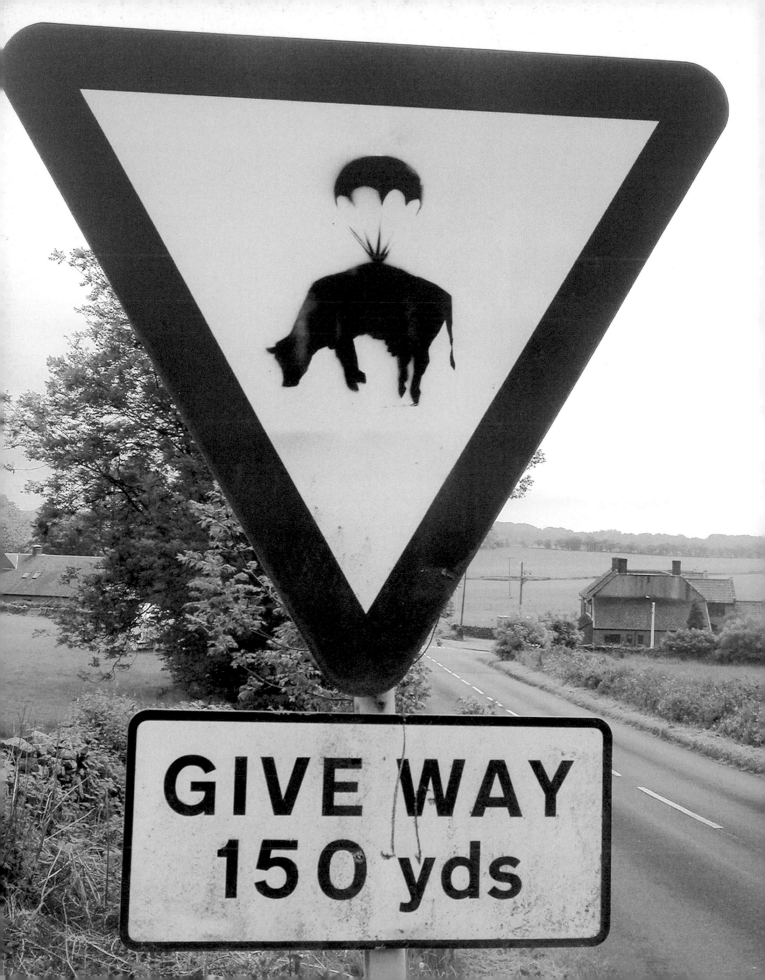

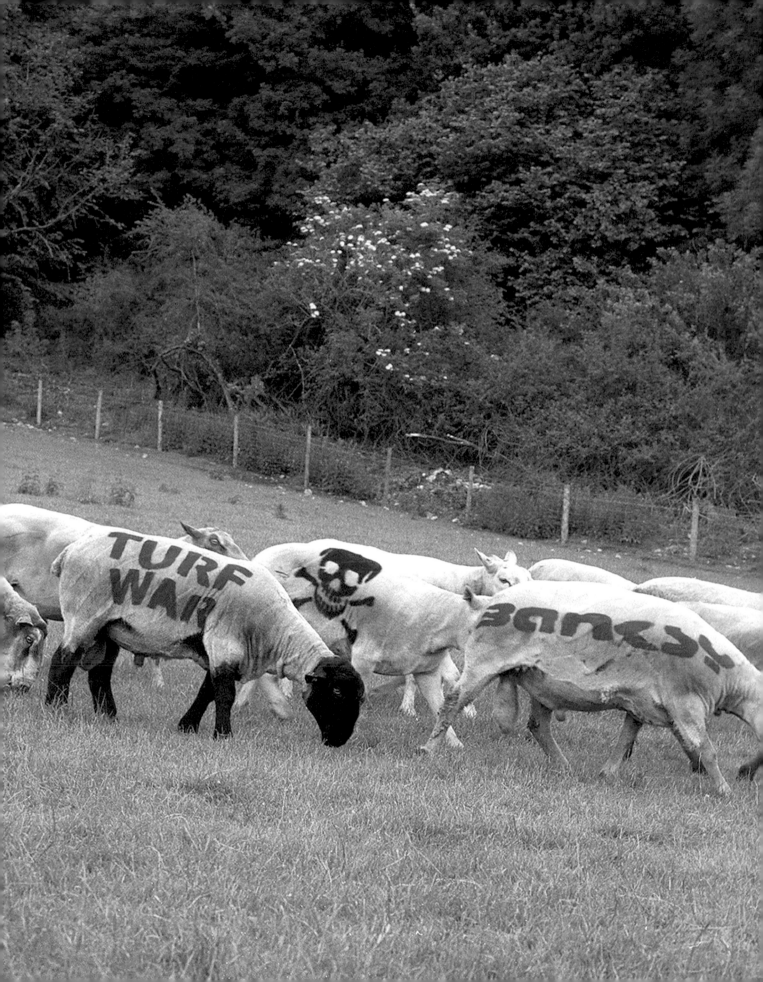

Hick Hop

If you grow up in a town where they don't have subway trains you have to find something else to paint on.

It's not as easy as it sounds because most subway train drivers don't wander around with shotguns.

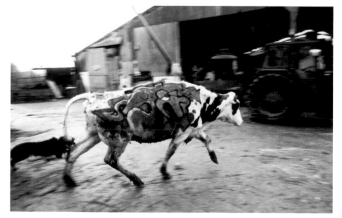 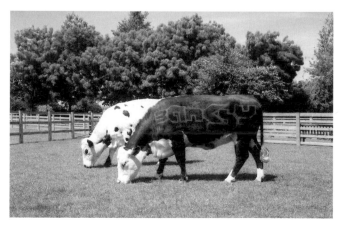

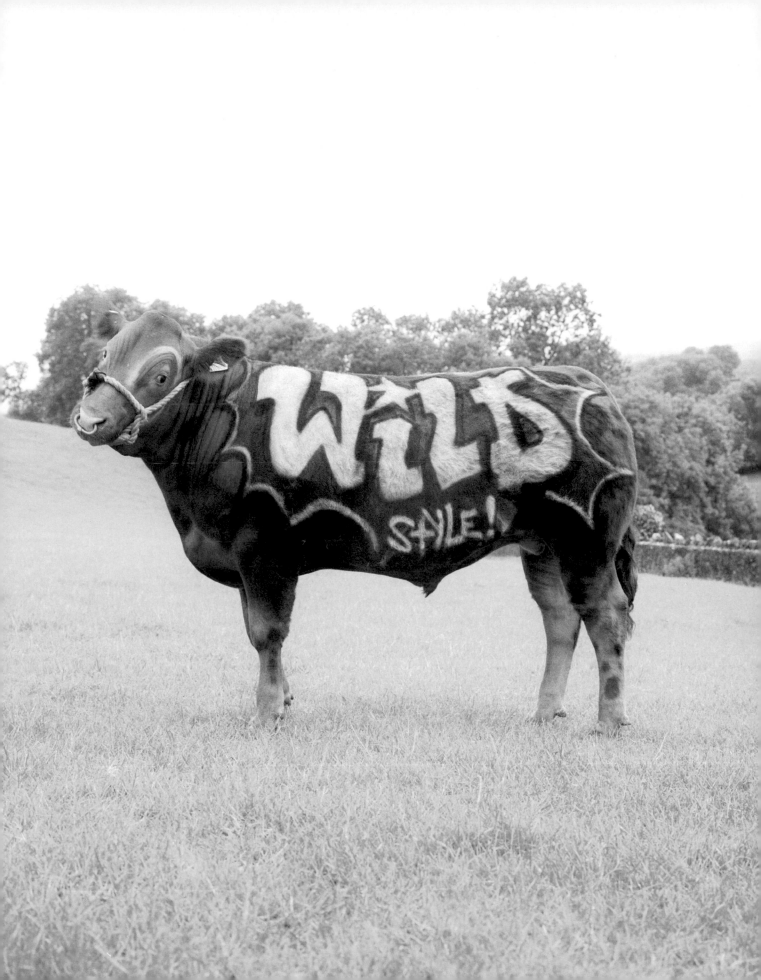

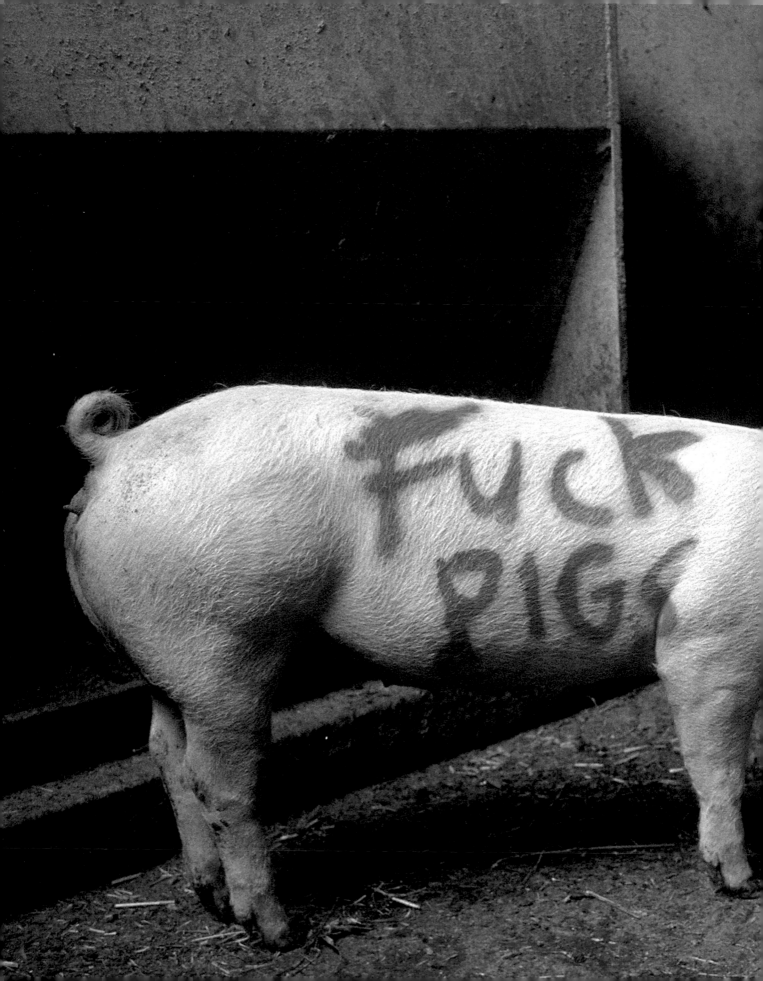

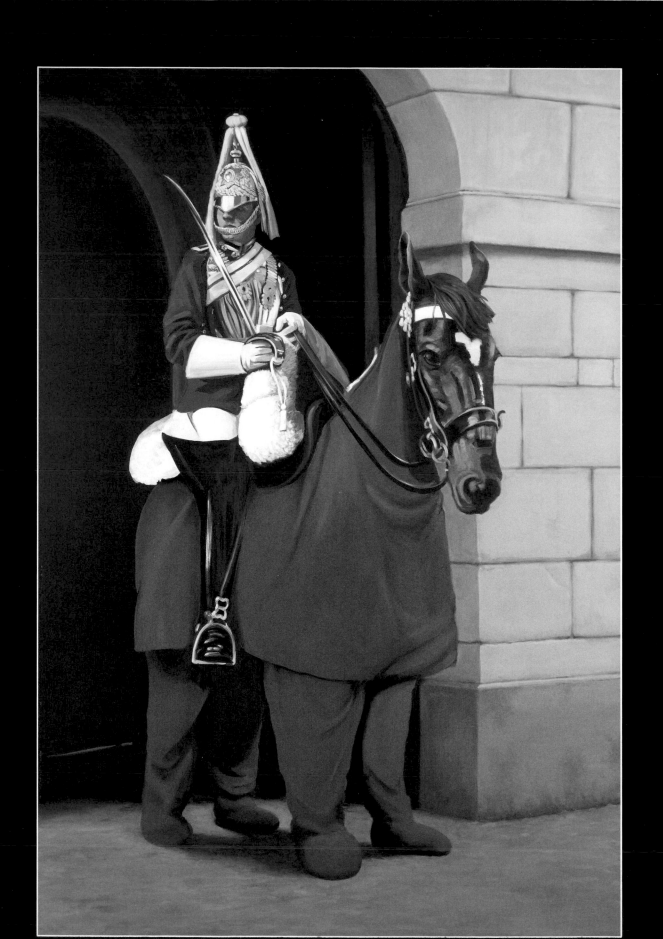

Art

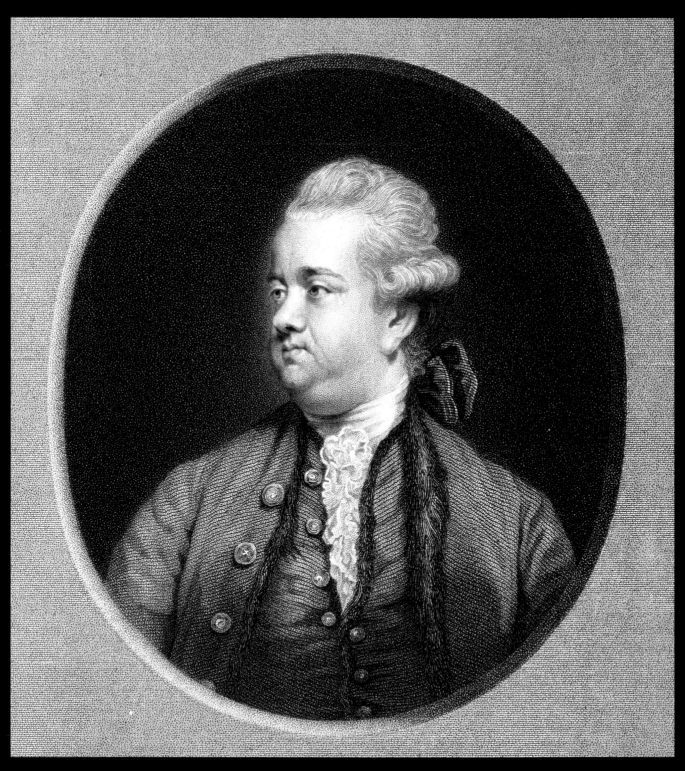

Vandalised paintings

If you want to survive as a graffiti writer when you go indoors I figured your only option is to carry on painting over things that don't belong to you there either.

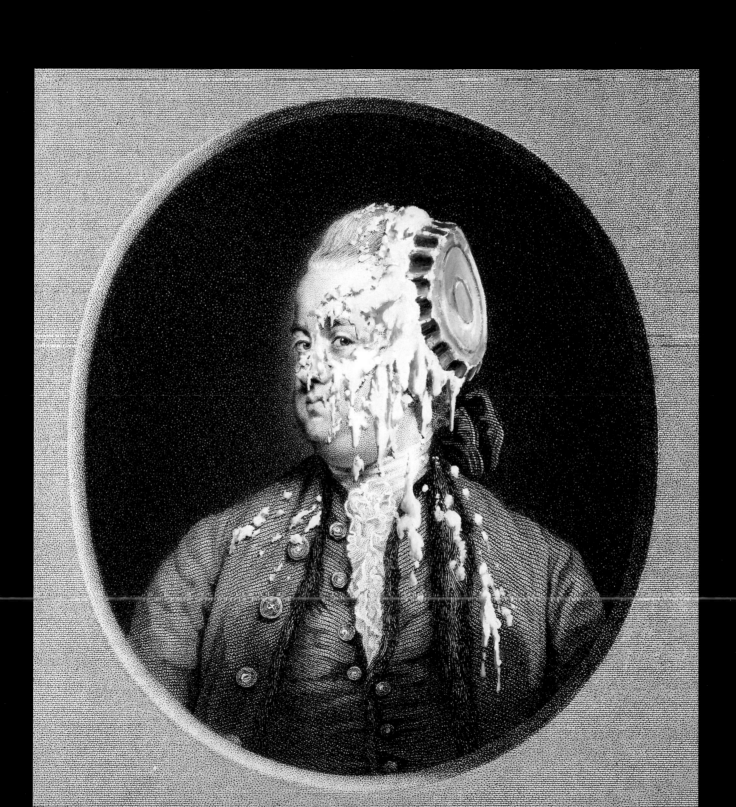

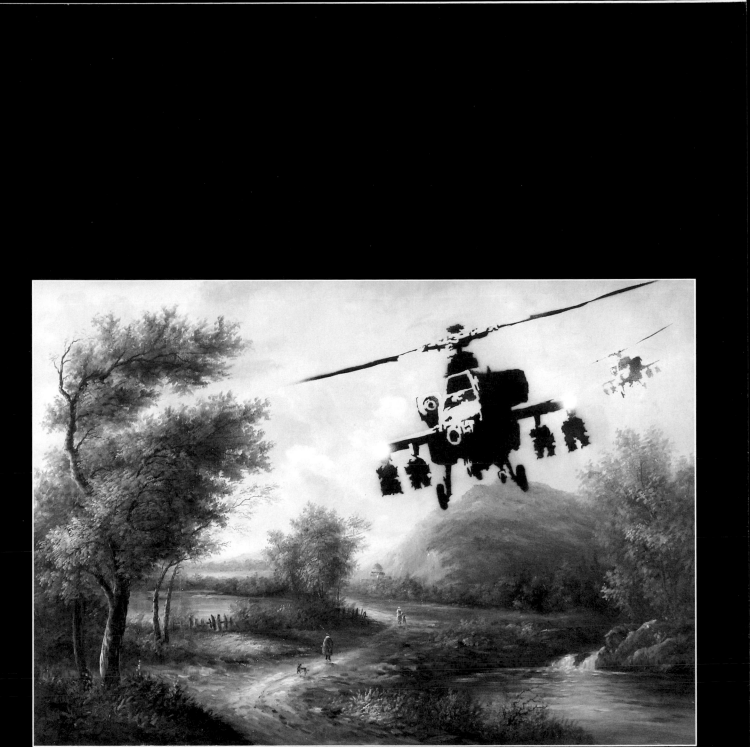

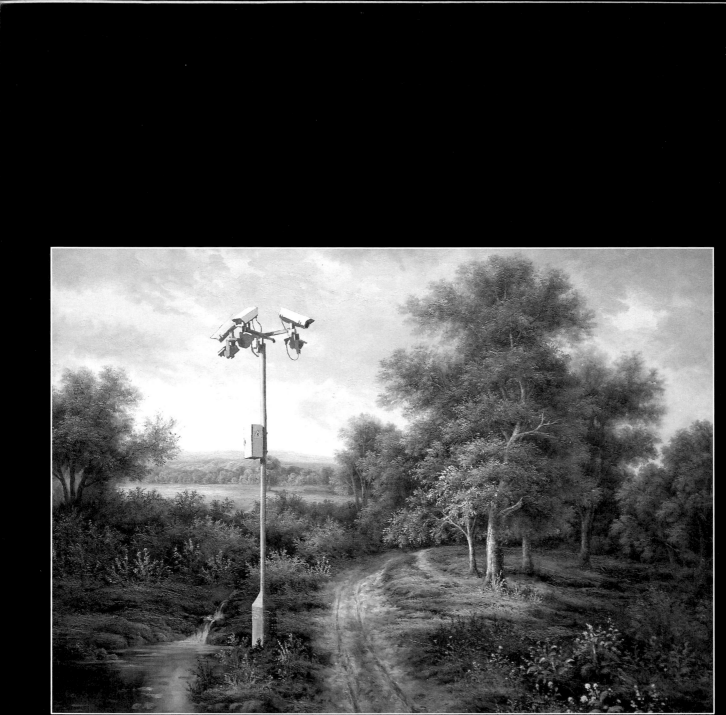

METROPOLITAN POLICE

WE ARE APPEALING FOR WITNESSES
CAN YOU HELP US?

INCIDENT

WERE YOU IN THE AREA BETWEEN 2am - 3am
ON FRIDAY 24th SEPTEMBER 04. IF SO
CONTACT THE POLICE STATION ON THE
NUMBERS SHOWN BELOW

In strictest confidence please phone
020 8649 2477/8

DID YOU SEE OR HEAR ANYTHING?
PLEASE CALL US

On the number above or at your local police station
or ring CRIMESTOPPERS

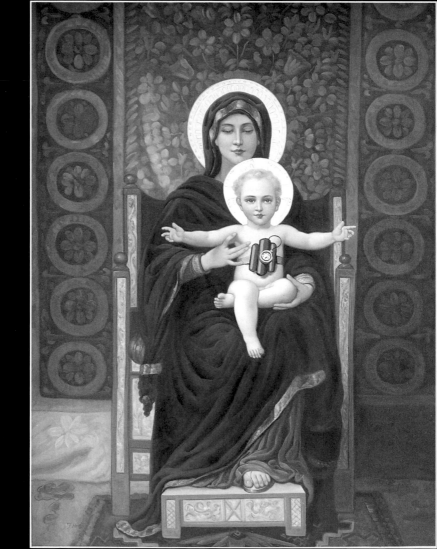

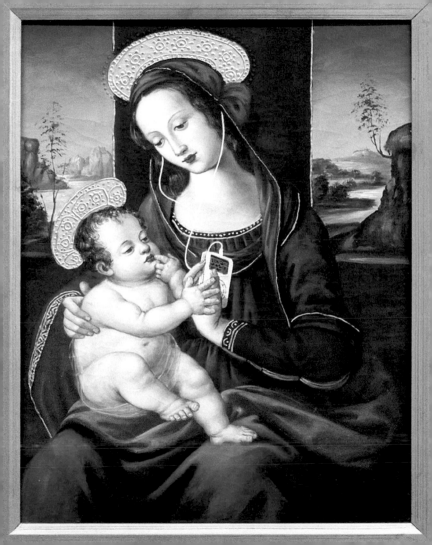

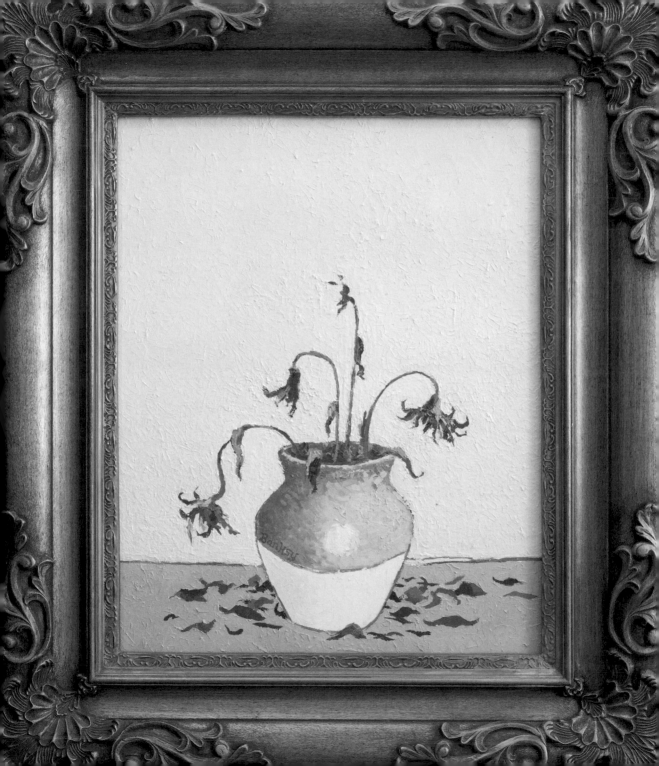

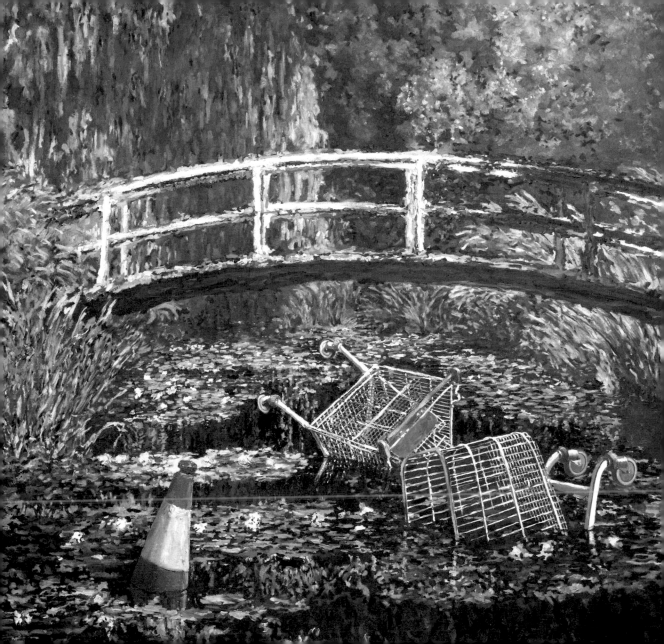

'Crimewatch UK has ruined the countryside for all of us'
2003 Oil on canvas

This new acquisition is a beautiful example of the neo post-idiotic style. The Artist has found an unsigned oil painting in a London street market and then stenciled Police incident tape over the top. It can be argued that defacing such an idyllic scene reflects the way our nation has been vandalised by its obsession with crime and paedophilia, where any visit to a secluded beauty spot now feels like it may result in being molested or finding discarded body parts.

Presented by the artist personally 2003

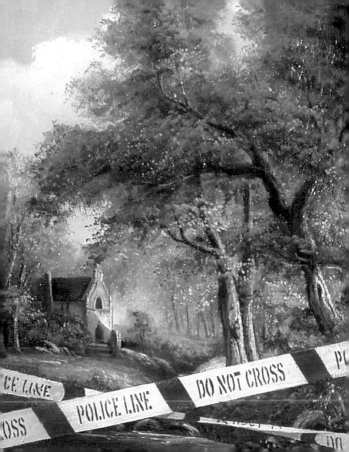

Art is not like other culture because its success is not made by its audience. The public fill concert halls and cinemas every day, we read novels by the millions and buy records by the billions. We the people, affect the making and the quality of most of our culture, but not our art.

The Art we look at is made by only a select few. A small group create, promote, purchase, exhibit and decide the success of Art. Only a few hundred people in the world have any real say. When you go to an Art gallery you are simply a tourist looking at the trophy cabinet of a few millionaires.

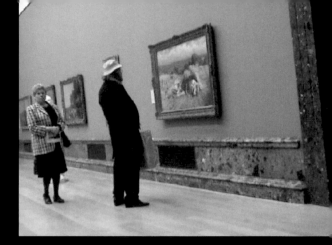
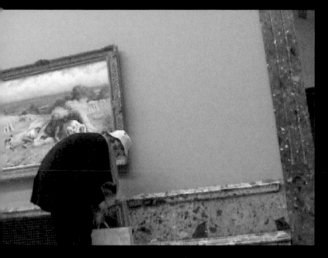
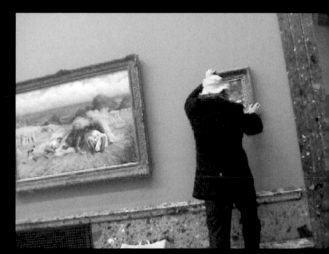
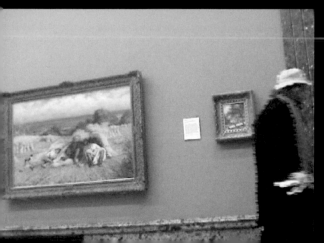

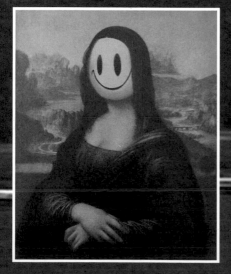

My sister threw away loads of my drawings when I was a kid and when I asked her where they were she shrugged and said 'Well it's not like they're ever gonna be hanging in the Louvre is it?'

Installation in the Louvre, Paris 2004
Duration unknown

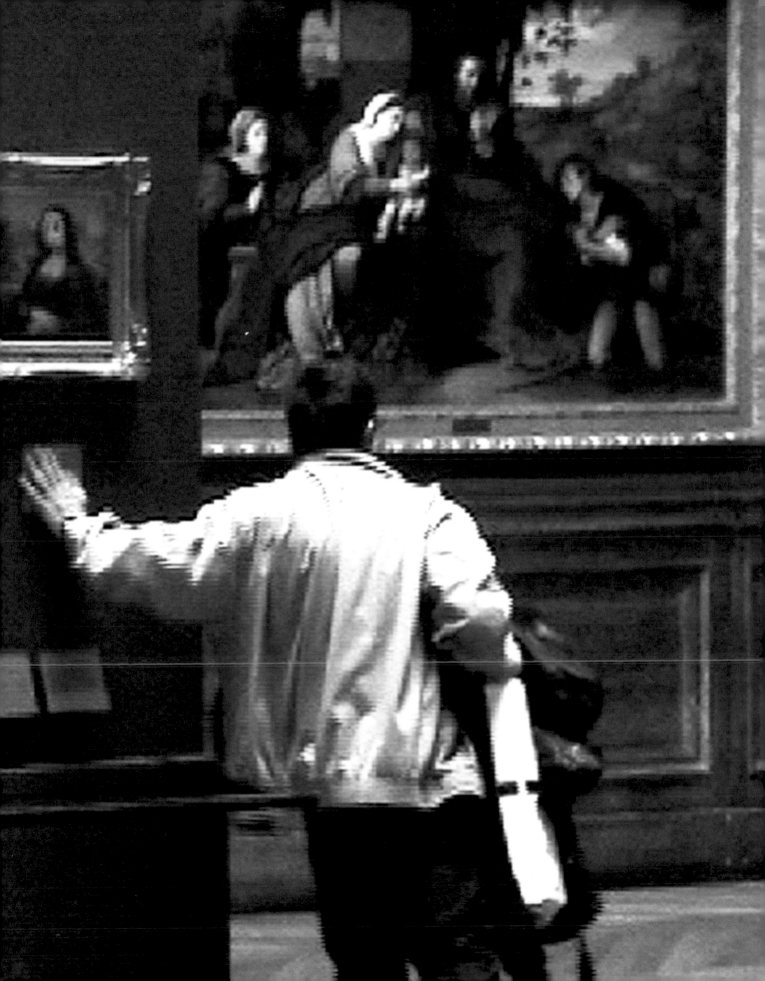

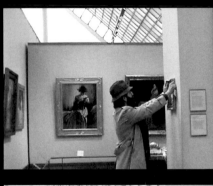

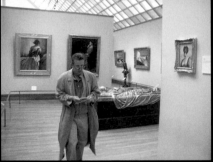

Become good at cheating and you never need
to become good at anything else

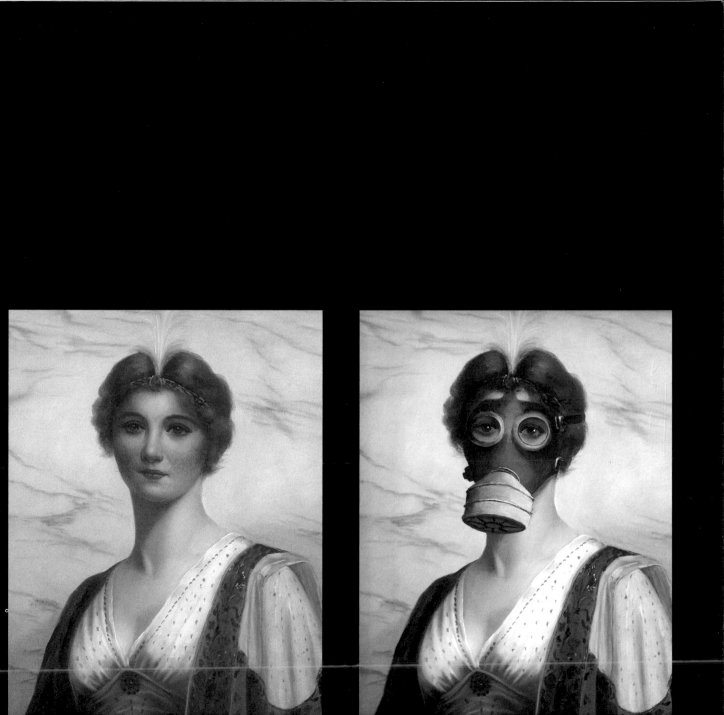

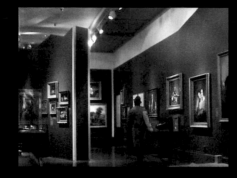
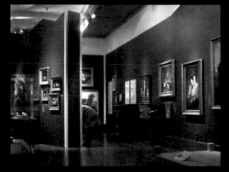
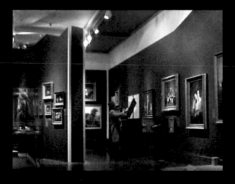
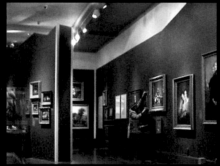
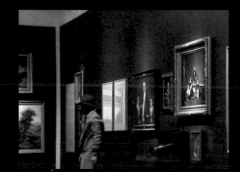

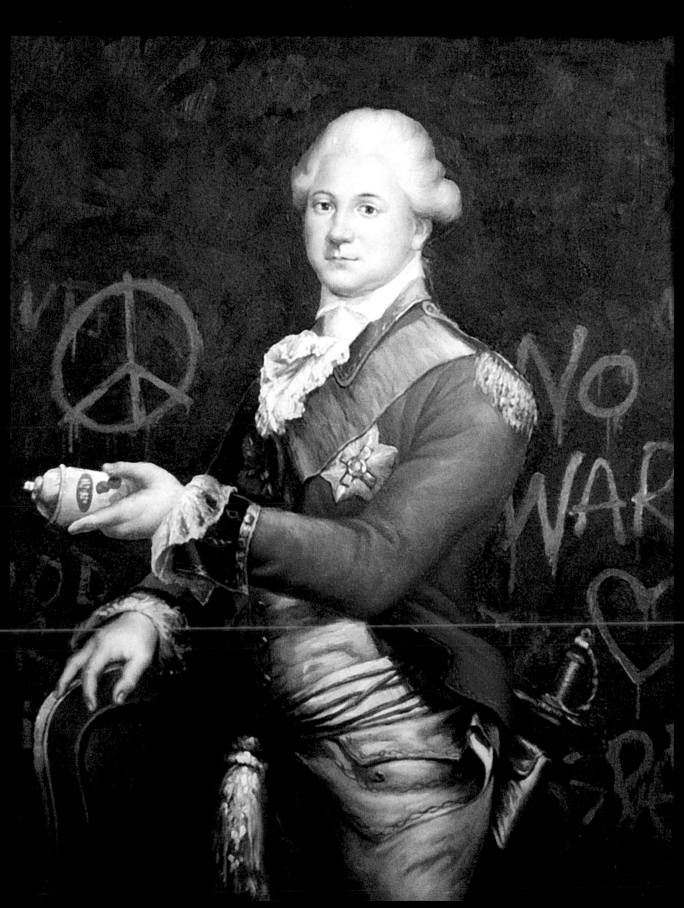

Modified oil painitng installed Brooklyn Museum 2005. Lasted 8 days

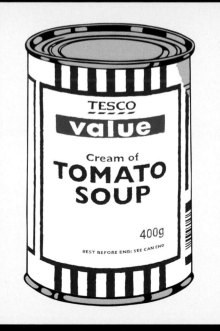

Discount Soup Can. Museum of Modern Art, New York.
Lasted 6 days

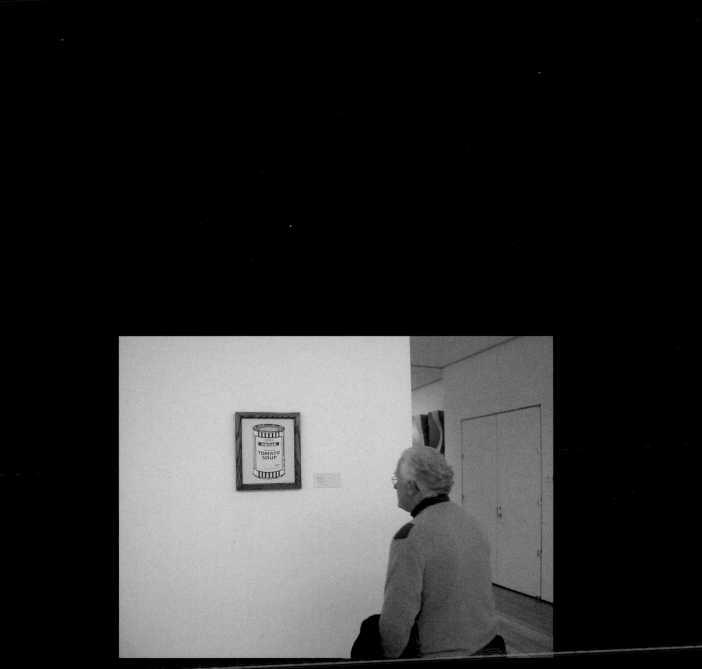

After sticking up the picture I took five minutes
to watch what happened next. A sea of people
walked up, stared and moved on looking confused
and slightly cheated. I felt like a true modern artist.

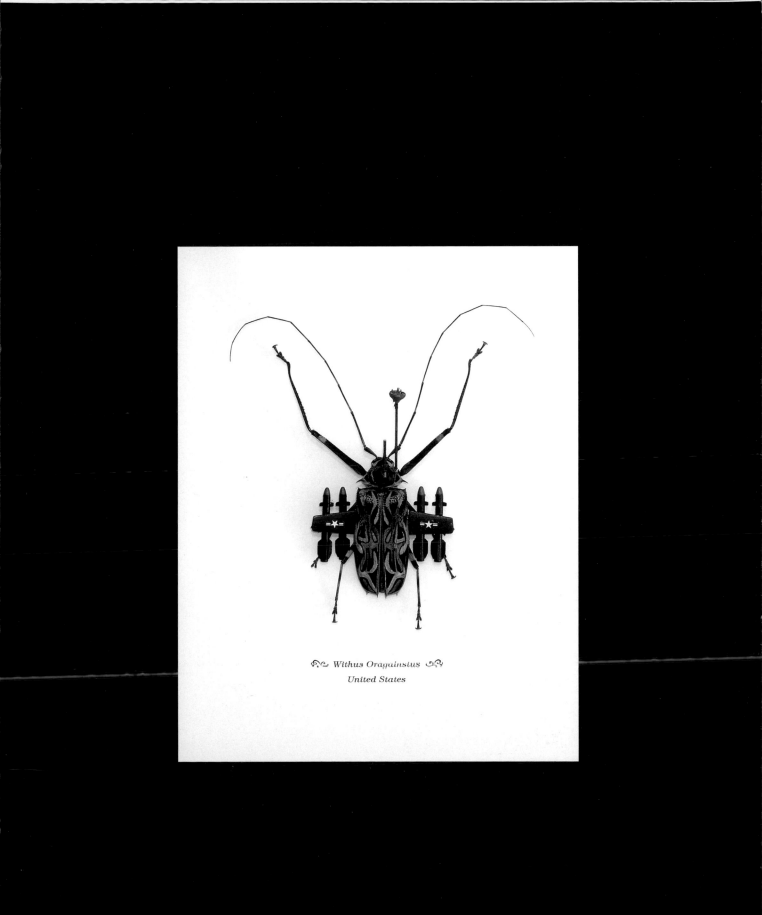

Withus Orayuinsius

United States

Harlequin beetle with airfix weapons. Natural History Museum, New York. Lasted 12 days

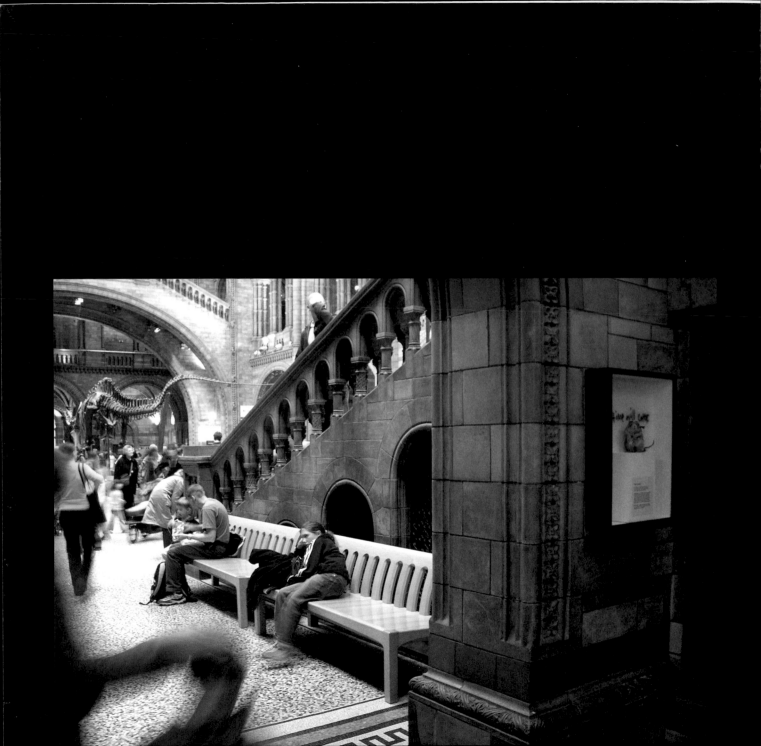

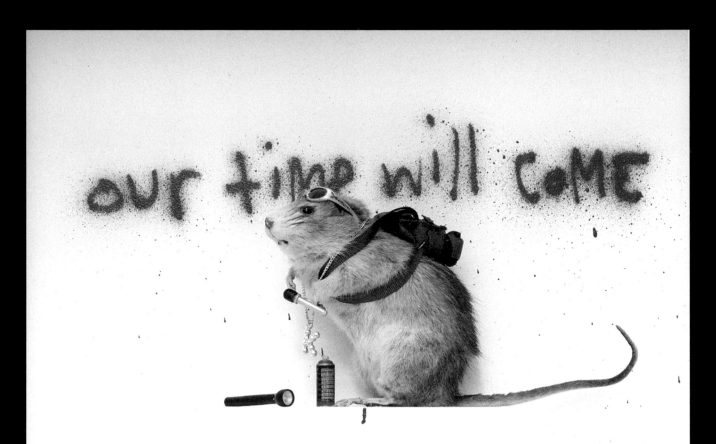

Pest Control

Recently discovered specimens of the common sewer rat have shown some remarkable new characteristics.

Attributed to an increase in junk food waste, ambient radiation and hardcore urban rap music these creatures have evolved at an unprecedented rate. Termed the Banksus Militus Vandalus they are impervious to all modern methods of pest control and mark their territory with a series of elaborate signs.

Professor B. Langford of University College London states "You can laugh now... but one day they may be in charge."

TV has made going to the theatre seem pointless, photography has pretty much killed painting, but graffiti remains gloriously unspoilt by progress.

Wall art
East London

This finely preserved example of primitive art dates from the Post-Catatonic era and is thought to depict early man venturing towards the out-of-town hunting grounds. The artist responsible is known to have created a substantial body of work across the South East of England under the moniker Banksymus Maximus but little else is known about him. Most art of this type has unfortunately not survived. The majority is destroyed by zealous municipal officials who fail to recognise the artistic merit and historical value of daubing on walls.

PRB 17752,2-2,1

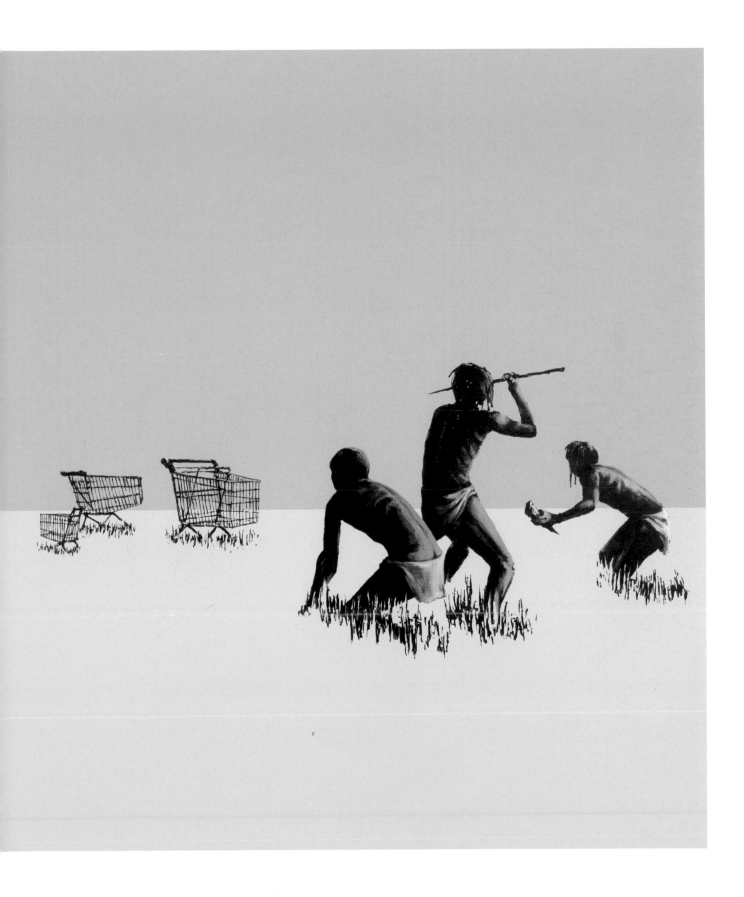

Sometimes I feel so sick at the state of the world I can't even finish my second apple pie

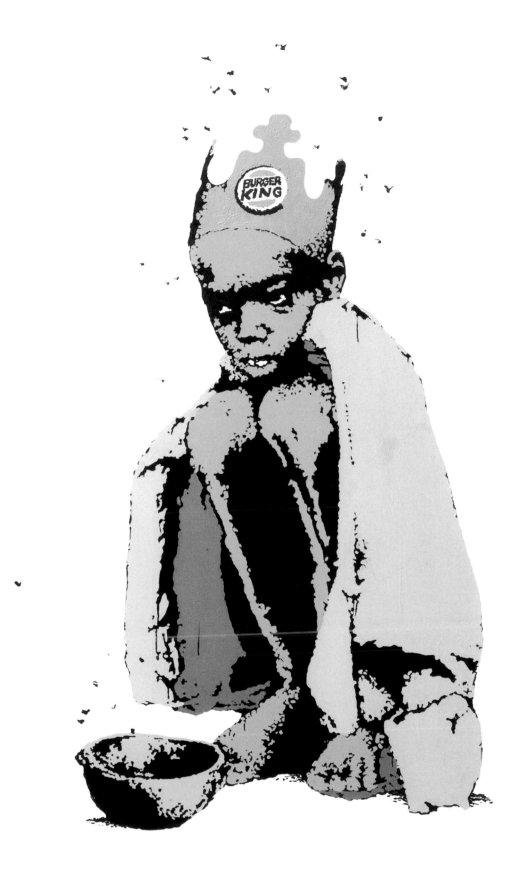

Can't beat the feelin'

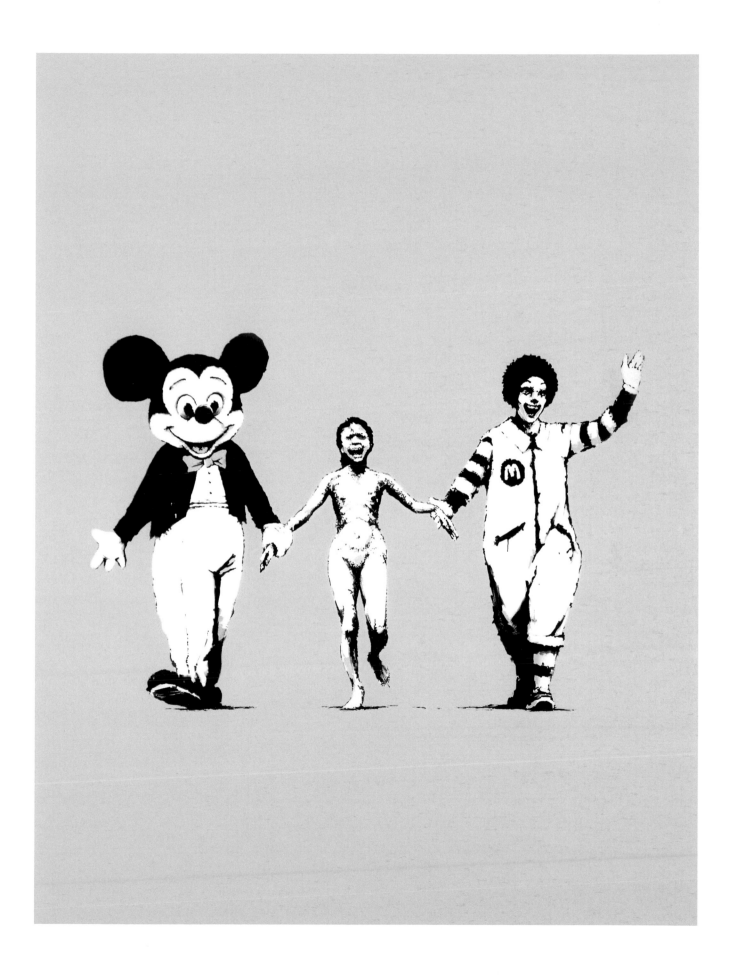

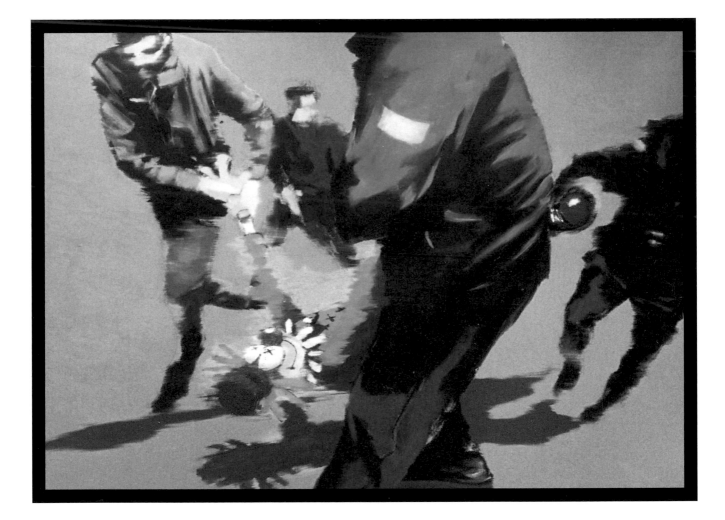

You told that joke twice

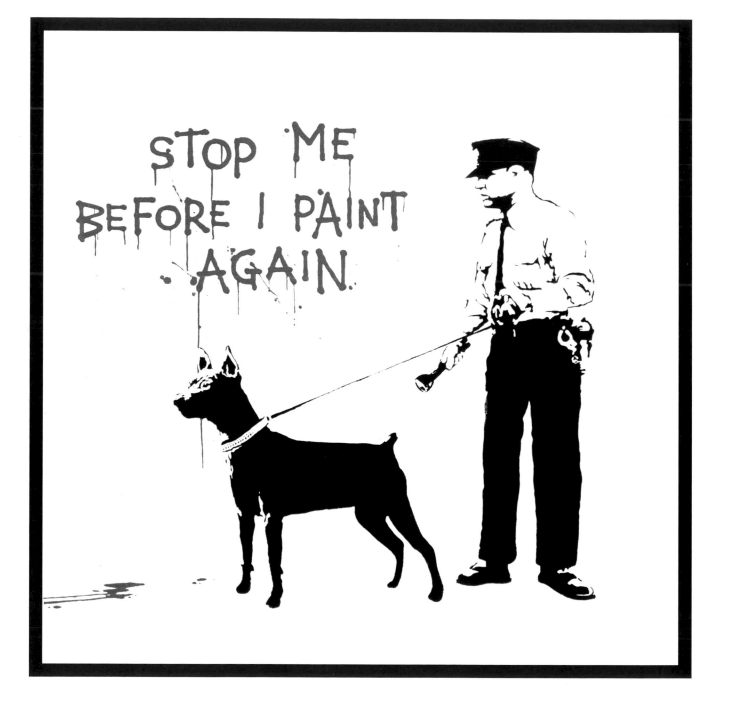

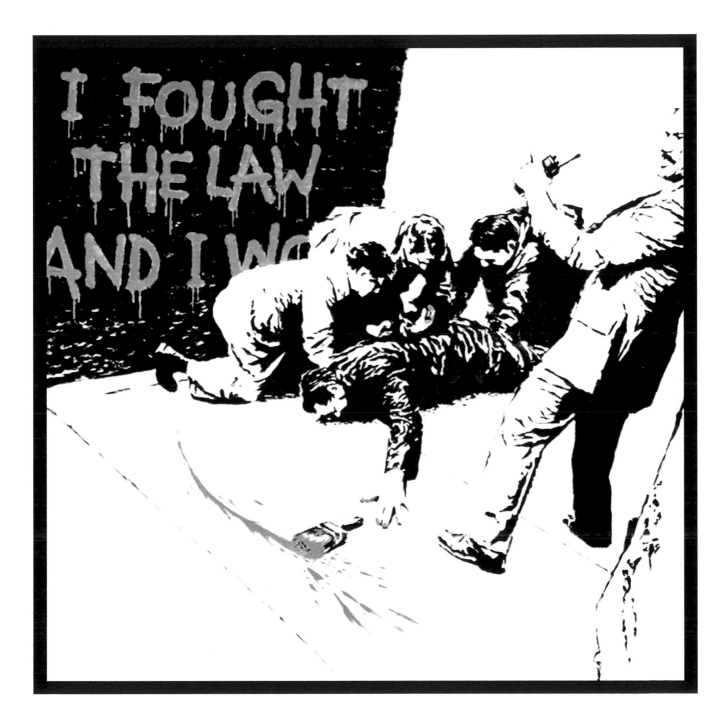

Brandalism

Any advertisement in public space that gives you no choice whether you see it or not is yours. It belongs to you. It's yours to take, re-arrange and re-use. Asking for permission is like asking to keep a rock someone just threw at your head.

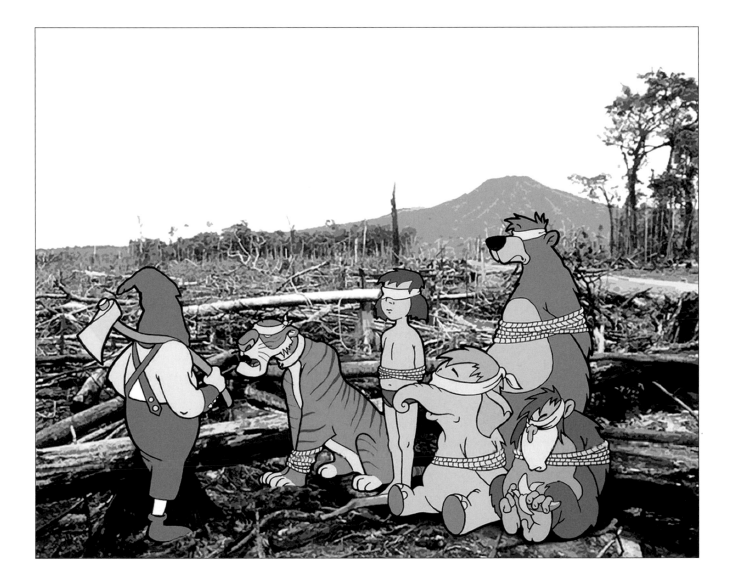

Poster for Greenpeace campaign against deforestation

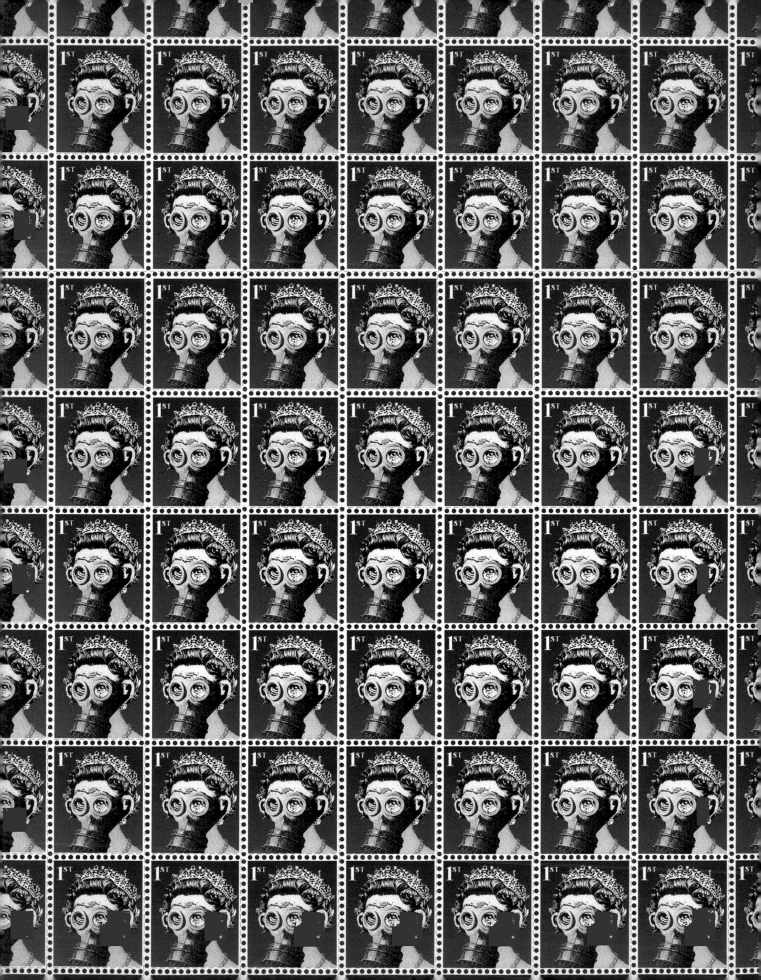

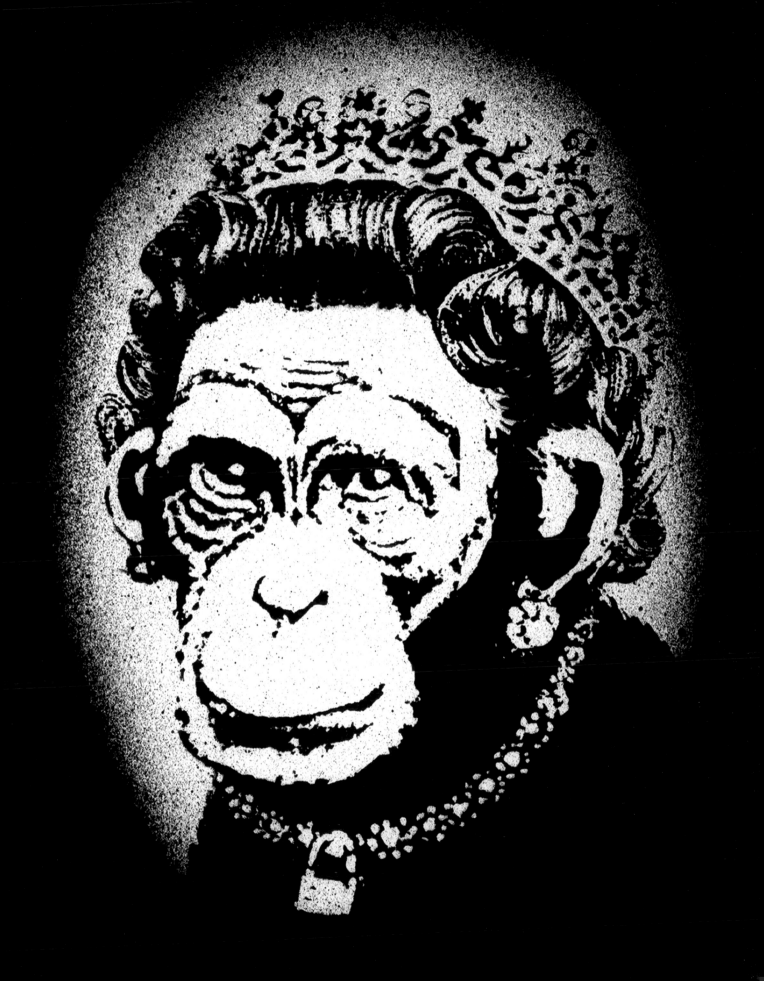

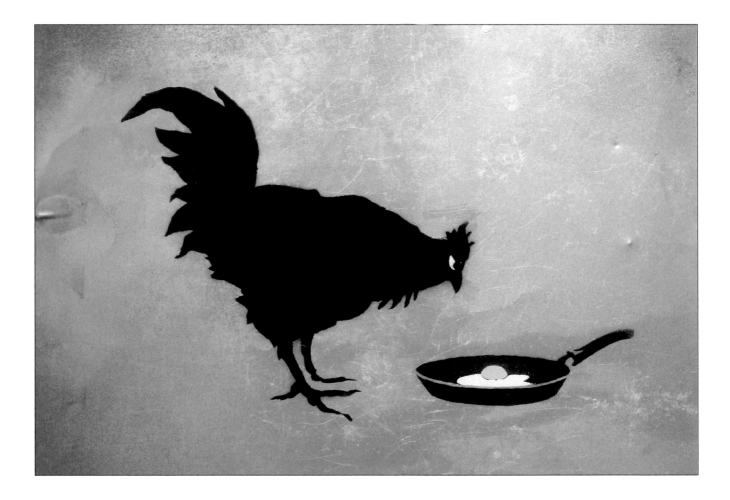

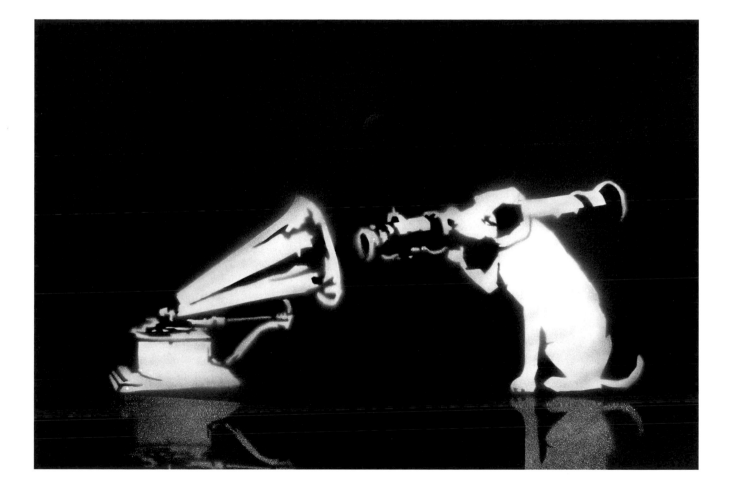

We don't need any more heroes, we just need someone to take out the recycling

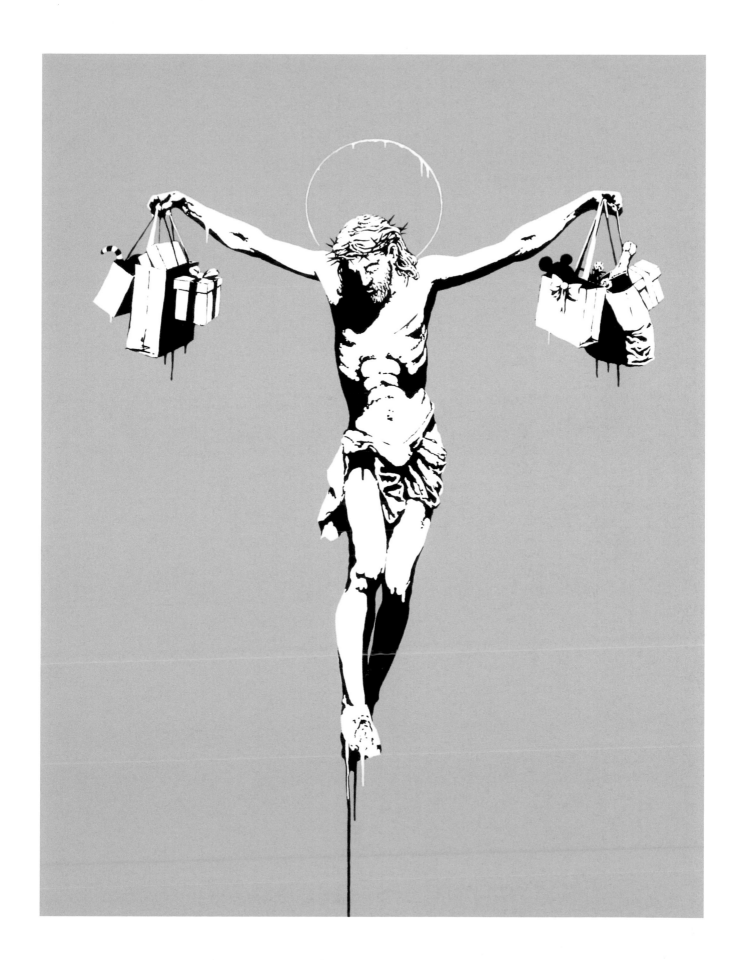

We can't do anything to change the world until
capitalism crumbles. In the meantime we should
all go shopping to console ourselves.

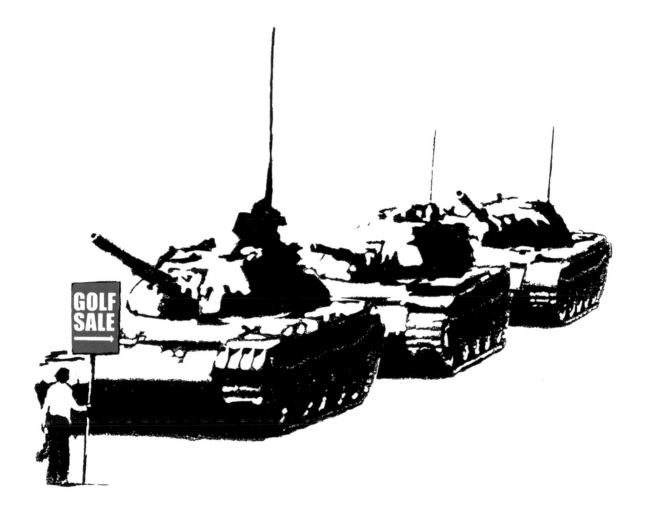

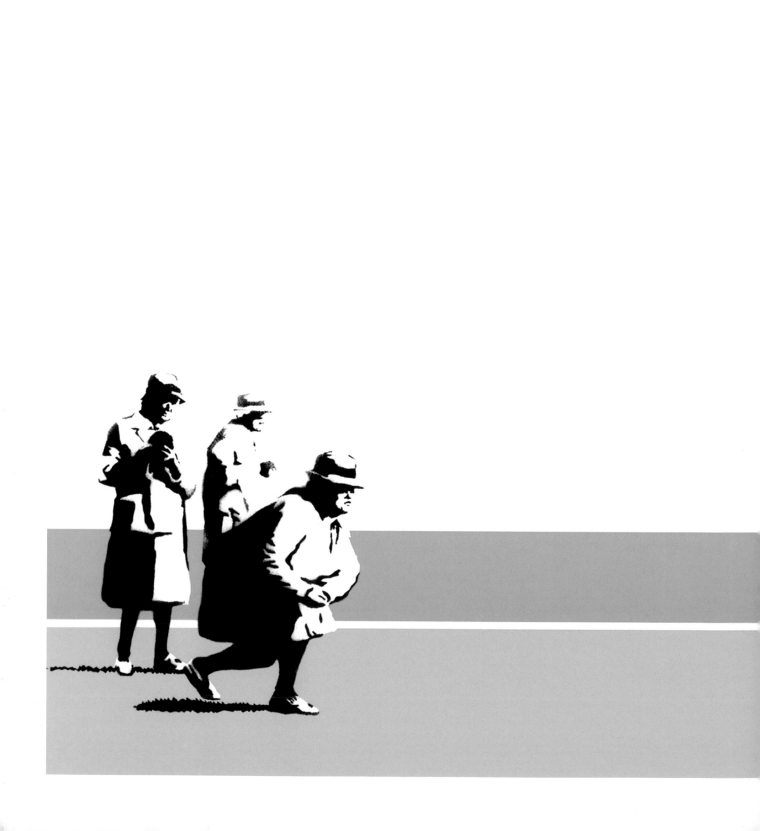

People who get up early in the morning cause war, death and famine

Street Sculpture

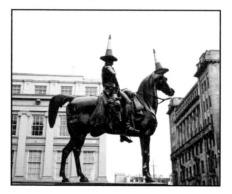

If you want someone to be ignored
then build a lifesize bronze statue of
them and stick it in the middle of town.

It doesn't matter how great you were,
it'll always take an unfunny drunk
with climbing skills to make people
notice you.

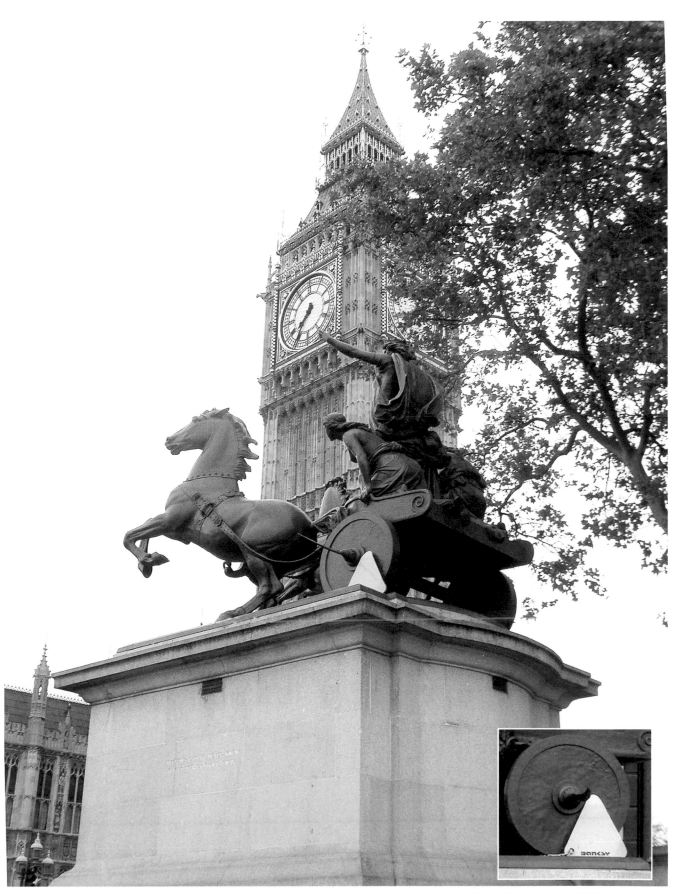

Boudicca with wheel clamp, 2005. Lasted 12 days

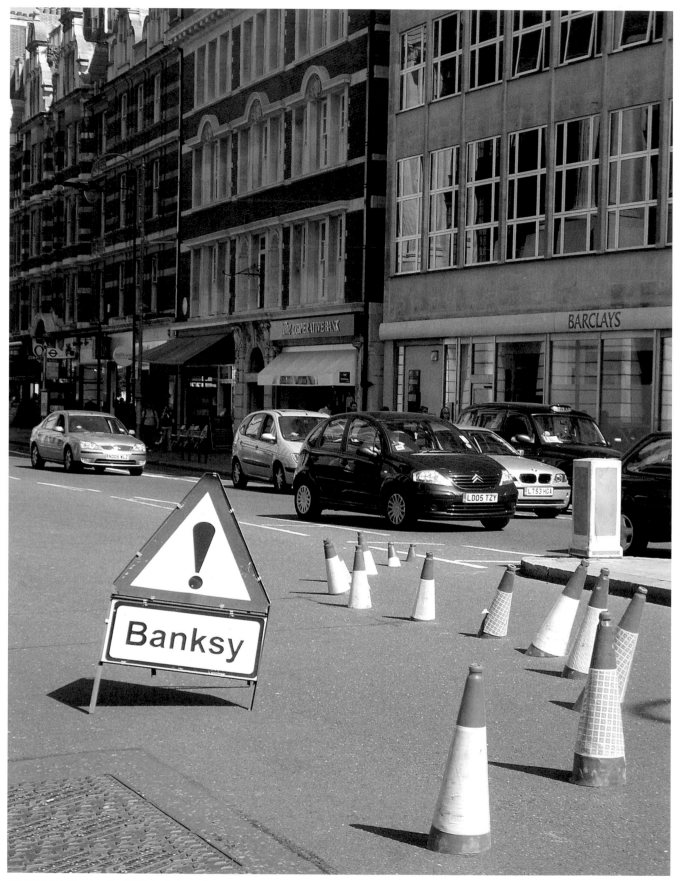

Southampton Row, London 2005. Lasted one day

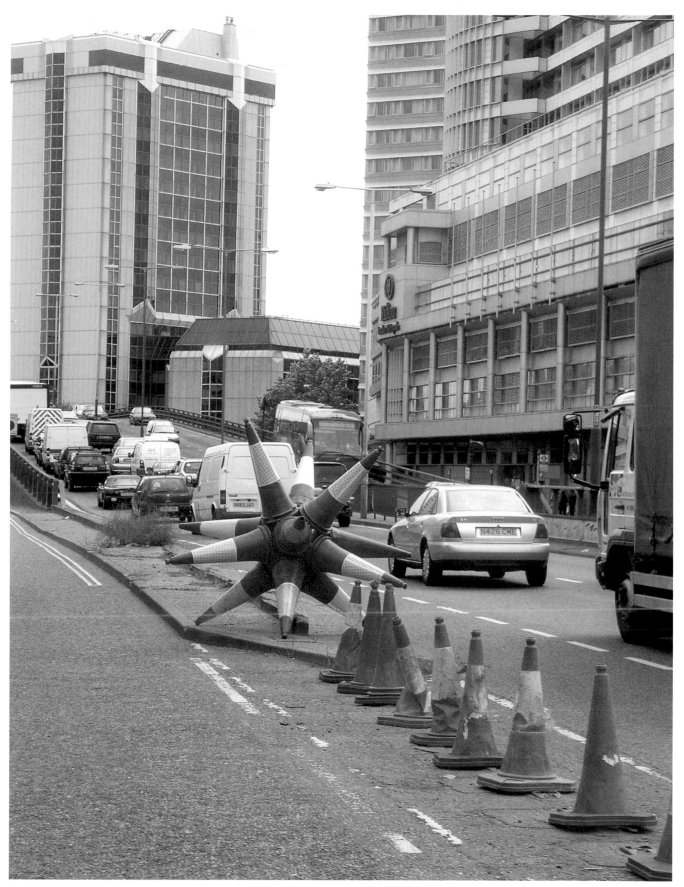

Edgeware Rd, London 2005. Lasted six days

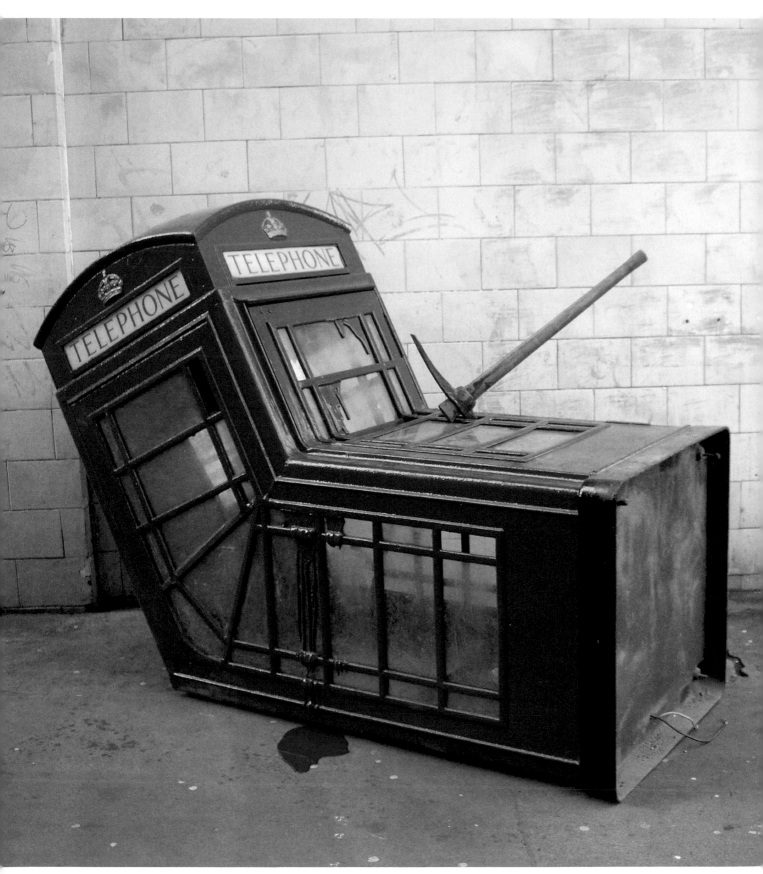

Vandalised phone box, Soho square, London 2006

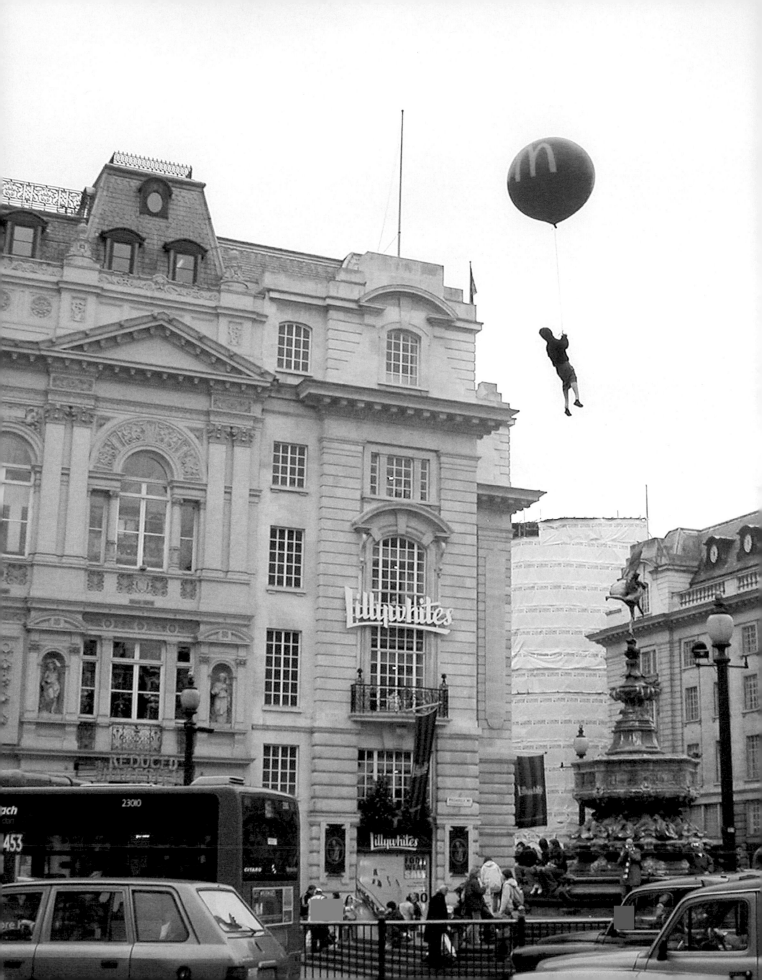

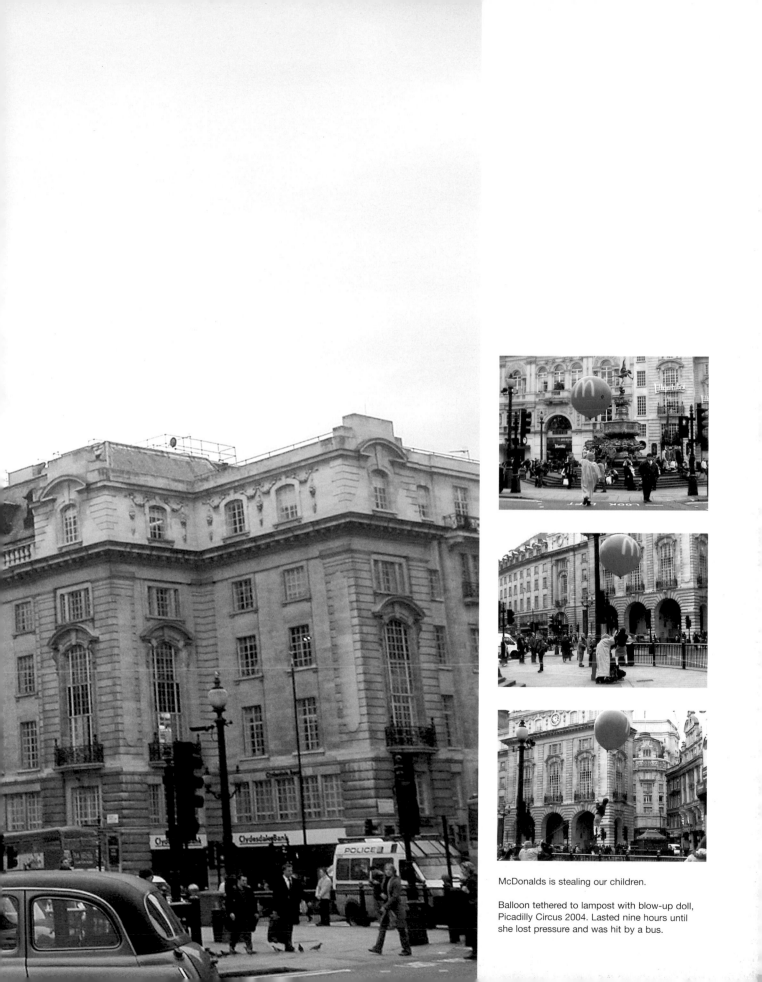

McDonalds is stealing our children.

Balloon tethered to lampost with blow-up doll, Picadilly Circus 2004. Lasted nine hours until she lost pressure and was hit by a bus.

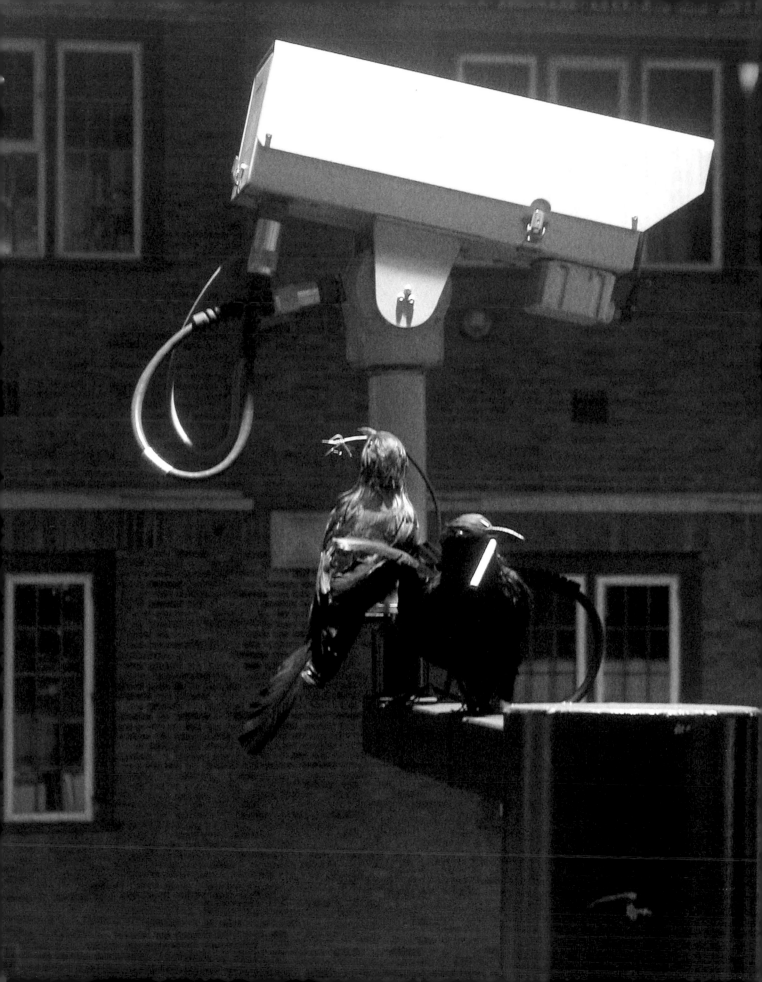

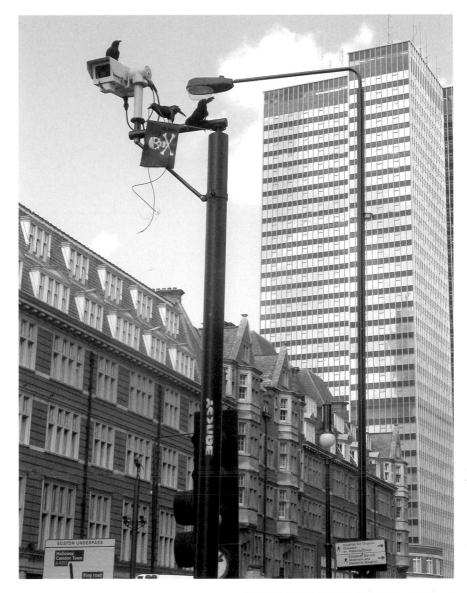

'I heard they was put there by the police so you look up and a computer can scan your face' a stallholder on Portobello market told me when I was taking photographs.

Tottenham Court Road, lasted 2 weeks

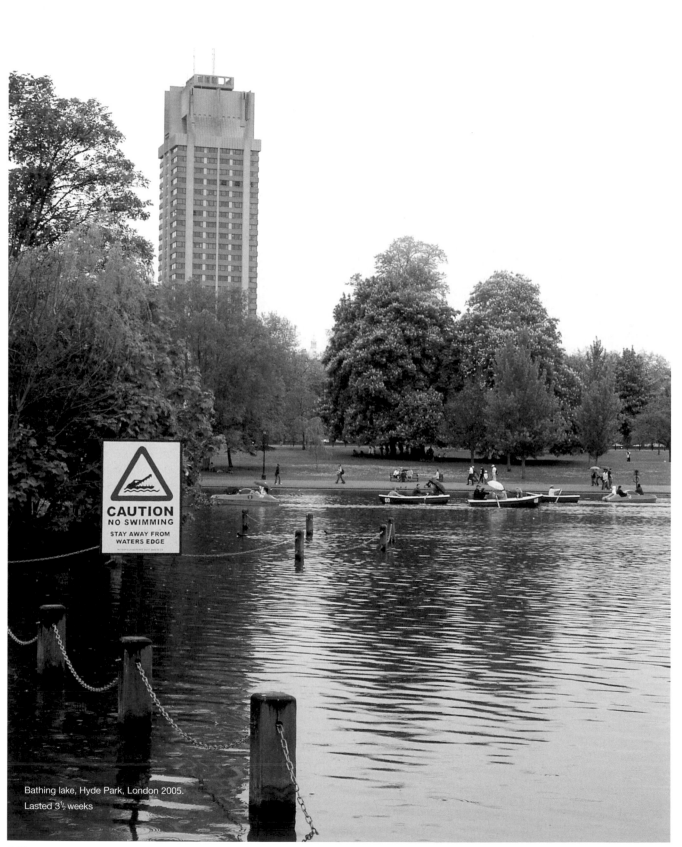

CAUTION
NO SWIMMING
STAY AWAY FROM
WATERS EDGE

Bathing lake, Hyde Park, London 2005.
Lasted 3½ weeks

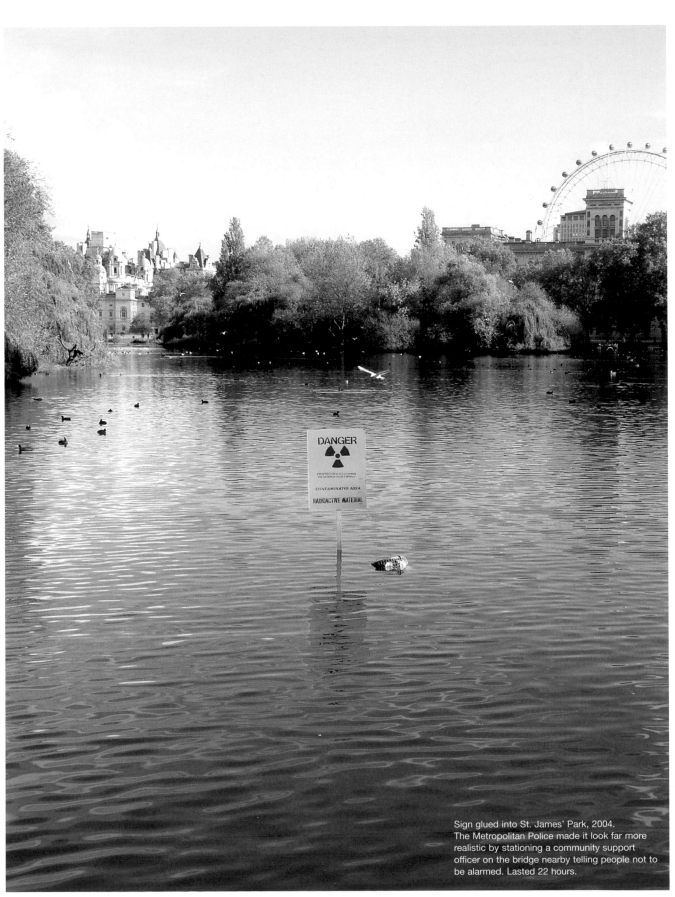

Sign glued into St. James' Park, 2004.
The Metropolitan Police made it look far more
realistic by stationing a community support
officer on the bridge nearby telling people not to
be alarmed. Lasted 22 hours.

DANGER

PROTECTIVE CLOTHING
REQUIRED PRESENTLY

CONTAMINATED AREA

RADIOACTIVE MATERIAL

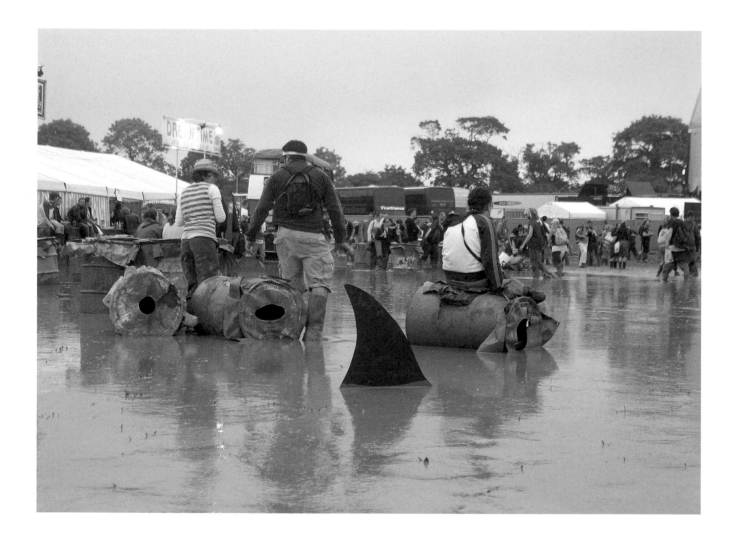

Glastonbury Festival, 2005

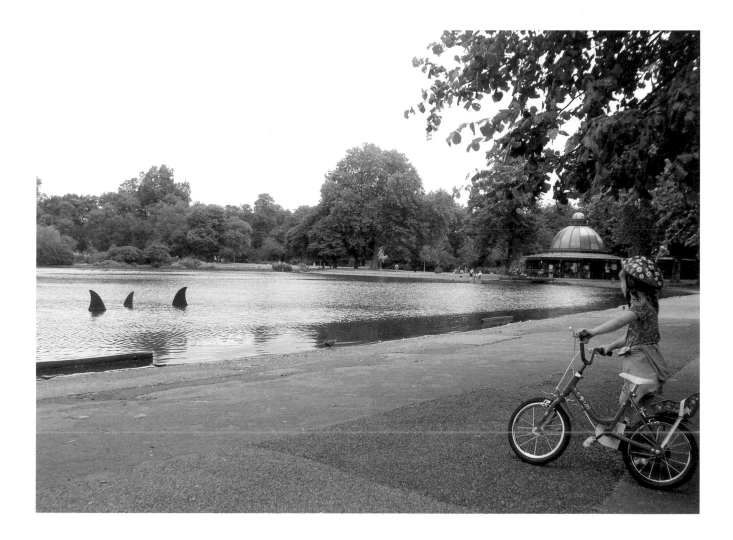

Victoria Park, London 2005. Lasted 3 months

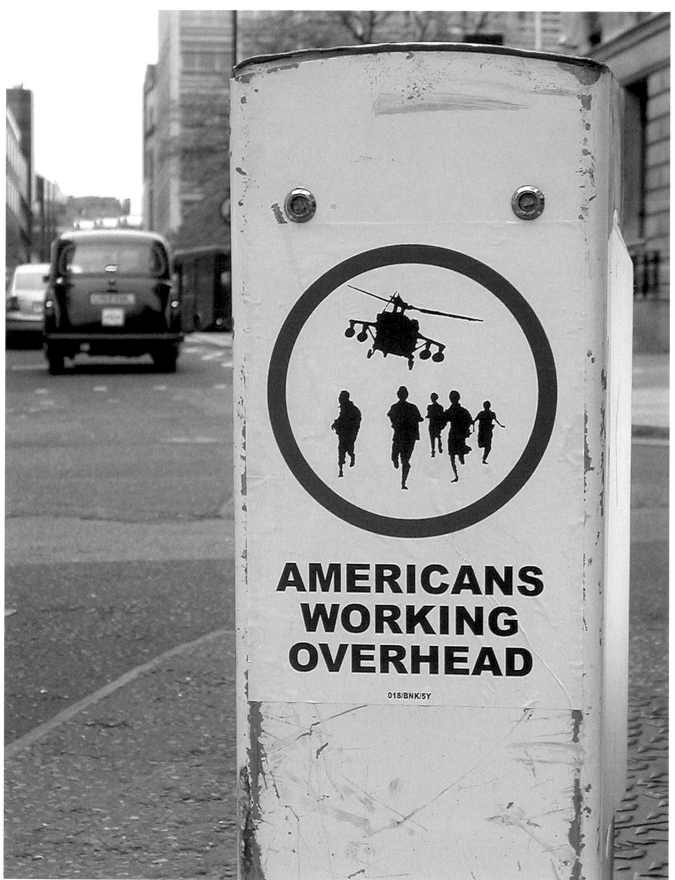

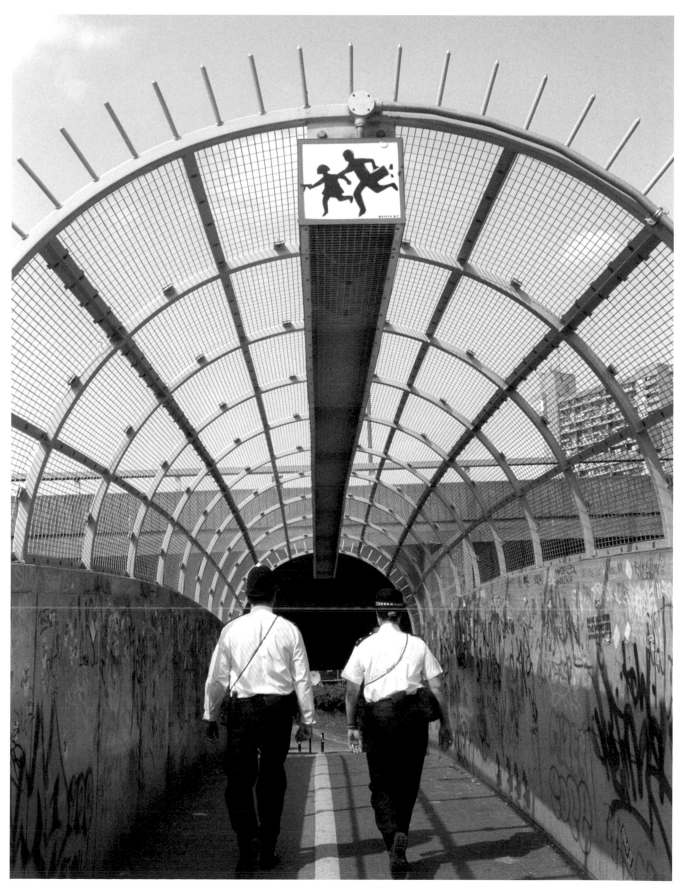

Stop the War Coalition
NOT IN MY NAME
DON'T
ATTACK IRAQ
stopwar.org.uk

WRONG WAR

People in glass houses shouldn't throw stones.
People in glass cities shouldn't fire missiles.

Anti-war demonstration, London 2003

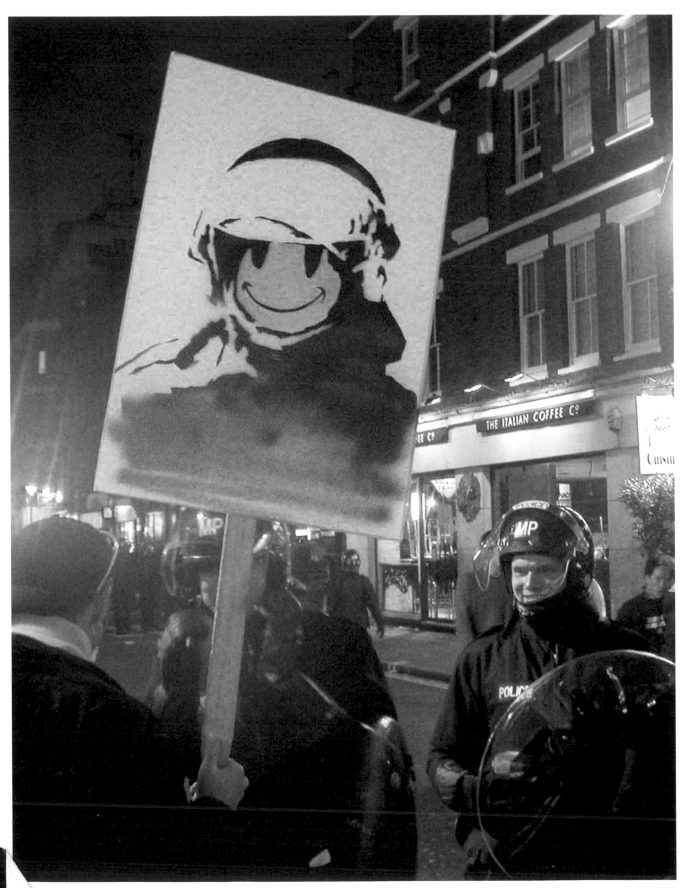

May day demonstration, London, 2003

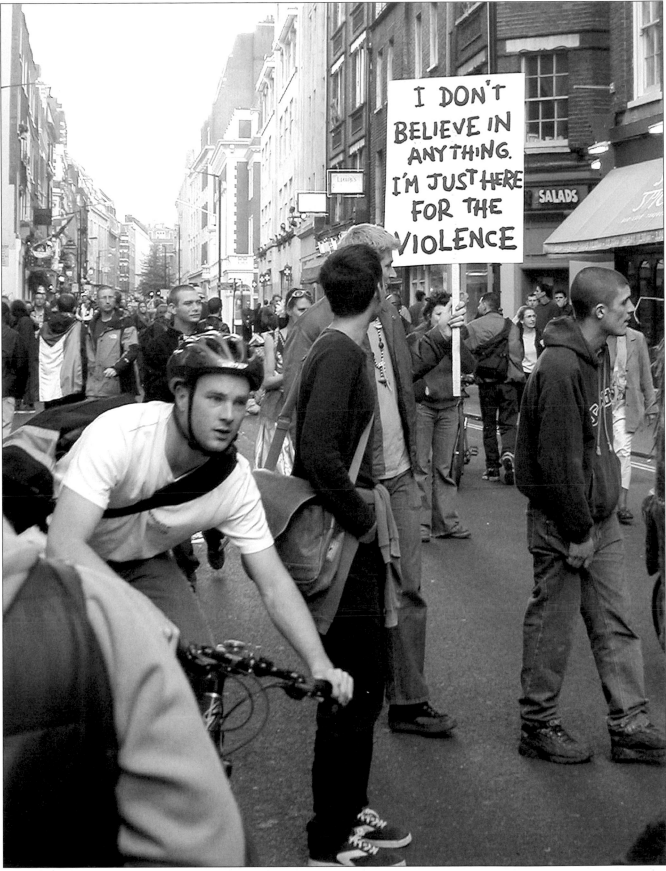

Placards handed to strangers, May Day demonstration, London 2003

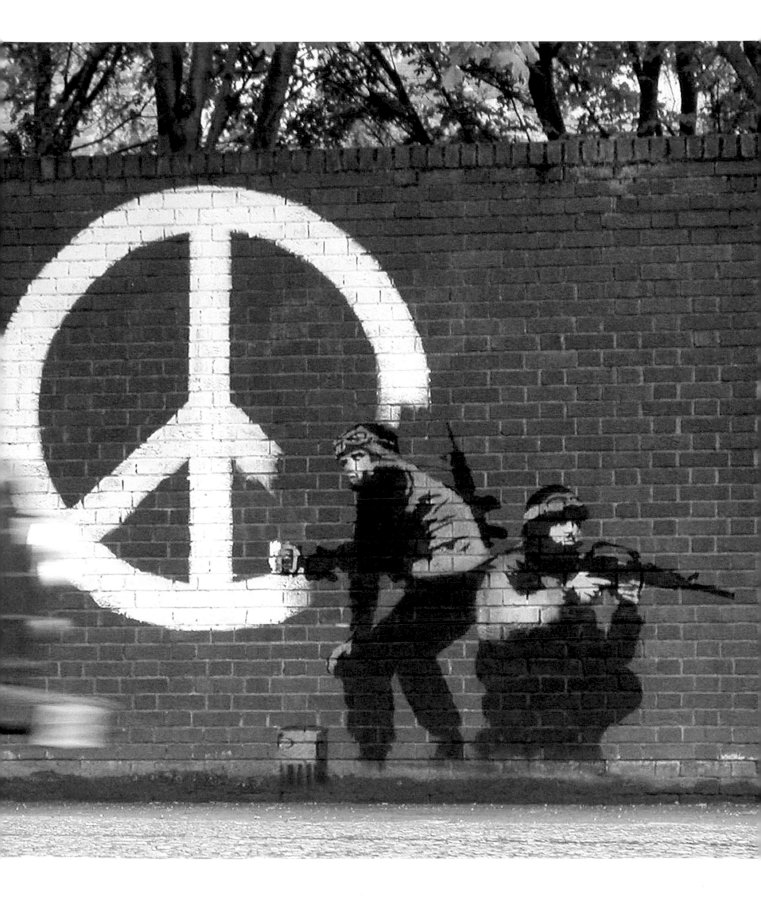

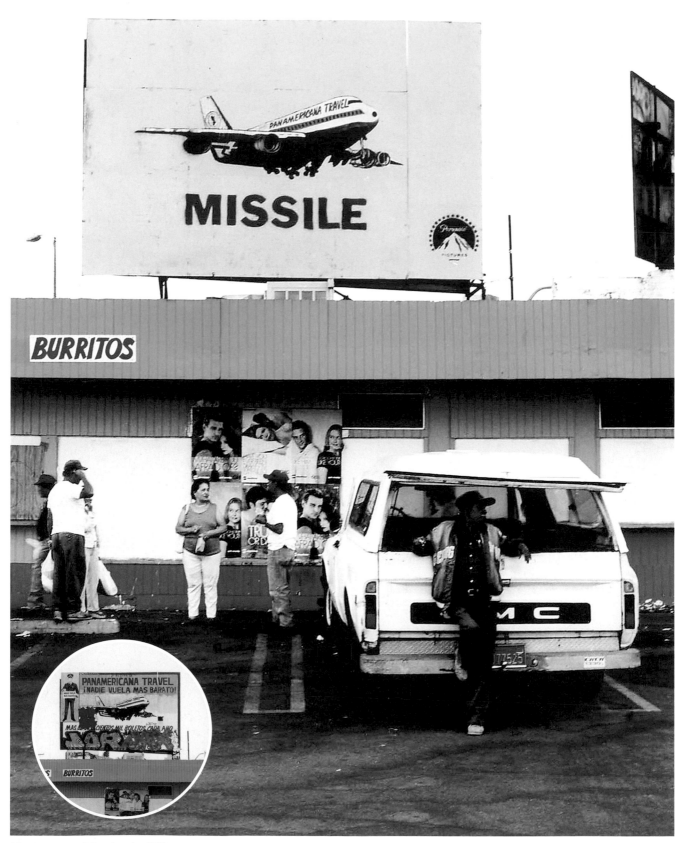

Modified billboard, Los Angeles 2002

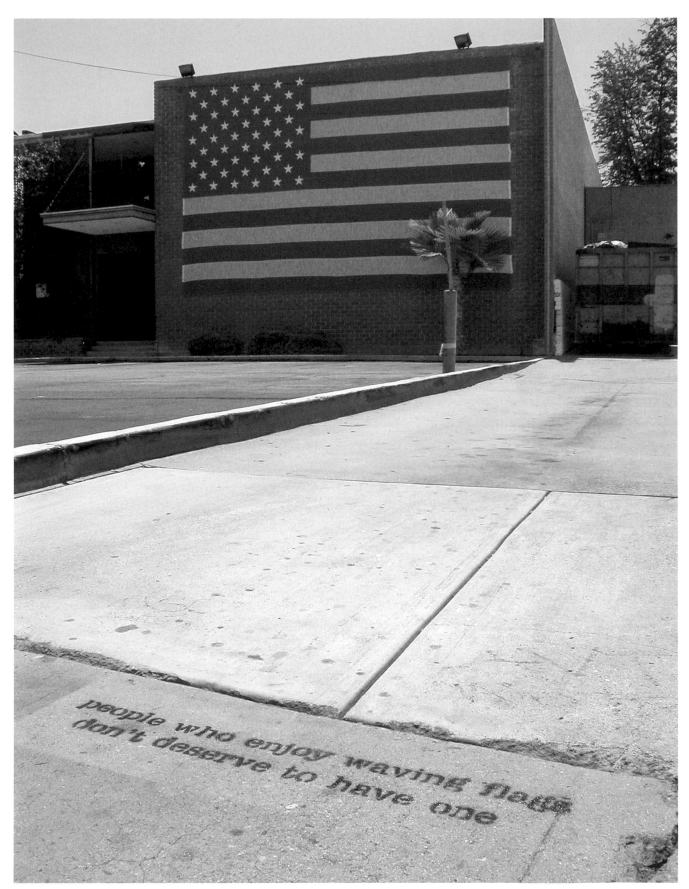

Manifesto

Extract from the diary of Lieutenant Colonel Mervin Willett Gonin DSO who was amongst the first British soldiers to arrive at the Nazi death camp Bergen-Belsen. It was liberated in April 1945 close to the end of the second World War.

I can give no adequate discription of the Horror Camp in which my men and myself were to spend the next month of our lives. It was just a barren wilderness, as bare as a chicken run. Corpses lay everywhere, some in huge piles, sometimes they lay singly or in pairs where they had fallen.

It took a little time to get used to seeing men women and childen collapse as you walked by them and to restrain oneself from going to their assistance. One had to get used early to the idea that the individual just did not count. One knew that five hundred a day were dying and that five hundred a day were going on dying for weeks before anything we could do would have the slightest effect. It was, however, not easy to watch a child choking to death from diptheria when you knew a tracheotomy and nursing would save it, one saw women drowning in their own vomit because they were too weak to turn over, and men eating worms as they clutched a half loaf of bread purely because they had had to eat worms to live and now could scarcely tell the difference.

Piles of corpses, naked and obscene, with a woman too weak to stand proping herself against them as she cooked the food we had given her over an open fire; men and women crouching down just anywhere in the open relieving themselves of the dysentary which was scouring their bowels, a woman standing stark naked washing herself with some issue soap in water from a tank in which the remains of a child floated.

It was shortly after the British Red Cross arrived, though it may have no connection, that a very large quantity of lipstick arrived. This was not at all what we men wanted, we were screaming for hundreds and thousands of other things and I don't know who asked for lipstick. I wish so much that I could discover who did it, it was the action of genious, sheer unadulterated brilliance. I believe nothing did more for those internees than the lipstick. Women lay in bed with no sheets and no nightie but with scarlet red lips, you saw them wandering about with nothing but a blanket over their shoulders, but with scarlet red lips. I saw a woman dead on the post mortem table and clutched in her hand was a piece of lipstick. At last someone had done something to make them individuals again, they were someone, no longer merely the number tatooed on the arm. At last they could take an interest in their appearance. That lipstick started to give them back their humanity.

Source: Imperial War museum

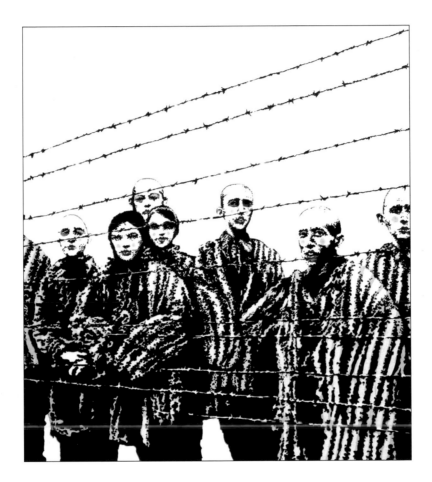

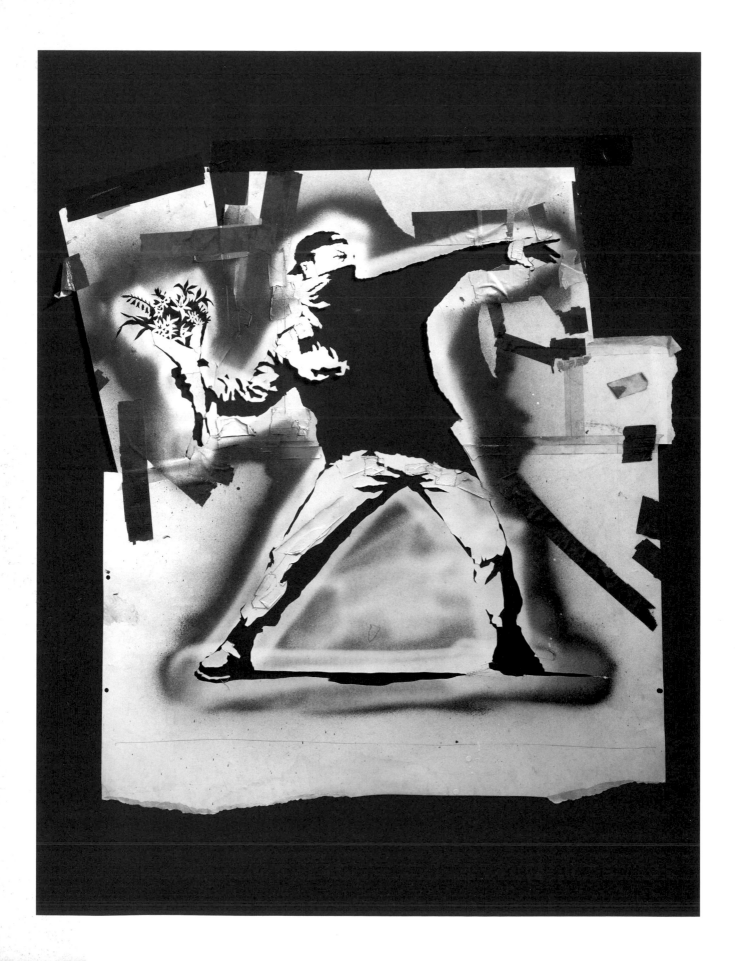

Advice on painting with stencils

- It's always easier to get forgiveness than permission

- Mindless vandalism can take a bit of thought.

- Nothing in the world is more common than unsuccessful people with talent, leave the house before you find something worth staying in for.

- Think from outside the box, collapse the box and take a fucking sharp knife to it.

- A regular 400ml can of paint will give you up to 50 A4 sized stencils. This means you can become incredibly famous/unpopular in a small town virtually overnight for approximately ten pounds.

- Try to avoid painting in places where they still point at aeroplanes.

- Spray the paint sparingly onto the stencil from a distance of 8 inches.

- When explaining yourself to the Police its worth being as reasonable as possible. Graffiti writers are not real villains. Real villains consider the idea of breaking in someplace, not stealing anything and then leaving behind a painting of your name in four foot high letters the most retarded thing they ever heard of.

- Be aware that going on a major mission totally drunk out of your head will result in some truly spectacular artwork and at least one night in the cells.

- The easiest way to become invisible is to wear a day-glo vest and carry a tiny transistor radio playing Heart FM very loudly. If questioned about the legitimacy of your painting simply complain about the hourly rate.

- Crime against property is not real crime. People look at an oil painting and admire the use of brushstrokes to convey meaning. People look at a graffiti painting and admire the use of a drainpipe to gain access.

- The time of getting fame for your name on its own is over. Artwork that is only about wanting to be famous will never make you famous. Fame is a by-product of doing something else. You don't go to a restaurant and order a meal because you want to have a shit.

People either love me or they hate me, or they don't really care

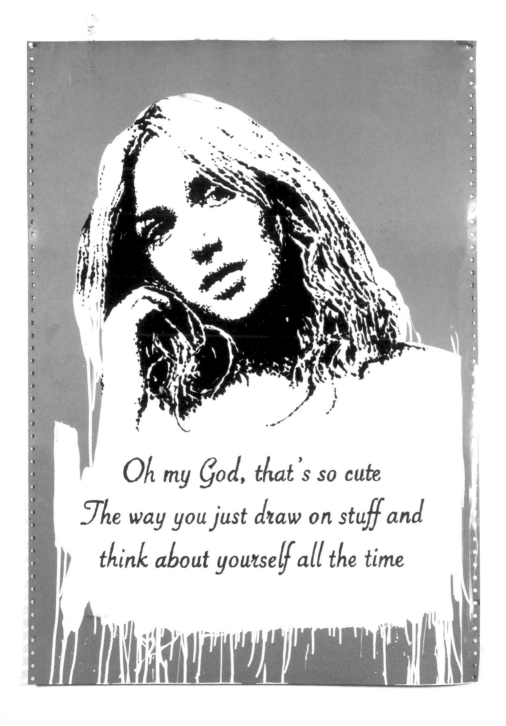

Oh my God, that's so cute
The way you just draw on stuff and
think about yourself all the time

Additional words and inspiration by Simon Munnery, Dirty Mark, Mike Tyler, BCP, Crap Hound, Brian Haw, Tom Wolfe and D. Additional photography by Steve Lazarides, James Pfaff, Andy Phipps, Maya Hyuk, Aiko and Tristan Manco. Technical support by Eine, Farmer, Luke, Tinko, Faile, Kev, Paul, Wissam, Jonesy, Brooksy and D. Layout by Jez Tucker. www.banksy.co.uk Dedicated to the memory of Casual T.